The Digital Sublime

The Digital Sublime
Myth, Power, and Cyberspace

Vincent Mosco

The MIT Press
Cambridge, Massachusetts
London, England

Set in Sabon by Achorn Graphic Services, Inc. Printed and bound in the United States of America.

Library of Congress Cataloging-in-Publication Data

Mosco, Vincent.
The digital sublime : myth, power, and cyberspace / Vincent Mosco.
p. cm.
Includes bibliographical references and index.
ISBN 0-262-13439-X (hc : alk. paper)
1. Information Society. 2. Cyberspace—Economic aspects. 3. Cyberspace—Political aspects. 4. Telecommunication. 5. Myth. I. Title.

HM851.M667 2004
303.48'33—dc22

2003060753

Contents

Acknowledgments

This book was very much a family affair. I am first and foremost grateful to Catherine McKercher, my wife, best friend, and colleague, for hours of conversations that made the often banal process of writing and editing simply sublime. My daughter Rosemary Mosco provided excellent research assistance by spending a summer in the library stacks gathering material on the history of technology and reading an entire early draft of the manuscript. Thank you, Ro, for filling several notebooks with wonderful material on old media when it was new. I am also grateful for your terrific editorial advice. Finally, a big thank you to my daughter Madeline Mosco, a university student of myth and history, thanks to whom I experienced one of the great joys of parenthood—carrying on intelligent, stimulating discussions with the person you used to rock to sleep reading *Goodnight Moon*. Thank you, Madeline, for helping me to appreciate myth, from the *Bhagavad Gita* to *The Simpsons*.

I started this book as Professor of Communication in the School of Journalism and Communication at Carleton University. I am grateful to Peter Johansen, who, as director of the school in 1996, nominated me to give the annual Davidson Dunton lecture. Thank you, Peter. The lecture provided the opportunity to test some of the ideas that effectively launched this project. I also wish to thank Derek Foster, who served as my graduate research assistant for part of this project and who contributed extensively to my work on the myth of the end of politics. It was a pleasure to collaborate with you, Derek, on an article for the *Journal of Communication Inquiry*, and I thank you for reading through and offering your advice on the entire manuscript.

I began writing *The Digital Sublime* shortly after making a presentation on myth and cyberspace at Harvard on a wonderful occasion, the

seventieth-birthday celebration of Anthony Oettinger, Gordon McKay Professor of Applied Mathematics and chairman of the Program on Information Resources Policy. Thanks, Tony, for introducing me to myths of cyberspace in your book *Run, Computer, Run,* and for all of your help over the years. Among other institutions that gave me opportunities to share some of the ideas contained in this book, I would like especially to thank Gricis, the interdisciplinary research group on communication, information, and society in Montreal, and especially cochairs Gaëtan Tremblay and Jean-Guy Lacroix; the Beijing Broadcasting Institute for having me deliver an address on myths of globalization; the University of California at San Diego for inviting me to speak at a conference honoring the work of Herbert Schiller; the University of Maine, especially Michael McCauley; and the Urban Affairs Association, which gave me the opportunity to present material from my research on the World Trade Center. The University of New Brunswick provided a warm welcome, stimulating conversations, and perceptive questions and comments in March 2003, when I visited to deliver the annual Pacey Lecture. Thanks especially to Vanda Rideout and Andrew Reddick in Fredericton and Dan Downes in St. John, who were most generous hosts.

I completed this book at Queen's University in Kingston after taking up residence as the Canada Research Chair in Communication and Society in July 2003. I would like to thank David Lyon of Queen's University, who invited me to speak at his June 2002 conference on The Network Society. The conference, which, among other things, honored the extraordinary contribution of Manuel Castells, was so spirited, engaging, and full of heated but respectful debate that I understood immediately why it was important for me to step up my research on myths of cyberspace and return to Queen's. David was also kind enough to help Roberta Hamilton, head of the Department of Sociology, to put together the chair application that brought me to Queen's. Thank you very much, David, and thank you, Roberta, for all your hard work on my behalf.

David Lyon's conference gave me the opportunity to present some of the ideas I develop in chapter 6 of this book. But the chapter began in my mind nearly fifty years ago when my father, Frank, would take my brother Joe and me on Sunday walks from Mulberry Street in New York's Little Italy through the quiet canyons of Wall Street and past what

would one day become the site of the World Trade Center on our way to Battery Park to watch the ships sail out to sea. The walk down Broadway, the smells and sites of the sea (which had intoxicated generations of New Yorkers, including Herman Melville), and the occasional stop at Trinity and St. Paul's Churches, with their old burial grounds, all resonated with myth and magic. As an adult I would return many, many times. Once, with Catherine and a then very young Rosemary and Madeline, I wandered down to the World Financial Center to view an exhibit of animatronic dinosaurs that inspired an article on political economy and computers. Years later I would return with Catherine and another time with Madeline to line up outside St. Paul's to view the ruins at "Ground Zero." I remember looking up with Madeline at a makeshift memorial outside St. Paul's containing photos, letters, and memorabilia of the victims, including a picture and the New York Yankees baseball cap of my cousin Joseph DiPilato. Joe grew up in the Mulberry Street tenement next door to ours. In the 1950s he liked to come over to our place because we had one of the first TVs on the block. In the 1960s he played third base on our parish team. Later he would learn the electrician's trade, only to die while practicing his profession in the south tower on September 11, 2001. Just a short time earlier, my sister Bernadette watched the plane that would strike the north tower fly by her 41st-story window in the U.S. government building on Broadway before hearing the crash. So I return to Ground Zero and cyberspace to write about the myth, magic, and politics of my neighborhood, lower Manhattan, whose business and government leaders gave birth to the myth of a post-industrial society, enshrined it in two "purifying" towers, and now wonder about the fate of both the myth and the space that today contains the pure dust of those towers.

The Digital Sublime

1

The Secret of Life

Moore's Law: The processing power of the computer doubles every 18 months.

Gore's Law[1]: Myths about the Internet double in their distance from reality every 18 months.

Although I began to think seriously about writing this book in 1996, shortly after the publication of *The Political Economy of Communication,* and started work in earnest in 1999, my interest in the field dates back to 1973, when, as a graduate student, I spent a summer doing research for Daniel Bell on trends in communication and information technology. My specific job was to write a critical review of research on forecasts about the new technology, particularly that of the mass media. I read much of what had been written about radio and television, including promises that broadcasting would bring about revolutionary changes in society, both for better and for worse. But my focus was to be on new technology. At the time, that meant cable and "pay" television and the prospects for computers (which, of course, had not yet appeared on the desktop). I decided to concentrate on cable television, which many people were taking seriously as a potential successor to radio and broadcast television. Cable TV, the typical conclusion went, had the potential to connect people like no other technology. It would bring about ubiquitous two-way communication, and it would likely usher in a Wired Society governed by Electronic Democracy. The multichannel universe would revitalize communities, enrich schools, end poverty, eliminate the need for everything from banks to shopping malls, and reduce dependence on the automobile. If only we had the will, the money, the right policies, etc., etc. In short, cable TV would transform the world. Sound familiar? It is striking how little predictions about new technology have changed over the years. As people

once hailed the Telegraph Age, the Age of Electricity, the Age of the Telephone, the Age of Radio, or the Age of Television, we are now said to be in the Age of the Computer.

It is not surprising that we call it the Age of the Computer. In the 1990s, personal computers entered homes and offices throughout the developed world and even began to make inroads in the less-developed countries. What sense would it make to call this the Age of Radio? But how many of us recall, through personal experience or reading, that people once spoke of the Age of Radio as easily as we speak of the Computer Age? Even fewer would know that among the heroes of that earlier age were the Radio Boys—youngsters who lent romance and spirit to the time by building radios, setting up transmitters, and creating networks. Often this was done surreptitiously, contravening patents, copyrights, and other government rules as well as the business plans of big companies. Popular fiction celebrated their exploits. Elsewhere, their unwillingness to conform was decried. We might view them as equivalent to today's computer hackers. Anthropologists would see them as electronic tricksters. But we hardly remember them today, for radio, like its predecessors the telegraph and the telephone and like communication media that followed (including broadcast and cable television), entered the realm of the commonplace and the banal. They no longer inspire great visions of social transformation. They are no longer sublime. Yet who among us would disagree that the telephone, radio, and television (even cable television) are powerful forces in society and in the world? The irony, it appears, is that, as these once-new technologies lost their luster, gave up the promises of contributing to world peace, and withdrew into the woodwork, they gained a power that continues to resonate in the world. The Age of Radio is dead, but radio continues to grow. Cable television did not bring about a Wired Society, but it expands throughout the world.

And what about the computer? In the late 1990s, the computer was anything but banal. All the wonders that were forecast for the telegraph, electricity, the telephone, and broadcasting were invested in the computer. One of the central points of this book is that computers and the world of what came to be called cyberspace embody and drive important myths about our time. Powered by computer communication, we would, according to the myths, experience an epochal transformation in human

experience that would transcend time (the end of history), space (the end of geography), and power (the end of politics). It is easy to dismiss myths as inconsequential fictions, thus making the task of understanding them simple: unmask the fiction, open people's eyes to the truths that myths conceal, and thereby eliminate their power to fog minds and manipulate behavior. If myths about cyberspace were simply lies that exploited people (for example, by getting them to bet their retirement money on firms that promised to make millions of dollars selling pet food over the Internet), unmasking myths would be likely to correct the behavior. By revealing that "dot-com was more like dot-con" (Cassidy 2002), it would end the matter.

Useful as it is to recognize the lie in the myth, it is important to state at the outset that myths mean more than falsehoods or cons; indeed, they matter greatly. Myths are stories that animate individuals and societies by providing paths to transcendence that lift people out of the banality of everyday life. They offer an entrance to another reality, a reality once characterized by the promise of the sublime.

I will have much more to say about the specific meanings of myth, transcendence, banality, and the sublime in the next chapter. For now, it is important to emphasize the need to resist the peculiarly modern temptation to see myth as falsehood. Enticing as it is for people influenced by science to want to assess stories as true (accurate) or false (myth), this is myopic and beside the point. Myths are not true or false, but living or dead. "Disproving" a myth by pointing to its failure to conform to an accepted truth or to evidence usually does little to dispel it (Ohmann 1962).

For at least 2 years, people continued to bet on Internet companies whose prospects for success were nearly nonexistent. They did so because people believed, among other things, that ".com" after a firm's name conferred a mythical power that allowed the firm to transcend accepted marketplace conventions. History, skeptics contended, teaches that stock prices should not go up for companies that are losing large amounts of money and can demonstrate little concrete evidence that they will stop doing so. But instead of listening to stories like this, even when backed up by the rigors of a historical analysis of price-earnings ratios and other statistical indicators, people continued to bid up stock prices. Rather than allow the myth to be undermined by facts proving it false, many people, including some of the experts, answered with myths of their own.

In a widely read book, an economics writer for the *Washington Post* predicted that the Dow Jones Industrial Average, which at the time was near its historic high of about 11,000, would soon reach 36,000. Not to be outdone, the editor of the magazine *Wired* predicted in a popular book titled *New Rules for the New Economy* that by the year 2020 the average annual family income in the United States would surpass $150,000 and the Dow would be between 50,000 and 100,000. That may yet happen, but in March 2003 the old economy still ruled and the Dow dipped below 8,000, down about 35 percent from its high of less than 3 years earlier.[2]

Many Internet experts and gurus came to the conclusion that history had changed fundamentally. It may have once taught us something, but this is the end of history. Convinced by the demise of the Cold War and the magic of a new technology, people accepted the view that history as we once knew it was ending and that, along with the end of politics as we once knew it, there would be an end to the laws propagated by that most dismal of sciences, economics. Constraints once imposed by scarcities of resources, labor, and capital would end, or at least loosen significantly, and a new economics of cyberspace (a "network economics") would make it easier for societies to grow and, especially, to grow rich. It was as if we had uncovered a new set of scientific laws, the equivalent of a new physics. However, instead of a quantum world in which the behavior of subatomic particles followed its own set of laws (laws dramatically different from those, such as gravity, that defined traditional physics) we now encounter a network world in which the laws of economics follow strange but generally beneficent patterns. What made the dotcom boom a myth was not that it was false but that it was alive, sustained by the collective belief that cyberspace was opening a new world by transcending what we once knew about time, space, and economics.

Of course, the world that gave rise to these myths began to change fundamentally in the spring of 2000 when stock markets everywhere, led by the dotcom and telecommunications firms that had propelled the boom, began a steep slide. By the fall of 2002, markets were at 6-year lows, most of the new Internet companies had disappeared, once-dominant telecommunications equipment firms (Lucent, Nortel, Cisco, JDS) had lost about 90 percent of their value, and new telecommunications providers (WorldCom, Global

Crossing) were either bankrupt or nearly so. Between the first quarter of 2001 and the second quarter of 2002, Silicon Valley lost 127,000 jobs— 9 percent of its workforce. The losses were most acute in the clusters that had driven economic growth. Software, computer hardware, and semiconductor firms lost 22 percent of their jobs over the same period (Fisher 2003). When not dealing with economic collapse, many firms and their top executives faced criminal charges for having defrauded their stockholders by falsely inflating profits to pump up their stock values. For some it appeared that the only genuine break with history turned out to be the unprecedented collapse of a major industrial sector. Nothing like this had been witnessed since the Great Depression.[3] Most historians reached further back, to the collapse of the railroad industry in the last quarter of the nineteenth century, for anything resembling a precedent. But even the comparison to the building binge of the railroads' heyday, when twice as many rail lines as were needed were built, was not entirely fitting. The fiber optic spree created more than 20 times as much capacity as was required, and in only 5 or 6 years (Howe 2002).

Remarkably, the collapse even had a profound impact on long-established firms that presumed they had purchased protection from anything approaching such a disaster by aggressively pursuing a policy of convergence (that is, the merging of firms based in different lines of media activity but particularly incorporating Internet-related activities). The leading example, and the one that propelled the convergence mania, was the January 2000 merger of the media giant Time Warner and the Internet leader America Online. As the world's top Internet service provider, AOL, the betting went, would greatly extend the reach of Time Warner's enormous array of content providers, including magazines, books, video, and film, by giving them a gateway to cyberspace. Pundits agreed that people would be using the Internet for media access, and that therefore the convergence of the world's dominant content provider and its major Internet company was certain to succeed. But after 2 years the sure bet turned sour, and after 3 years the industry was in deep trouble. Between March 2000 and March 2003, AOL lost 80 percent of its value. Almost every other convergence venture suffered a similar fate. Even mighty Microsoft shed 53 percent of its value over that same period, and Intel was down 73 percent. Established telecommunications firms fared much worse. JDS shrank in value by 98 percent, Lucent by 97, and Cisco by 81 (Norris 2003).

The responses to this catastrophe followed a predictable range, including, at least for a time, denial (the turnaround is just a quarter away) and escape (get out of the business). Suddenly the network world went from promising to transfer the entire social fabric (shopping, banking, education, entertainment, etc.) to the Internet, and painting sweet visions of a lucrative world rebranded as Everything.com, to making people wonder whether the Internet would do anything more substantial than deliver messages and pornography. Was it all a digital hustle?

This book is, in part, a response to the extraordinary boom-and-bust cycle. But it aims to provide more than just a set of answers to the question "What happened?" Though that question must play a large role in any current book about cyberspace, the goal of this effort is to deepen and extend what we know about cyberspace by situating it within what we know about culture, and specifically about mythology, about central myths of our time, about the history of communication media, and about the political economy of computer communication. The book is not meant to question those who would maintain that communication and information technologies are powerful instruments of social change; they are, and it is important to demonstrate carefully how they contribute to social change and how they retard it (Kogut 2003; Woolgar 2002). In fact, I will argue that it is when technologies such as the telephone and the computer cease to be sublime icons of mythology and enter the prosaic world of banality—when they lose their role as sources of utopian visions—that they become important forces for social and economic change.

The Digital Sublime is structurally similar to but substantively different from my 1996 book *The Political Economy of Communication*. That book took political economy as a starting or entry point and built a bridge to the cultural analysis of communication. This one begins with culture, particularly as manifested in mythology, and builds a bridge to political economy. The earlier book aimed to demonstrate the usefulness of a political economic approach to communication, but only as part of an epistemology that was non-essentialist and based on mutual constitution. In particular, it defined political economy as the study of the social relations, particularly the power relations, that mutually constitute the production, distribution, and exchange of resources, such as communication. As a starting point in analysis, political economy pro-

vided a useful way to understand media, communication, and information. But, the book insisted, political economy did not comprise an essential core to which all other perspectives could be reduced. Rather, it maintained, the social field is mutually constituted out of multiple perspectives, including political economy and cultural studies. That book began by systematically interrogating political economic theory, proceeded to demonstrate how it has been applied to communication research, and "rethought" these applications by showing how the political economic processes of commodification, spatialization, and structuration provide useful tools for broadening and deepening our understanding of the field. The concluding chapter documented the mutually constitutive relationship between political economy and cultural studies, indicating how each provided a useful critique of the other and how together they could deliver a powerful perspective on communication and media analysis. In sum, while political economy offered the primary basis for understanding the field, it was certainly not determinative. A sophisticated cultural analysis was also required to provide a robust comprehension of social communication.

In this book I start with culture and specifically examine the range of ways to think about myth. It is beyond the scope of one book to provide a complete cultural analysis of cyberspace. Rather, I choose to focus here on one important dimension of a cultural analysis—myth—and its application to computer communication. But, on the epistemological grounding of my 1996 book, I eschew determinism to demonstrate how an analysis founded on myth can build a bridge to a political economic understanding, indeed is mutually constituted with political economy. Myth is the starting or entry point to a valuable understanding of computer communication, but it leads to, requires, and (particularly as I will demonstrate in the final chapter) is mutually constituted with a political economic perspective.

Chapter 2 takes up the meaning of myth and examines how cyberspace contributes to the construction of contemporary myths. In large measure it provides a cultural analysis of myth and cyberspace. However, it demonstrates the mutually constitutive relationship between myth and power by examining some of the leading mythmakers from the academic, political, and business worlds and the institutions that support this mythmaking process. The chapter concludes by considering the relationship between

myths of cyberspace and other ways of reflecting on and telling stories about it, particularly the connection between myth and metaphor.

Chapter 3 takes up the connection between myths of cyberspace and one of the central myths of our time: the end of history. The mix of powerful new information and communication technologies and widespread support for the belief that we have entered an age marked by radical changes having to do with time, space, and social relations creates a new vision of social life.

Chapter 4 discusses two related myths: the end of geography and the end of politics. These myths promise that, in addition to a radical disjunction in time, we are participating in radical transformations in space and in social relations.

Chapter 5 shifts from the intellectual sources of cyberspace myths to their history in the experience of earlier communication and information technologies. It examines popular and intellectual responses to the telegraph, electricity, telephone, radio, and television. The widely held beliefs that computer communication is ending history, geography, and politics are not at all new. Time, space, and politics were also to be radically transformed by earlier new technologies. Not only does this demonstrate that our response to computer communication is far from unique; it also documents our remarkable, almost willful, historical amnesia. One generation after another has renewed the belief that, whatever was said about earlier technologies, the latest one will fulfill a radical and revolutionary promise.

Chapter 6 concludes the book by building a bridge from the largely cultural analysis of myth to a political economic analysis by concretely examining the political, economic, and social significance of cyberspace. It starts in an increasingly mythic place: "Ground Zero," the site of the attack on the World Trade Center. But the site was mythic even before the attack. If there ever was a physical location for the birth of the myths of cyberspace, it was here, even more so than in Silicon Valley or any of the many other high-tech centers that claim to be the birthplace of the Information Age. The World Trade Center was constructed as the centerpiece of a planning effort that began in the 1950s to transform lower Manhattan into a global center for communication, information, and trade, the international capital of a burgeoning post-industrial world.

New York was to be the informational city and the twin towers its icon. Beginning at Ground Zero, this chapter goes on to consider the significance of what grew from those towers, taking us through the political economic forces that propelled the boom that inspired so much mythic thinking to the bust that, in combination with the physical destruction of the World Trade Center, led some to surmise that the Information Age might be over. The chapter suggests that any such judgments are as premature and shortsighted as visions of the end of history. It ends by returning to Ground Zero, where questions about what will be done there mirror questions about the future of cyberspace and call to mind a perennial myth of American culture and politics.

"The Secret of Life"

Since this is a book about myths, it is appropriate to begin with my own version of an old myth[4]:

The Norse god Thor liked to descend from Valhalla from time to time to play among the mortals. On one such occasion, he overdid it and found himself outwrestled by a local hulk named Sven, who managed to maneuver Thor into a painful headlock. Thor protested but Sven would hear nothing of his godly claims. In fact, Sven's only response was to tighten his already powerful grip. It was time for stronger measures. Thor offered a deal.

"What would it take for you to release me?" Thor moaned.

Sven initially ignored the offer but finally bit. In fact, he took a big bite: "Tell me the secret of life."

"The secret of life?" Thor groaned. "What kind of deal is this? You want me to give up the secret of life just to be released from a headlock?"

Sven smiled and then applied more pressure. Finally, the god relented, but came back with a counter-offer.

"I'll tell you the secret of life, but on one condition," Thor insisted, a smile, visible only to the gods, growing around the corners of his mouth. "Pluck out one of your eyes."

"This headlock must have cut off the blood to your brain," Sven bellowed. "I'm the one in control here and I'll be the one to offer the deals."

"Don't press your luck," bristled Thor. "Remember, I may look like a mortal now but I'm capable of reminding you that I am a god at any time. Now think about it. You receive something no mortal has ever possessed, something that people far smarter than you, and after far more sacrifice, have failed to acquire. Most would give both eyes for such gift. All I ask for is one of yours."

Although he kept his grip firm, Sven's determination loosened as he thought about the offer. The more he thought, the more he liked the idea of knowing

something that no other person, in all of human history, has ever known. But an eye is a high price to pay. His mind bounced backed and forth like a teeter-totter: "Secret of life/Pluck out an eye; Pluck out an eye/Secret of life; Secret of life/Pluck out an eye." At last, first with some hesitation and then with cold determination, Sven relented. He reached into his left eye and, with a scream that could be heard throughout the land, ripped it out.

"Here, Thor, my eye for life's secret."

Finally released from the painful power of the brute, Thor relaxed his own muscles, looked at the bloody organ in Sven's hand, took it, and spoke.

"You have earned your reward, dear Sven. Now for the secret of life. It is painfully simple: See vigilantly, with both eyes."

One of the primary sources of a myth's power is its elasticity, which allows the reader or the listener to draw many conclusions from myth's inherent ambiguity. For me, "The Secret of Life" offers two important meanings. The first is that the secret of life is not a thing, something material such as wealth, an object that one can point to as clear evidence of life's secret. If there is a secret of life, it is a process, like the act of seeing, which can be used in many different ways, provided that we do so with vigilance. But, as Thor insists, much to Sven's consternation, we must see vigilantly with both eyes, and that admonition helps me to explain a central purpose of this book.

Much of what has been written about computer communication, the Internet, or cyberspace focuses with one eye on what we might call its material characteristics. These describe the major technologies that produce cyberspace, the political rules of government, and the economic rules of the market that go a long way toward organizing it. This singular focus is understandable: cyberspace is somewhat new, and so the technologies and rules that govern its use are in a formative stage and warrant close scrutiny. Nevertheless, we would benefit by considering what the other eye sees: the cultural or mythic character of what computer communication creates. Cyberspace is indeed technological and political, but it is also a mythic space—perhaps even a sacred space in the sense that Mircea Eliade (1959) meant when he referred to places that are repositories of the transcendent. Seeing vigilantly with both eyes means recognizing that computer communication makes up and is made up by technological and political practices as well as by mythic and cultural ones. To be more precise, we can say that cyberspace is mutually constituted out of culture and political economy, out of the interconnected realities of myth and social institution.[5]

The technical, political, and economic dimensions of cyberspace are important to understand, and some of these are taken up below, particularly in the final chapter. But so too are the mythic and cultural dimensions. Moreover, the book maintains, we must comprehend the culture of cyberspace if we are to deepen what we know about its more material qualities. In essence, culture, particularly myth, is our starting or entry point, the main discourse in the book's analysis, but political economy is always present as subtext, related to culture in mutual constitution.

What Is Cyberspace?

The word 'cyberspace' was coined by William Gibson, whose 1984 novel *Neuromancer* described a world in which computers define the terms of life, including its struggles, pleasures, and pains. Much of the action takes place in a netherworld that is part material and part computer code. By defining the literary genre that came to be called "cyberpunk," Gibson launched himself into the ranks of the "digerati," a select group of the computer savvy who create the language, imagery, and tone for what they and their followers see as a new world.

'Cybernetics'—a word derived from 'kubernetes', the classical Greek word for the helmsman of a ship—designates the science of steering or managing large systems. One genuinely attractive aspect of the word 'cyberspace' is that it is connected both to a mythic world conjured in code and to a world rooted in and increasingly dependent upon large, complex, formally rational systems.[6]

Remarkably for someone writing in 1984, more than a decade before 'Internet' and 'World Wide Web' became household words, Gibson acknowledges the strange combination of myth, science, magic, and logic that made up cyberspace in the very first mention of the word: "A year here and he still dreamed of cyberspace, hope fading nightly. All the speed he took, all the turns he'd taken and the corners he'd cut in Night City, and still he'd see the matrix in his sleep, bright lattices of logic unfolding across the colorless void." (Gibson 1984: 4–5) And why shouldn't Gibson's protagonist pine for a digital world far richer than what the material world of atoms and molecules might provide! "He'd operated on an almost permanent adrenaline high, a byproduct of youth and proficiency, jacked into a custom cyberspace deck that projected his

disembodied consciousness into the consensual hallucination that was the matrix." (ibid.: 5)

Gibson's definition of 'cyberspace'[7] stands up well over the multiple generations of systems that have spread both the myth and the science, the vision of two eyes, since 1984: "Cyberspace. A consensual halluci-nation experienced daily by billions of legitimate operators, in every nation, by children being taught mathematical concepts. . . . A Graphic representation of data abstracted from the banks of every computer in the human system. Unthinkable complexity. Lines of thought ranged in the nonspace of the mind, clusters and constellations of data. Like city lights, receding. . . ." (ibid.: 51)

Three Eyes?

In what might be called "seeing vigilantly with three eyes," the sociolo-gist Bruno Latour (1993) challenges us to break through the neat but false compartments of nature, politics, and texts that many use to explain the secrets of life. According to Latour, we insist on under-standing science as natural (that is, as the rational integration of mate-rial forces, including technologies); as politics (the strategic maneuvers of self-interested social actors and forces); or as text (that is, the rhetor-ical strategies that are used to explain and thereby linguistically consti-tute the world). By placing each of these elements in its own box, Latour maintains, we are able to retain the natural quality of science even as we understand that politics and rhetoric play roles. By doing this, accord-ing to Latour, we retain a powerful fiction—sustain a myth, perhaps—that we are distinct from our pre-scientific predecessors. We say we are modern; Latour disagrees. In making the case that "we have never been modern," Latour insists that the three ways of seeing—natural, political, and textual—are mutually constitutive, or, perhaps better put, mutually contaminative. There is no distinctly natural world of sci-ence separate from the political and the rhetorical. There is therefore no distinctly modern.

One does not have to accept Latour's conclusion that we have never been modern and are therefore no different from the ancients to recog-nize the value of his perspective.[8] We do indeed tend to acknowledge the

political and rhetorical influences on scientific understanding—witness the discourse about networks, relatedness, and entanglement in quantum physics that challenges the discourse about discrete atomic units popular in Newtonian physics. Nevertheless, we continue to compartmentalize politics and rhetoric as forces external to an entirely different process, which we call science. But Latour and his fellow science-studies scholars (Hughes 1983; Pinch 1986) compel us to examine how politics and rhetoric are constitutive of the scientific enterprise. We may see with two or even three eyes, but they all create one vision. Historians of technology are also increasingly recognizing that our machines have been created out of a powerful religious ethos (Noble 1997). James Carey and other communication scholars have spoken about a ritual theory of communication and how it draws us to the inescapable conclusion that "in contemporary popular commentary and even in technical discussions of new communications technology, the historic religious undercurrent has never been eliminated from our thought" (Carey 1992: 18). "From the telegraph to the computer," Carey continues, "the same sense of profound possibility is present whenever these machines are invoked."

Myths and the Computer

This book applies some of these ideas to the growth of the computer, the Internet, and cyberspace. Specifically, it argues that cyberspace is a mythic space, one that transcends the banal, day-to-day worlds of time, space, and politics to match the "naked truth" of reason with the "dancing truth" of ritual, song, and storytelling (Lozano 1992: 213). Indeed, cyberspace is a central force in the growth of three of the central myths of our time, each linked in the vision of an end point: the end of history, the end of geography, and the end of politics. The purpose of the book is to understand these myths in order to develop a deeper appreciation of the power and the limitations of computer communication. As we shall see, myths are not just a distortion of reality that requires debunking; they are a form of reality. They give meaning to life, particularly by helping us to understand the seemingly incomprehensible, to cope with problems that are overwhelmingly intractable, and to create in

vision or dream what cannot be realized in practice. For the novelist Christa Wolf, who brought new life to the mythic figure of Cassandra, "to learn to read myth is a special kind of adventure. An art that presupposes a gradual peculiar transformation; a readiness to give oneself to the seemingly frivolous nexus of fantastic facts, of traditions, desires and hopes, experiences and techniques of magic adapted to the needs of a particular group—in short, to another sense of the concept 'reality'." (Wolf 1988: 196)

Cyberspace may not be bringing about the end of history, of geography, and of politics, but there is much to be gained from studying why it is not doing so and why people believe that it is. And even after what is arguably the greatest collapse in modern business history, after millions of people lost billions of dollars in the telecommunications and dotcom industries alone, people still believe. Forget the crash, forget the banality of technology; the December 2002 issue of *Wired* offers a cover story and several feature articles on computers, science, transcendence, and religion. New media convergence may have failed, but there is a "new convergence" between technology and religion. Editor-at-large Kevin Kelly (2002: 183) announces that "God is the Machine" and concludes that "the universe is not merely like a computer, it is a computer."

Perhaps the greatest mistake people make about technology is to assume that knowledge of its inner workings can be extrapolated over years to tell us not only where the machine is heading but also where it is taking us. Research has provided some correction to this view by demonstrating that economic, political, and social forces are as important in determining where we are headed as is an understanding of the technology. We now know that culture is also deeply implicated in the mix of influential forces, and that culture, even for us moderns, includes mythology. For some, myth is indispensable to understanding. The philosopher Mary Midgley writes: "We have a choice of what myths, what visions we will use to help us understand the physical world. We do not have a choice of understanding it without using any myths or visions at all. Again, we have a real choice between becoming aware of these myths and ignoring them. If we ignore them, we travel blindly inside myths and visions, which are largely provided by other people. This makes it much harder to know where we are going." (1992: 22) The media critic Neil Postman makes a similar case, although he under-

standably worries about the use of the word 'myth' because it summons thoughts of falsehood rather than of vision. Nevertheless, Postman maintains, while his purpose is neither burying nor praising gods, he must insist "that we cannot do without them, that whatever else we call ourselves, we are the god-making species" (1996: 6). In fact, Postman asserts, this god-making or mythmaking capacity demonstrates that "our genius lies in our capacity to make meaning through the creation of narratives that give point to our labors, exalt our history, elucidate the present, and give direction to our future" (ibid.: 7).[9] But it is a genius that exacts a price by tempting us to use myths about the future to avoid present conflicts and create a false sense of social cohesion. The sociologist C. Wright Mills noted several decades ago that "the more the antagonisms of the present must be suffered, the more the future is drawn upon as a source of pseudo-unity and synthetic morale" (1963: 302). Critically examining myths of cyberspace may help us to loosen the powerful grip of myths of the future on the present. It may lead us to question the naturalized tendency to see the future as the pure extension of logic, technical rationality, and linear progress, and other bulwarks against the primitive forces of instinct and intellectual poverty that have historically weighed against human accomplishment. In this view, cyberspace is a mythic gloss on individual achievement and genuine community against the ostensibly backward Others who would undermine both.

The critique of mythology helps to disturb and subvert the conventional and therefore solid sediment of meaning and common sense that gives cyberspace a normality and indeed a certitude of superiority. This is particularly important now because cyberspace is today's repository of the future. As Carey has said (1992: 200), "nostalgia for the future, among the pastorals available to us, seems the more pernicious precisely because it is less self-conscious." But it is also instructive because in their texts, and more so in their subtexts, the myths of cyberspace point to an intense longing for a promised community, a public democracy, or what Carey (ibid.) refers to in the American context as John Dewey's "conjoint life of the polity." It is this element of genuine hope that an understanding of mythology, rather than an outright dismissal of it, aims to uncover. By splitting open the solidly constructed images of technical progress and juxtaposing them with other images, we can contribute to productively

destabilizing the dominant representations of what we are supposed to be and where we are going. In this regard, I would agree with the historian of religion Wendy Doniger (1998) on the need to replace Roland Barthes's vision of myth as post-political (in essence, what is left after the politics is eliminated) with the view of myth as pre-political. Myths can be viewed as an early step in a process that, when examined with a critical eye, can restore with every critical retelling a political grounding that myths appear to leave out. In essence, myths can foreclose politics, can serve to depoliticize speech, but they can also open the door to a restoration of politics, to a deepening of political understanding.[10]

2

Myth and Cyberspace

The Digerati Worship the Burning Man

In 1986, on a beach near San Francisco, a small group of people began an annual ritual that culminated in the burning of a large wooden icon of a man. By 1990 the burning man had grown to a height of 40 feet and the attendance to 800. Meanwhile the venue shifted to the Black Rock Desert of Nevada. Six years later, with widespread attention and support on the Internet, the now five-day event swelled to 8,000 participants. After the next year, when 10,000 showed up, journalists began paying attention to what was now called The Burning Man Festival and describing its unique details: "A naked couple poses on the baked desert plain, wearing black net face masks, goggles and snorkels. A bald man in blue lipstick wears a baby dress and carries a pinwheel. A man squats in ersatz tribal gear complete with a stick through his nose. At their center is a five-story-high statue of a man, constructed of wood and lighted with neon. On the final night, the statue is set ablaze as celebrants dance in painted skin and loincloths and scream in ecstasy." (Rothstein 1997). Particularly striking to journalists was the seemingly strange connection between the primitive nature of the festival and the overwhelming number of "digerati" in attendance. The first book about the festival was published by a press created to promote doings in cyberspace. Kevin Kelly of *Wired* touted Burning Man as "the holiday of choice for the digerati" (ibid.). In 1999 the Burning Man symbol played a central role in the surprise hit film *The Blair Witch Project*—it dangled from trees to symbolize the point of no return for the film's doomed characters. In 2001 nearly 26,000 people trekked into the desert to worship the burning man, now 70 feet tall. The web site burningman.com and its offshoots continue to flourish, recalling

the early years of the ritual with the reverence and hyperbole of a classical myth, and people continue to scratch their heads over the connection between this at least quasi-primitive ritual and its attendance by many high-tech enthusiasts, media professionals, and academics. What is the link between myth and cyberspace?

The Great Transformation: From Here to Banality

The news media, popular culture, and government policy debates are increasingly filled with variations on the theme that society and culture are in the process of a great transformation brought about by the introduction of computers and communication technology. It is common for serious academic books to begin with sentences like this: "The invention of the computer is one of the pivotal events in the history of civilization." (Robertson 1998) Some supporters of this view maintain that we are going through a period that rivals in significance the development of agriculture, which, about 10,000 years ago, took the human race out of its nomadic hunting and gathering way of life; others compare it to the development of industry, which, starting 300 years ago, made manufacturing products more central than farming to modern economic and social life. This view maintains that computer communication is bringing about an Information Revolution that links people and places around the world in instantaneous communication and makes the production of information and entertainment a central economic and political force.

Here is a common refrain from one of the song books of the cyberspace revolution: "Today, we are witnessing the early turbulent days of a revolution as significant as any other in human history. A new medium of human communications is emerging, one that may prove to surpass all previous revolutions—the printing press, the telephone, the television, the computer—in its impact on our economic and social life." (Tapscott 1996: xiii)

It is agreed that not all societies are at the same level of informational development, that the revolution is well entrenched in the richest countries and is only beginning in the poorest. It is asserted, however, that no society can resist the impact of the computer, particularly when the computer is linked to advanced telecommunications and video systems. In fact, information technology is widely perceived to be a major ingredient in economic and social development. Indeed, the computer, the telephone,

television, radio, and associated devices (the fax machine, the photo-
copier, the printer, the video camera, the MP3 player, the DVD player) are
making information and entertainment defining characteristics of life.
One of the consequences of all the talk is that information technology
"manages to dominate discussion in a straightforwardly quantitative
manner which makes it difficult for alternative perspectives to be heard"
(Webster and Robins 1986: 29). More important, "while it may not per-
suade the populace to wholeheartedly welcome the new technology," it
creates "a general sense of acquiescence to innovation" (ibid.).

This book argues that one cannot understand the place of computer
communication technology without taking account of some of the cen-
tral myths about the rise of global computer communication systems,
particularly those identified with the Internet, the World Wide Web, and
cyberspace. It maintains that myths are important both for what they
reveal (including a genuine desire for community and democracy) and
for what they conceal (including the growing concentration of commu-
nication power in a handful of transnational media businesses). Focusing
on myths about technology, it suggests that by understanding the myths
that animated the spread of earlier technologies, such as electrification,
broadcasting, and telecommunications systems, we can deepen our under-
standing of cyberspace. Along the way, the book describes a pattern in
the history of technology: the real power of new technologies does not
appear during their mythic period, when they are hailed for their ability
to bring world peace, renew communities, or end scarcity, history, geog-
raphy, or politics; rather, their social impact is greatest when technolo-
gies become banal—when they literally (as in the case of electricity) or
figuratively withdraw into the woodwork. For example, it was not when
electricity was hailed for its ability to light up the streets, end crime, and
bring peace and harmony to the world that its power was most pro-
found. It was long after the numerous World's Fairs and Exhibitions that
celebrated "the Great White Way" or lit up the sky with "Celestial
Advertising" were over and electricity ceased to inspire rapture, ceased
to fill popular fiction with a cornucopia of imagined blessings, that it began
to change how people led their lives and organized their societies. Indeed,
it was not until we stopped looking at electricity as a discrete wonder and
began to see it as a contributor to all the other forces in society that it
became an extraordinary force. Electricity achieved its real power when

it left mythology and entered banality. Is there anything more prosaic than an electric utility? Yet it was the recognition that only by giving up individual possession of its power, by giving up discrete generators in homes and businesses, that society could literally generate a new level of power.

One can make a similar argument about the computers that sit on home and office desks. It is particularly important to view the computer with one eye on mythology today because the technology, in spite of early boom-and-bust cycles, is still in a strong mythic phase. Electricity and radio broadcasting are, of course, still powerful forces in the world. But the Age of Electricity, like the Age of Radio, is over. Both electricity and radio have passed into powerful banality. But we remain in the Computer Age. Not unlike electricity in its early days, computer communication has a unique identity that is acclaimed by individual promoters, storytellers, and gurus, among them Bill Gates, Nicholas Negroponte, Al Gore, Don Tapscott, George Gilder, and Esther Dyson. It is also celebrated collectively in trade shows and online "world's fairs," in the dubbing of numerous places around the world with names that resemble that of the venerated sacred space of the technology, Silicon Valley,[1] and in the creation of utopian spaces in cyberspace (Mihm 2000). In addition to spreading across these magic places, it enters deeply into the culture. For the literary scholar Richard Lanham, this means taking the advice of economists who call for a new terminology and for accounting systems to track the ephemeral digits of the global economy. Even more important, Lanham argues (1993: 229), we must transform our conception of language in general, because all the old ways of thinking, writing, arguing, and valuing change with the epochal transformation we popularly know as the information society.

And, as happened with electricity, many critics worry whether computer communication can possibly live up to its promise. It is especially interesting to observe that a frequently given answer is connected to a pattern of development that electricity followed. Specifically, some have worried that genuine productivity gains will not arrive until the computer is divorced from its unique identity with a specific location and withdraws into the woodwork of a specialized information utility. According to others, just as companies gave up their own power generators when electric utilities took over the work, they may well give up their own individual

"information generators" in favor of centralized utilities that will power not the computer we are familiar with but "information appliances" embedded in objects throughout the workplace and the home (Mitchell 1999: 43–44; Lohr 1999). Information appliances and information utilities may not be the terms we use, and what Mitchell and Lohr describe may not be the specific configuration we adopt; however, if the history of communication technology is any guide, they are closer to the likely model than the unique device we now call a computer.[2] Consequently, it is useful to avoid technomania, which shouts "It's gonna change everything. It's gonna be here next Thursday. Watch out or you'll be left behind." (Myhrvold 1997: 236) Perhaps a great deal will change, but the nature of that transformation, and even what the "it" is, is up for grabs. For example, will cities, uniquely transformed from economic parasites to powerhouses of industrial production, undergo another transformation? That will depend in part on how central telecommuting is in the mix of evolving forces.

More generally, just as electricity withdrew into the woodwork to become an even more powerful force by virtue of its ability to empower a full range of activities, computers may well withdraw into what in 1988 Mark Weiser of Xerox's Palo Alto Research Center called "ubiquitous computing." In the 1970s, Xerox PARC researchers called for a shift in our thinking about what is a computer: we were to scrap the bulky mainframes that filled rooms and imagine a computer on a desk. In the 1980s, they began to think even more dramatically about the inevitable withdrawal of the computer from the desktop and into a host of old and new devices, including coffeepots, watches, microwave ovens, and copying machines. These researchers saw the computer as growing in power while withdrawing as a presence.

This view, what some have called "embodied physicality," is the unrecognized sibling of the more popular notion of virtual reality. The development of electricity certainly does not precisely match that of the computer, but there is sufficient similarity to compel the conclusion that embodied physicality may prove to be a more potent force for social change than the development of virtual worlds. The problem is that virtual reality has more purchase on our mythic consciousness. Making a new world has far more allure than extending an old one. In any event, we are not likely to know whether embodied physicality is the direction

cyberspace will take for 50 years or so. Thus, the hopes for its immediate arrival and the fears of being left behind make for powerful technomania but poor forecasting.

What Is Myth?

Let us turn from technology to mythology, specifically by taking up the meaning of myth and considering how different ways of thinking about it help us to understand the power of cyberspace. A simple but quite limited way to understand a myth is to see it as a captivating fiction, a promise unfulfilled and perhaps unfulfillable. Indeed, this is the primary definition that the 1989 *Oxford English Dictionary* offers: "a purely fictitious narrative usually involving supernatural persons, actions, or events, and embodying some popular idea concerning natural or historical phenomena." Following this are two closely connected meanings: "an untrue or popular tale, a rumor" and "a fictitious or imaginary person or object."

Much has been written about the history of technology from this conception of mythology. We look with amusement, and with some condescension,[3] at nineteenth-century predictions that the railroad would bring peace to Europe, that steam power would eliminate the need for manual labor, and that electricity would bounce messages off the clouds (Mulgan 1991), but there certainly have been more recent variations on this theme. In the 1950s, supporters of nuclear power boasted that the "mighty atom" would soon bring us heat and electricity "too cheap to meter" and, when applied to treating the oceans, would deliver a near limitless supply of drinking water to the world (Nye 1994: 4). In 1949, *Popular Mechanics* issued these prophecies concerning nuclear power: "Poverty and famine, slums and malnutrition will disappear from the face of the earth. . . . Wars will fade out as amplitude of production of all things necessary to adequate and enjoyable living any where and everywhere will remove the fundamental economic and material rivalries that provoke war."[4] (Del Sesto 1986: 73) These are all myths in the sense of seductive tales containing promises unfulfilled or even unfulfillable. As myths, they promote what the historian David Nye has called a vision of the "technological sublime," a literal eruption of feeling that briefly overwhelms reason only to be recontained by it. According to Nye's mentor Leo Marx (1964: 207), "the rhetoric of the technological sublime" involves hymns to progress

that rise "like froth on a tide of exuberant self-regard sweeping over all misgivings, problems, and contradictions." Much of their discussion of the technological sublime draws on the classic work of Edmund Burke, who remarked that the sublime so fills the mind with its object that it cannot entertain any other or apply reason to it. Why? Because the sublime emerges from "whatever is fitted in any sort to excite the ideas of pain and danger, . . . whatever is in any sort terrible, or is conversant about terrible objects, or operates in a manner analogous to terror" (Burke 1756, p. 86). Unlike beauty and love, which, according to Burke, transcend the banal through pleasure and identification, the sublime achieves transcendence through astonishment, awe, terror, and psychic distance.

The sublime was originally associated with natural wonders: the Grand Canyon, Niagara Falls, the Natural Bridge, Yosemite. Indeed, it was to that version of the sublime that Burke directed his attention: "It comes upon us in the gloomy forest, and in the howling wilderness, in the form of the lion, the tiger, the panther, or rhinoceros." (ibid.: 109) Later, when the natural gave way to the technological, the sublime came to be associated with the humanly constructed world, including, but not limited to, the railroad, the airplane, and great dams (Steinberg 1993). Virginia Woolf, in just a few pages of her novel *Mrs. Dalloway*, brilliantly captures the sublime and foreshadows the inevitable banality of the airplane as she describes one soaring over London shortly after World War I: "Away and away the aeroplane shot, till it was nothing but a bright spark; an aspiration; a concentration; a symbol (or so it seemed to Mr. Bentley, vigorously rolling his strip of turf, at Greenwich) of man's soul; of his determination, Mr. Bentley thought, to get outside his body, beyond his house, by means of thought, Einstein, speculation, mathematics, the Mendelian theory—away the aeroplane shot." (Woolf 1925: 28) But more than just the embodiment of strange modernism, the unfamiliar object in the no-longer-empty skies over England also contains the sublime's awesome terror: "It was strange; it was still. Not a sound was to be heard above the traffic. Unguided it seemed; sped of its own free will. And now, curving up and up, straight up, like something mounting in ecstasy, in pure delight. . . ." (ibid.: 28–29) Well, not exactly pure; this vision of ecstasy is also "pouring white smoke looping" as it spells TOFFEE in the sky and reveals its purpose: advertising a popular candy. The airplane remains aloft, but the sublime comes crashing down, and Woolf's ecstatic mechanical phoenix turns into a flying

billboard to banality. In a question drenched with irony, Clarissa Dalloway asks "What were they looking at?"[5]

Around the time of *Mrs. Dalloway,* the sublime took another turn, adopting the character of what Nye and James Carey call the "electrical sublime." Transcendent virtues were associated with the telegraph, the telephone, and radio. Today, as science and religion are increasingly intertwined in what one author calls "sci/religion," we encounter something like "the scientific sublime." Drawing inspiration from Einstein's view that the harmony of natural law provides "a rapturous amazement," the scientific sublime fills the void left by established religion with "its own forms of ecstasy" (Powell 2002: 12, 135).

Paired with the sublime is the process of demonization, which also encases its object in a transcendent aura, particularly when it is applied to technology. For example, Nye reminds us that the railroad was not only viewed as an instrument of world peace; it was also considered a fearsome evil that could disrupt the "normal" process of moving people and goods by horse. In fact, it was so powerful that one Connecticut clergyman was convinced that its revolutionary power could literally drive people insane (Nye 1994: 54). Today, cyberspace has become the latest icon of the technological and electronic sublime, praised for its epochal and transcendent characteristics and demonized for the depth of the evil it can conjure. Just as the romantic poets were transfixed before majestic peaks of Europe, today's poets, indeed all of us, experience reveries in cyberspace (Johnson 1997).[6] But there are also horrors— consider, for example, Ted Kaczynski (the Unabomber), a man driven by his revulsion with a computer-driven society to kill and maim people associated with new technology (Chase 2003).

The positive visions of the technological sublime may have succeeded in winning popular support for railroads, for steam, for electricity, and for nuclear power. And many would say that on balance those technologies (particularly the first three) created more good than harm. Nevertheless, society has also paid an enormous price for their promises in lives and resources sacrificed to realize impossible dreams. Myths matter in part because they sometimes inspire powerful people to strive for their realization whatever the cost (Buck-Morss 2002). Some would argue that we are giving in to false promises about the new computer communication technologies. Guarantees of instantaneous worldwide communication,

of a genuine global village, are in essence promises of a new sense of community and of widespread popular empowerment. They promise a world in which people will communicate across borders without the filters and censors set up by watchful governments and profit-conscious businesses.

Well before the development of the personal computer, such mythic visions occupied the minds of computer enthusiasts. In the late 1960s, one author observed that computers were the latest technology to feed "the mythology of educational innovation" (Oettinger 1969). In the 1990s, critics repeated the contention that promises concerning the computer are no less mythological than promises of boundless low-cost energy or water (Stoll 1995; Sussman 1998). Yes, critics concede, many people are using relatively inexpensive computers to exchange messages with people around the world. But the number of people doing so is relatively small in a world most of whose people have yet to use a telephone. Writing about proposals for a global electronic superhighway, the telecommunications expert A. Michael Noll puts it starkly: "The superhighway is a lot of hype and fantasy, promising services that most people do not want, nor are willing to pay for; the superhighway would be costly to build; much of the technology exists only on paper and is not real; its construction might result in a total monopoly of entertainment and telecommunication by a few, super-large firms." (1997: 2) Noll concludes that the "spiral of hype" continues as the Information Superhighway builds on myths surrounding early technologies. And even as the highway myth recedes in power, what Woolgar (2002) calls "cyberbole" continues to influence popular understandings.

Two examples illustrate the spiral of hype or cyberbole. First, in August 1999 three researchers from Purdue University released a study, titled "A rose.com by any other name,"[7] that provided empirical support for the hypothesis that companies that changed their names to include '.com', '.net', or 'Internet'—whether or not the business changed, and whether or not the company did anything resembling Internet work—received a major boost in the value of their stock. Specifically, controlling for extraneous factors (good earnings reports, merger rumors), over ten trading days—five before the name change and five days after—the companies that had added Internet-related words or abbreviations to their names reported that their shares gained 125 percent more than

those of their peers. A comparison of companies whose name change led to no shift to Internet activity with those whose name change did, found no difference in their stock value change. The conclusion: investors were willing to put their money on anything that claimed an Internet link. The second example is linked even more closely to the politics of hype because it demonstrates how venture capitalists, those people who put money into new firms, made use of the public's euphoria over Anything Internet to make money. Caruso (1999) refers to this as the business equivalent of the "infinite loop" or the type of computer program that runs the same instructions over and over again. The corporate version starts with a few bright inventors coming up with a new idea, a new gadget or some piece of software that improves on an existing business (an e-something or other). A familiar pattern follows. According to Caruso (ibid.), "the newly minted 'visionary' asserts he has found the equivalent of the Holy Grail—if not in terms of the actual technology or concept, at least in terms of his ability to induce religious ecstasy in investors." The visionary wins some venture capital funding, hires a public relations firm and goes after media attention. If that works, venture capitalists line up with more funding (basing evaluations on "future earnings potential"), imitators latch on to the idea and attract some money to their projects, and the visionary and some of the wannabes take their companies public, mainly to a public that will buy almost anything "dotcom." The visionary, the imitators, and their venture backers sell off a chunk of their stock right away, making a good return, at the expense of those who bought on rising share prices and some, when the prices head straight south, lose more than their shirts. Then begins the media backlash, some of which complains mightily of excessive hype about Internet stocks—until the next visionary starts the cycle again.

Caruso cites artificial intelligence, pen computing, and CD-ROMs, all 1980s examples of "can't miss" ideas that would save the education system and transform the entertainment business. Interactive television and the 500-channel universe would do it in the early 1990s. Later on it would be e-commerce, e-advertising, streaming media, cable modems, and various versions of "dotcoms on steroids." In the wake of the dotcom crash, perhaps it will be biotechnology or 2003's darling of convergence, NBIC (the field created by the melding of nanotechnology, biotechnology, information technology, and cognitive science). Certainly

these and other ideas will continue to have their impact. But the only certainty appears to be that hype matters. And venture firms know how to use it. One major technology executive concluded: "They have every incentive to keep shoveling new companies and new shares out there as fast as the investors will buy them up, and they have no incentive to try to talk investors down. I think they're mostly in the mode of raking in the bucks as fast as possible while the getting is good and assuming that it won't last forever." (Caruso 1999).

But there is nothing particularly new about hype. As chapter 5 describes in more detail, a parallel can be drawn between the people who regularly travel down today's information highway and the early users of radio. In the 1920s, amateur enthusiasts and educators pioneered the new wireless technology, communicating over vast distances without political or economic controls. Emboldened by their new invention, many of these people also felt the allure of virtual community and popular power. How could any material force get in the way of invisible messages traveling through the ether? But, the critics remind us, many things got in the way of these dreams of democratic community. Once businesses figured out that they could make money by selling the ether or, more specifically, by selling radio audiences to advertisers (giving new meaning to T. S. Eliot's "patient etherized upon a table"), they pressured governments to open radio to commerce. These same governments quickly recognized the power of the new technology and either took complete control or shared it with business, leaving the amateurs, educators and other pioneers with little. By the 1930s in North America and Europe, radio was no longer the stuff of democratic visions (Barnouw 1990; Koppes 1969). Today, educational institutions are giving up their radio stations because, as one school board spokesperson put it, the board "has a $30 million deficit and we have to make sure that our kids can read, write, and do arithmetic" (Siska 2002). And in another indicator that a free, vibrant radio would not be reborn on the Internet, university radio stations, forced to pay hefty copyright fees, have scaled back webcasts substantially (Medina 2002). Much to the chagrin of education supporters, in 2003, the Federal Communications Commission took up proposals that would permit schools and universities to sell airwaves that are now licensed for educational television to businesses for high-speed Internet and wireless uses. It is not surprising for critics to

conclude that history is in the process of repeating itself. Part of the process of preventing another lost opportunity, they argue, is to unmask the myth that today's Internet is inevitably leading us to a new sense of community, to democratic communication, and to a rebirth of education online (McChesney 1999).

Notwithstanding its considerable value, simply debunking these myths reflects a limited view, one restricted to the idea that myth simply falsifies reality. It is undeniably important to demonstrate how myths about cyberspace fall short of reality and ensuing chapters do show that it does not mark the end of history (or even the start of a new age), does not presage the end of geography (place matters more than ever), nor does it signal the end of politics (the struggle for power goes on). But myths are more than fabrications of the truth. As the anthropologist Claude Lévi-Strauss asserted (1978, 1987), myths are stories that help people deal with contradictions in social life that can never be fully resolved. They are one response to the inevitable failure of our minds to overcome their cognitive or categorical limits to understanding the world. One such contradiction is the desire to retain our individuality and yet participate fully in a collective community. Another is the wish to control our circumstances, even as we also desire to give up some control to bring about a more democratic society. Still another is our wish to retain the comfort that day-to-day routine provides, even as we seek to transcend its banality, what Burke (1756: 79) referred to as that "stale, unaffecting familiarity," with experiences that break through to something new and different. The inability to figure out how to "have our cake and eat it too" leads people to embrace myths that help them to deal with the irreconcilable.

Myths do not always provide a satisfactory response; indeed, their basic message is not that contradictions are resolvable, rather, that they are scalable. We cannot solve life's fundamental divisions, but myths tell us that we can talk about them in ways that are manageable (Lévi-Strauss 1963). Or even more than talk about them, we can sing them, that is, respond to them with the feeling that comes from song. When asked whether mythology is the story of a song, one that celebrates or laments, the scholar of myth Joseph Campbell responded as follows (1988: 27): "Mythology is the song. It is the song of the imagination inspired by the energies of the body. Once a Zen master stood up before his students and was about to deliver a sermon. And just as he was about to open his mouth, a bird sang. And he said 'The sermon has been delivered.'" This

is not as far-fetched as it may sound. Scholars of technology are increasingly turning their attention to the role of music in the development of our machines. In this respect, music takes on the aesthetic form of a myth that gives meaning to the practical arts. One student of technology with an interest in its links to music and myth puts it this way: "If we wish to understand what technology means to those who invent, tinker with, build, or just use its products, we must investigate how the aesthetic is intertwined with the practical; how the giving of meaning is related to building and making; and how work with tools or with hands may have some correspondence with musical experience." (Pacey 1999: 18) In this respect, a more robust definition of 'myth' than the contemporary dictionary provides is contained in the Greek origins of the word, which, derived from 'muthos', means "to murmur with closed lips, to mutter, to moan," suggesting to one student of myth a "strange melody" (Cousineau 2001: 9).

The key point to keep in mind is that, as the philosopher Alisdair MacIntyre (1970) concludes, myths are neither true nor false, but living or dead. A myth is alive if it continues to give meaning to human life, if it continues to represent some important part of the collective mentality of a given age, and if it continues to render socially and intellectually tolerable what would otherwise be experienced as incoherence. To understand a myth involves more than proving it to be false. It means figuring out why the myth exists, why it is so important to people, what it means, and what it tells us about people's hopes and dreams. It is, as Kathleen Woodward describes (1980: xiv), "a reading of history in which is implicit the shape of things to come." Put simply, myth is congealed common sense, with common sense understood as in the following passage from Antonio Gramsci (1971: 326): "Every philosophical current leaves behind a sedimentation of common sense: that is the document of its historical effectiveness. Common sense is not something rigid and immobile, but is continually transforming itself, enriching itself with scientific ideas and with philosophical opinions that have entered ordinary life. Common sense creates the folklore of the future, that is a relatively rigid phase of popular knowledge at a given place and time." Although slightly different, there is a congruence of myth, common sense, and what Michel Foucault (1973) would call a "discourse."

This conception of myth as living, meaningful story is particularly powerful because it suggests why people embrace it even in the face of otherwise compelling contrary evidence. Myth does not just embody a truth, it

shelters truth by giving it a natural, taken-for-granted quality. According to the literary critic Roland Barthes, myths naturally conjure up a desired end, rather than suggest how to deflect or critique it. In this respect, myths transform the messy complexities of history into the pristine gloss of nature. "Myth," as Barthes puts it (1972: 143), "does not deny things, on the contrary, its function is to talk about them; simply, it purifies them, it makes them innocent, it gives them a natural and eternal justification, it gives them a clarity which is not that of an explanation but that of a statement of fact." Myth provides a "euphoric clarity" by eliminating complexities and contradictions. In essence, according to Barthes, myth is depoliticized speech, with political understood broadly to mean the totality of social relations in their concrete activities and in their power to make the world.

'Myth' is not merely an anthropological term that one might equate with human values. It is also a political term that inflects human values with ideology. By denying the fullness of the political, myth naturalizes its narrative and raises it to the level of a near impregnable fortress unassailable by ordinary mortals. Myths are what is and there is not much that can be done about them. But some would see myths more positively, as containing the potential to energize change and these views serve as a subtextual counter to Barthes's popular formulation. In this regard, Thomas Hine maintains (1991: 34), myths are "an attempt to invest our lives with a meaning and a drama that transcend the inevitable decay and death of the individual. We want our stories to lead us somewhere and come to a satisfying conclusion, even though not all do so." According to Leslie Fiedler (1996: 34), myths provide a way of seeing amounting to "projections of certain unconscious impulses otherwise confessed only in our dreams, but which once raised to the level of full consciousness serve as grids of perception through which we screen so-called 'reality.'"

The Internet provides the basis for a powerful myth because it goes a long way toward satisfying these characteristics. It is a story about how ever smaller, faster, cheaper, and better computer and communication technologies help to realize, with little effort, those seemingly impossible dreams of democracy and community with practically no pressure on the natural environment. According to this view, computer communication empowers people largely by realizing the perennial dream of philosophers

and librarians: to make possible instant access to the world's store of information without requiring the time, energy and money to physically go where the information is stored. Moreover, the story continues, computer networks offer relatively inexpensive access, making possible a primary feature of democracy, that the tools necessary for empowerment are equally available to all. Furthermore, this vision of the Internet fosters community because it enables people to communicate with one another in any part of the world. As a result, existing communities are strengthened and whole new "virtual" communities arise from the creation of networks of people who share interests, commitments, and values. All of this is accomplished safely because violent crime does not invade virtual communities. "I live in a terrible part of town," said one heavy Internet user. "I see a rat hole of an apartment, I see a dead-end job, I see AIDS." But in his online community, he noted, "I see friends, I have something to offer, I see safe sex." (Turkle 1995: 239)

Moreover, because energy use is more than counterbalanced by savings in travel, there is little stress placed on the natural environment. In essence, by transcending time, space and resource constraints, approximating what Karl Marx (1973: 539) called "the annihilation of space with time," the Internet provides the literal and figurative missing links that bring genuine, sustainable democracy and community to a world in desperate need of both.

The myth of cyberspace can be seen to demonstrate Barthes's claim that myths are depoliticized speech because they purify social relations by eliminating the tensions and conflicts that animate the political life of a community. But if myths evacuate politics, then the critique of mythology can restore and regenerate it. If the telling and retelling of the mythic story shields cyberspace from the messiness of down-to-earth politics, then the critique of the myth, told many times over in many different ways, gives new life to the view that cyberspace is indeed a deeply political place. This happens when we expand the assessment of myths to include not only whether they conform to an agreed-upon reality. (Will the information highway expand education?) It also involves assessing what myths mean to the people who produce and believe in them, and what they reveal about the society that sustains them. It is here, on the intellectual border, where cultural and political economic understandings meet, that the analysis of myth becomes particularly productive.

Cyberspace Makes Myths

Cyberspace is not just the space in which myths are enacted; it also contributes to mythic thinking today, because it embodies the sense of betwixt and between (or, more formally, what cultural theorists call liminality). Myths are fed by the sense that we are leaving one era, the Industrial Age, and entering a new one, with a host of names, most of which, like "Information Age" and "Digital Age," have to do with computers. The "then" and "now" markers change depending on whether one accentuates the technological, the economic, the political, the social, or the cultural (e.g., are we moving from the factory to the office? from modernism to postmodernism?). They also change depending on how one feels about (e.g.) the difference between the Information Age and the Surveillance Society. But they all convey a sense of neither here nor there; of having left something behind that is still partially with us and of taking on something new that we cannot define clearly. We live in a liminal state that breeds uncertainty and therefore numerous myths that offer certain remedies or just a road ahead, as Bill Gates describes, to guide us across the murky "current." But there is also another side to liminality: the sense of power and possibility that comes with the release from custom and the loosening of traditional ties. For example, at the approach of the millennium, the times appeared to overflow with pure potency, the potential that made people giddy with the view of limitless possibility, from the trajectory of the stock market to Moore's Law, but also terrified at the need for constant change. Myths also provide a way to cope with both the mania and the fear by feeding them in a way that is sustaining, but also in scaling them by reconstituting a new version of the Great Chain of Being that allows us to place ourselves in the new order.[8]

This may help to explain why business is increasingly interested in mythology, as both a way of knowing and a way of presenting knowledge. It is not surprising to find companies drawing on myths to sell products. The use of myths to market and brand products is as old as the market itself. In addition to selling products by connecting them to transcendent values like community and immortality, companies have used myths to sell the company itself, particularly connections between the company and mythic values like progress. A great technology company used to repeat this slogan over and over: "At General Electric, progress

is our most important product." But it is quite another thing for business to use myth and experts on mythology to train its own executives. That is precisely what many companies are doing today to forge new ways of thinking among senior managers.

According to one account, meetings that feature training in mythmaking have been supported by a number of major firms, including Monsanto, DuPont, International Paper, Procter & Gamble, and Unilever—certainly not lightweights in their respective industries (Feder 1999). Take the example of Monsanto, whose biotechnology division is frequently in the public eye. In 1999 the company hired a professor of poetry and literature, and a former student of the noted expert on mythology Joseph Campbell, to teach executives how to develop stories or scenarios about the future, in essence grand narratives about the likely consequences of biotechnology use under various conditions. On the surface, this appears to be just another management fad, and it may be just that, destined to show up in a mocking Dilbert cartoon.[9] But if we were to focus solely on what appears to be little more than a setup for sketch comedy—a poetry professor among the engineers—we would be ignoring what is to be learned by determining why a company like Monsanto takes myths seriously. Admittedly, some of the value is predictably pragmatic. One of the participants at a biotechnology conference that featured a mythological approach commented that "every child knows you get the really big issues across with stories" and noted that learning about myths means learning how to understand and to tell big stories (ibid.). But beyond that, myths free executives and engineers, icons of scientific-rational thought, to think in new ways. "Our aim," said one executive (ibid.), "is to think the unthinkable and speak the unspeakable and by doing so in mythic terms people feel freer to do so."

The grand narratives that celebrated the making of the nation state provided one major version of this process in the liminal time that introduced the industrial revolution. The nation was what Benedict Anderson (1991) calls the "imaginary community" of unlimited possibility that invoked both pride and awe, but which also remapped the territory on which people located themselves. Less a part of the Mystical Body of Christ or some similar religious construction of the Great Chain of Being, people were now citizens of the nation state. The process is mythic in many ways, including the tendency to reduce history to nature in the

sense that the myth glosses or naturalizes the conflicts, struggles, and divisions that occupy a wide range of social groups by incorporating them into a process of nation-building, giving it a teleology that is more often than not far from the minds of combatants. Today's grand narratives tell a similar story as they move heaven and earth (as well as hell) to inspire us, terrify us, and incorporate us into a new Chain of Being in Cyberspace (Wertheim 1999).

Versions of myth come in various shapes and sizes. But many are characterized by a protective cover Barthes calls inoculation, by a denial or transcendence of history, by the powerful voice of human icons or bricoleurs, by an organized effort to actively sustain the mythology, and by the resistance of tricksters.

Inoculation

It is common to see myths presented with what Barthes called inoculation or the admission of a little evil into the mythic universe in order to protect against a more substantial attack. In *Mythologies*, Barthes provides us with a good example from the 1954 film *On the Waterfront*, which, he suggests, is a mythic celebration of the ultimate beneficence of our world because it makes the corruption of a few thugs exorcise the larger demons of corporate or management corruption. And so it also goes in cyberspace. Yes, these more sophisticated versions admit, there are potholes in the Information Highway. Not everyone has access to the network, nor does every virtual community feel like a neighborhood. Not all information is available and some of it is too expensive for many people. Breaches of privacy take place and some people log on with mischief on the mind. Such admissions serve to protect the myth by granting that there are flaws in cyberspace. But the flaws, it is concluded, are well outweighed by the unique potential to overcome time and space with communication.

The Denial and Transcendence of History

Inoculation is particularly strong when combined with another protective covering that Barthes found in most major mythologies, the tendency for myth to deny and transcend history. Here the myth encourages

us to ignore history because cyberspace is genuinely something new, indeed, the product of a rupture in history, the Information Age. Until now, information was scarce; it is now abundant. Until now, communication technology was limited; it is now universally available at prices that are rapidly declining. Until now, people had to work primarily with their hands making things; they now work primarily with their heads creating knowledge and providing services. Until now, your choice of community was limited mainly by accident of birth; today it is entirely open to choice and subject to constant renewal and change. There is no need, the story goes, nor genuine value in placing the Information Age in historical context because everything that came before is prehistory, of little value save to account for the extent of the contemporary rupture. Like the division between Old and New Testaments, the Information Age and what came before are fundamentally different worlds, with the new era defined by information itself. However easy it is to debunk the uniqueness of this age for the singular focus that it places on information, there is enormous support for celebrating it as such (Hobart and Schiffman 1998: 201).

The denial of history is central to understanding myth as depoliticized speech because to deny history is to remove from discussion active human agency, the constraints of social structure, and the real world of politics. According to myth, the Information Age transcends politics because it makes power available to everyone and in great abundance. The defining characteristic of politics, the struggle over the scarce resource of power, is eliminated. In this respect, myths create a new history, a new time, by denying history. As an example of a powerful modern myth that has enormous contemporary resonance, take the French Revolution (Lévi-Strauss 1963). This is the quintessential myth of the end of history because its supporters, and even some of its strongest critics, believed that it marked the end of a history of scarcity. As well, it meant the end of limits, of the need for hierarchy, of religion, and of all the other encumbrances that were associated with not only the ancien régime of Louis XVI but with history as one vast ancien régime. Furthermore, the French Revolution did not only tear up the old calendar, like other revolutions before and since; it created a new calendar, marking the time that history began anew, when everything became possible, when it became possible to enjoy the future in the present and gain a glimpse of eternity.

Bricoleurs: Storytellers of Cyberspace

American history in particular is replete with visions of technological utopia spun by mythmaking optimists. The current era is no exception, particularly with its concentration on building a new world in cyber-space.[10] Nicholas Negroponte, the founding director of MIT's Media Lab, provides one of the more extreme versions of this radical break with history viewpoint. In *Being Digital* (1995) he argues for the benefits of digits (what computer communication produces and distributes) over atoms (us and the material world) and contends that the new digital technologies are creating a fundamentally new world that we must accommodate. In matter-of-fact prose, he offers a modern prophet's call to say goodbye to the world of atoms, with its coarse and confining materiality, and welcomes the digital world, with its infinitely malleable electrons, able to transcend spatial, temporal, and material constraints. The world of atoms is ending, Negroponte tells us, and we must learn to be digital.

In the world of mythology, Negroponte would be considered a bricoleur—someone who, following Lévi-Strauss's usage, pulls together the bits and pieces of technology's narratives, to fashion a mobilizing story for our time: what Nerone (1987) has called the heroic narrative with didactic effect. Characteristic of the mythmaker, Negroponte provides us with a story that defies history in that it admits of no alternative. There is no social or natural action that can stop it. "The change from atoms to bits is irrevocable and unstoppable." (Negroponte 1995: 4) Indeed, it is all the more powerful because it is aligned with nature: "Like a force of nature, the digital age cannot be denied or stopped." (ibid.: 228–229) "It is almost genetic in its nature, in that each generation will become more digital than the preceding one." (ibid.: 231)

Bill Gates, in *The Road Ahead* (1995) and *Business @ the Speed of Thought* (1999), demonstrates his mythmaking ability, extolling the transcendent virtues of computer communication as a conqueror of both space and time. For Gates (1995: 3–4, 7), there is no denying that the revolution, if not the rapture, is at hand: "We stand at the brink of another revolution. This one will involve unprecedentedly inexpensive communication; all the computers will join together to communicate with us and for us. . . . we may be about to witness the realization of Adam Smith's ideal market, at last. . . . Just about everything will be done differently.

I can hardly wait for this tomorrow, and I am doing what I can to make it happen."

As a good mythmaker, Gates is careful to inoculate his story with cautions, sharing a joke about *Popular Science*'s early predictions for the coming "family helicopter" and nuclear power "too cheap to meter." But he also reminds us, in what might be considered another form of inoculation, that an Oxford professor once dismissed the electric light as a gimmick and that a U.S. Patent Office commissioner called for the abolition of his own office in 1899 because everything that could be invented had been invented (ibid.: xiii). Perhaps the most powerful characteristic of a myth is its relentless inevitability. It transcends history because it offers little choice in whether to accept it. So, in a line that is remarkable for someone promoting a revolution of choice, Gates concludes that we have no choice about the revolution itself: "I'm someone who believes that because progress will come no matter what, we need to make the best of it." (ibid.: 11)

It is tempting to reflect on the irony that saturates Gates's words. For example, one of the key themes in *Business @ the Speed of Thought* is a campaign to transform Microsoft into an electronic organization. Drawing on the storytelling mode, Gates tells of the time he asked for every paper form the company used and was given an immense binder with hundreds of forms (including 114 for Procurement alone). Amazed, he tells us: "I looked at this binder of forms and wondered 'Why do we have all of these forms? Everybody here has a PC. We're connected up. Why aren't we using electronic forms and e-mail to streamline our processes and replace all this paper?' Well, I exercised the privilege of my job and banned all unnecessary forms. In place of all that paper, systems grew up that were far more accurate and far easier to work with and that empowered our people to do more interesting work." (1999: 41)

Gates's enthusiasm for e-mail flows on as he notes that it allows employees to work on documents with "reflex-like speed." Contrast this with Gates's testimony in the U.S. government's antitrust case against Microsoft, where he could not remember many e-mail messages critical to the case that he either sent or received over the years. Or his stated preference for printed paper over computer screens for reading because "reading off the screen is still vastly inferior to reading off of paper. . . . when it comes to something over about four or five pages, I print it out and I

like to have it to carry around with me and annotate. And it's quite a hurdle for technology to achieve to match that level of usability." (Darnton 1999: 5)

The testimony of an important witness in the Microsoft case is also instructive. When Richard Schmalensee, then dean of the Sloan School of Management at MIT, responded to a question about whether an analysis of Microsoft's books gave him the opportunity to determine how much of the company's profits come from operating systems, he said: "I was surprised, but I will be honest with you, the state of Microsoft's internal accounting systems do not always rise to the level of sophistication one might expect from a firm as successful as it is. They record operating systems sales by hand, on sheets of paper." (Brinkley 1999a)

One response to these anomalies is to seek out the real Bill Gates or the real Microsoft. This exercise is valuable but limited. It is valuable because it is important to understand the relationship of the myth to the actual social practices of the mythmaker and to what is mythologized. It is useful to determine that Microsoft either falls short of living up to the cyber-ideal or is simply posturing for the court. But it is also limited because the bricoleur's myth matters for how many of us think and feel about cyberspace, even if we do determine that Emperor Gates is naked.[11]

There are numerous other examples, but former U.S. Vice-President Al Gore would likely appear on most lists of the top bricoleurs of cyberspace. In this respect, Gore follows an earlier vice-president who used the mythic spirit of a reigning technology to dress up an otherwise drab appearance. Back in 1961, Lyndon Johnson wrapped himself in the mantle of NASA, the American space program, and specifically the manned trip to the moon, using it to assist his home state of Texas and to clean up his image as an old-style politician. Al Gore championed himself as the leader of cyberspace, speaking out on the need to build not just a national but a Global Information Infrastructure and even claiming to have given birth to the Internet.[12] Speaking to an audience of development experts, Gore makes the connection between information technology and modernization: "I believe that an essential prerequisite to sustainable development, for all members of the human family, is the creation of this network of networks. To accomplish this purpose, legislators, regulators, and business people must do this: build and operate a Global Information Infrastructure. This GII will circle the globe with information superhighways on which all people can travel. . . . From

these connections we will derive robust and sustainable economic progress, strong democracies, better solutions to global and local environmental challenges, improved health care, and—ultimately—a greater sense of shared stewardship of our small planet." (Gore 1994)

Again, it is valuable to demonstrate that Gore's attempt to connect computer communication, economic growth, democracy, and a clean environment fall far short of what we know about the reality. Indeed after a century of promises about access to technology, it is more than a little presumptuous to speak of wiring all the world's peoples. After all, most have yet to use a telephone. It also requires a stretch of the history books to think that economic wealth, democracy, and a clean environment result primarily from the application of technology. But it is also important to understand that the accuracy of a myth is not its major test. Rather, myths sustain themselves when they are embraced by power, as when legitimate figures such as the vice-president tell them and, in doing so, keep them alive.[13]

Gore demonstrated the importance of promoting cyber-mythology when he launched his campaign for the presidency in 1999. When a CNN reporter asked the vice-president what distinguished him most from his major challenger, Senator Bill Bradley, Gore responded: "During my service in the United States Congress, I took the initiative in creating the Internet." It would be easy to simply join the chorus of critics who challenged Gore's claim, but it is also important to recognize the power of a myth that compelled him to stake his claim, to identify his creation of the Internet as the accomplishment that most separated him from the pack. Soon thereafter, Gore again identified with the myth by making a pilgrimage to Silicon Valley and to the Technology Museum of Innovation, where he demonstrated his cyber-proficiency by unveiling his campaign web site.[14] But Gore was challenged in the press because of a faux pas that demonstrates the complexities of the Internet that even good bricoleurs have a hard time avoiding. His campaign web site initially contained a "Just for Kids" section that asked for their names, e-mail addresses and ZIP codes, a practice that, to protect privacy in cyberspace, the Congress, supported by Gore, decided to prohibit in 1998. The questions were removed and Gore was left with a slight blemish on his pilgrimage. He was a bit chastened, but nevertheless satisfied that, as a good bricoleur, he at least chose the right pilgrimage (Chen 1999).[15]

Another important bricoleur is the high-tech consultant Esther Dyson. Typically identified on most lists of the world's leading "digerati," Dyson is the author of a book titled *Release 2.1,* a 1998 "upgrade" of 1997's *Release 2.0,* which provides not merely a guide to the Internet but "a design for living in the digital age." Like most mythmakers, she needs to assert a radical break with history. Computer communication will make "everything different: power shifting away from the center toward individuals and small organizations, more fluidity and continuous change, increasingly irrelevant national boundaries" (Dyson 1998:338). For Dyson (ibid.: 340), "on the Net, there's a profusion of choices—content, places, shopping, environments, discussion groups. Most things are free. Even—especially—the pleasures." Dyson warns of dangers lurking in cyberspace (loss of privacy, too much to choose), but these merely serve to inoculate her upbeat "design rules for living" against the charge that she is wearing rose-colored glasses:

- Use your own judgment.
- Assert your own rights and respect those of others.
- Contribute to the communities you love or build your own.
- Don't get into silly fights.
- Be generous.
- Always make new mistakes.

With or without inoculation, it is easy to see the Pollyanna in Dyson's homilies. One reviewer calls her vision of the future in *Release 2.0* "today with luxury options" (Bickerton 1997: 6). It is also easy to ask what makes the Internet more likely to succeed where earlier technologies failed. It is hard to resist cynicism about Dyson's own commitment to them (particularly to the value of an open world), for, in spite of her own stated views about how the new technology can and will contribute to an open culture in which people can more fully respect one another, critics have complained that her behavior has demonstrated a different view. When Dyson headed the organization responsible for developing policies and plans for registering Internet domain names (the Internet Corporation for Assigned Names and Numbers, or ICANN), both liberals and conservatives complained loudly about closed meetings at which important policies were made even before the agency had established a permanent board or elected any at-large members. Her response to the criticism was less reminiscent of a New Age guru than of a skilled bureau-

crat. While formally supporting the idea of open meetings, she explained: "Many of its members feel that losing the ability to discuss matters in meetings in private will adversely affect the candor of those discussions, and potentially the ability to come to working consensus quickly. . . ." (Bowman 1999) Her organization's intransigence prompted several congressional hearings. The House Judiciary Committee held a session on the question "Is ICANN Out of Control?" Ultimately, Congress forced ICANN to change some of its procedures. As it turned out, critics on the right and on the left of the political spectrum were united in agreeing that one of the first organizations to be born out of cyberspace turned out to be less democratic and more bureaucratic than communication policy agencies that preceded it. Reasonable as these points may be, they are also somewhat beside the point of the myth, which is to keep breathing air into it, to keep it alive, rather than to debate its truthfulness.

There are certainly others who might be included among the leading exemplars of mythmaking. Chapter 4 takes up the intriguing document "Cyberspace and the American Dream: A Magna Carta for the Knowledge Age," whose major proponents—former Speaker of the U.S. House of Representatives Newt Gingrich, futurist Alvin Toffler, conservative technophile George Gilder, and George Keyworth (who headed former President Reagan's missile-defense venture) would all be candidates. The point is that as bricoleurs they are all fashionable "rag and bone men," in the sense that William Butler Yeats gave the expression when he said that myths are forged "in the foul rag and bone shop of the heart" (1971: 630).

Manufactured Magic

The magic wand of computer communication is undeniably seductive. It is also undeniable that much of the allure is manufactured by the very companies that stand to benefit from the sale of computer technology, software, and access to cyberspace. So, in addition to a global cadre of bricoleurs spinning the grand narratives of cyberspace, we can observe a global movement to bring the Word to the people. Indeed, we are in the midst of a worldwide effort, organized by many different companies and governments in many different ways, to make computer communication a transcendent spectacle, the latest iteration of Nye's (1994)

"technological sublime." Of course, today this is not done by having Moses climb a mountain to receive the Word and bring it to the people. Rather it takes the banal but powerful forces of political economy to promote the cultural discourse. These include massive advertising budgets that sell both specific products and the general message that a new age has dawned and we must, in the words of Apple Computer, "think different."[16] It is no doubt important for companies to spend huge sums to build brand identification, particularly because computers present a serious problem in this area. Since a personal computer and most of its peripherals make up a rather banal machine, more so than, for example, the automobile, giving people a reason to buy a Dell rather than a Gateway or, for that matter, a clone, is a genuine challenge. The actual design of the product is only now coming to matter in distinguishing one brand from another. Apple's design of its iMac personal computer marked a major departure in this direction, the first case where color (Will that be blueberry or tangerine?) and look were fundamental to the marketing of a PC. This is a far cry from the annual model changes that were mainstays of the automotive age. For the PC, most design remains virtual, with aesthetics embedded in the desktop, and, more forcefully, constructed in advertising rather than in the machine itself. Instead of building the computer equivalent of automotive tailfins or a ragtop model, most computer manufacturers invest their design dollars in advertising.

In addition to marketing magic, computer companies participate in the contemporary equivalent of the medieval pilgrimage circuit, the trade show. These range in scale from the blockbusters that bring upwards of 250,000 people to Las Vegas for the annual Comdex computer trade show down to the local shows that seem to take place all the time as vehicles for a city's high-tech community to show off their wares. Of course, just as religious pilgrimages dealt with the prosaic as well as the mystical, so too do these shows. Yes, there is a great deal of technical discussion ("open-standards-based computing in a Linux environment"), but there is as much boosterism touting the wonders of a new processor, high-speed modem, or storage device, or simply repeating some version of the cliché "smaller, faster, cheaper, better." With its attention to image, the Las Vegas computer show and its many counterparts around the world carry out what the anthropologist Marcel Mauss described as the

basic craft of magic. Magic, according to Mauss (1972: 141–142), involves "simply replacing reality by images. A magician does nothing, or almost nothing, but makes everyone believe he is doing everything, and all the more so since he puts to work collective forces and ideas to help the individual imagination in its belief."

Government plays an enormous role in manufacturing cyberspace magic because much of its legitimacy today is based on identification with this future wave. This is certainly understandable. The transfer of power from government to the private sector in the last 30 or so years and the spread of free trade, deregulation, and the creation of global trading blocs administered by private-sector-controlled bodies has diminished the authority of national government substantially. Much of government's activity is now taken up with the "dirty work" of dealing with policing (both domestic and international) and providing what limited social services it can budget for those who cannot afford the private provision of education, health care, and other infrastructure services. One of the few areas left for it to establish a genuine, universally recognized allure is with the new technology. As a result, governments scramble to spend money attracting high-technology companies, putting computers in schools, expanding business and household access, and whatever it takes to strengthen identification with the new technologies. Today a political photo opportunity often includes a computer, with a political figure demonstrating or observing students working on the latest object of government beneficence. Where they once burst champagne bottles against the bows of new ships or cut the ribbon on a new steel plant, politicians are now more likely to be pictured with the totems of cyberspace.

But it takes two for a photo opportunity or its verbal equivalent, the news story on the wonders of the Internet. The media have been more than willing partners in the near ritual adulation of cyberspace. With exceptions, the mass media, both elite and tabloid, have contributed to the process of manufacturing the magic by translating the mythical universe of people like Gates and Negroponte who lay out the broad vision for cyberspace into the practical prose of the daily news story. Admittedly, there has been enormous public relations pressure, particularly in the boom period between 1996 and 2000, applied to journalists. Yes, it has always been the case for company public relations specialists to wave carrots in front of journalists' faces, particularly if those faces appear

next to bylines in the elite newspapers. But, as one elite press journalist commented, "like everything else about the new economy, this dance is nothing new just taken to ridiculous extremes, with some new moves, twists and stumbles thrown in" (Napoli 2000). Journalists' typical responses range from wanderlust to skeptical acceptance. Indeed, while journalistic rapture is certainly important to advancing the cause, it is the cautionary tale that adds depth to the vision.

Let me demonstrate what I mean by this with an example from one of journalism's leading boosters of the World Wide Web: Thomas Friedman, a columnist for the *New York Times*. Friedman has written extensively about the Internet, and one could choose examples from a large collection of pieces. A typical one, dated June 1, 1999, asked "Are You Ready?" The column's question is posed by young people looking out to an audience in an advertising video which the president of Cisco Systems, John Chambers, gave to Friedman after an interview. The message is about the Internet and directed at the American people, particularly parents who worry about the effects of the Internet on children. So this is not the mythic vision of the bricoleur but the serious social encounter about a new technology. Or is it? Certainly, the mythic point is made from the outset. In the interview, which took place in 1997, Chambers announces that the Internet is "about to change everything about how people work, invest, learn, shop, and communicate" (Friedman 1999a). Friedman is initially skeptical, treating this "as the sort of overstatement one could expect from an Internet exec." But much happened in the year and a half after the interview and "I now appreciate Cisco's ad, and Mr. Chambers's prediction." In three paragraphs, the journalist distinguishes himself from the corporate position, suggesting that journalism is more reflective about these matters; then (with the assistance of a group of children asking "Are you ready?"), he wholly identifies with the corporate vision. As he says, "The year 1999 will go down as the year that the Internet really began to penetrate the consciousness of Americans—that the way they buy everything from cars to airline tickets, and the way they communicate, invest, work and learn, is being fundamentally transformed by the web." But this is not an unvarnished blessing. People, especially parents, are understandably troubled by a technology that is so "pervasive, unavoidable and indispensable" even as it is so "totally open" that "with one mouse click you can wander into a Nazi beer hall or a pornographer's library."

So what can we as a society do about this? What Friedman does is consult another corporate executive, Steve Case, then head of America Online, who offers a homily to parents which amounts to two things: "You have to make sure that your kids are connected because that is the future" and "You have to understand that this is an empowering medium. It gives you millions of new choices, but many will not be appropriate. So with empowerment must come greater responsibility." This prompts Friedman to provide as a solution "Friedman's Law," which, "with tongue slightly in cheek," he offers as a corollary to Moore's Law: "Parents should add one hour per week of quality time with their children each time the speed of their kid's modem doubles." The column ends by advising parents to check their kid's modem.

Friedman's column captures the skilled ways in which journalism serves mythology and helps to manufacture the magic of cyberspace. Because Friedman initially distances himself from the corporate position, his views gain a separate legitimacy: that of professional journalism. When, as time passes, he comes to identify with the myth, he rises above the status of corporate self-interest to acquire a higher degree of legitimacy. But this is more than simply retelling the story of the new world of cyberspace, it is also, like many myths, a morality tale. What do you do when the irresistible new force creates moral problems? Begin, Friedman tells us, by turning to a corporate CEO for moral advice. The head of America Online becomes the authority from which to draw the lesson: connect to the Internet but watch your kids. From the wide range of moral authorities and the diversity of possible solutions, a leading journalist with one of the world's leading newspapers chooses a corporate executive who preaches the lesson that the technology will change everything and the only protection is to teach self-control. The Internet is offering you the biggest candy store you will ever know and you have to learn to just say no. Admittedly, this is just one column, but in the details of its message, there is a great deal to learn about the role of media in the manufacture of mythology.[17]

From advertising to trade shows, from demonstration projects to conferences, there is a widespread effort to market the magic, to surround computer communication with power, speed, and the promise of freedom. There is nothing new here. Students of the history of technology will recall similar attempts to make electricity a spectacle by lighting up streets

and buildings in the downtowns of many cities and towns, turning them into miniature versions of New York's Great White Way. Moreover, one can argue that such spectacles as the Internet's own Electronic World's Fair, a cyberspace version of the great exhibitions that touted earlier technologies, are valuable in overcoming people's natural reluctance to try something new. But in doing so, they make it easier for people to turn to the technology for solutions to problems better addressed through the admittedly old, admittedly banal, forms of social mobilization.

The Trickster

Myths are frequently animated by tricksters, characters that cross over the line, shake up the accepted reality, engage in double-cross and doublethink, thrive on ambiguity, ambivalence, contradiction, and paradox. The trickster is antinomian but nevertheless attractive because he or she (the gender is often obscure) appeals to what we might like to be but cannot because we are firmly rooted in defined social ties and a culture of rules. The trickster is a guide, most practically to help find a way out of life's mazes, but it is also a guide to a culture and to the generative power underlying human life. From the Greek Hermes to the West African Legba and the Winnebago Indian Wakdjunkaga, from Reynard the Fox of European myth to the popular trickster in African-American story telling, Br'er Rabbit, the trickster connects separate worlds, sometimes by delivering messages, but also, especially when the gates are locked, by mastering the deceit it takes to open them and reconnect separate worlds (Hyde 1998). There are several candidates for contemporary versions of the trickster including the confidence man, the detective, the artist, and, in the world of cyberspace, the hacker.

The computer hacker is someone who moves between the established world of cyberspace, with its programmed hierarchy of business routines, firewall protected servers, lawyers guarding the vaults of intellectual property (frequently referred to by business writers as "the family jewels") and the shadowy world that would open the vault to everyone by breaking the routines, bringing communication networks, and the information they carry, to as many people as possible (Himanen 2001; Castells 2001). Sometimes this means playing the relatively benign role of Mercury, whose job in Greek mythology was to serve as messenger for the gods. Here the talented computer enthusiast works to widen information highways, create access for more travelers, particularly the poor and the

needy, and, in the process, enliven all of cyberspace by expanding the range and the depth of the conversation. At other times, it means playing the Raven who stole water and daylight for the indigenous people of the North Pacific coast or Prometheus himself, who brought us the gods' fire. Here we find the hacker as thief, now actually less hacker than cracker, driven to connect worlds that are divided by law or social convention.

What distinguishes the trickster thief from the common criminal is that the former does it to fight what is perceived to be a deeper injustice, for example, the gap between the information haves and have-nots or the growing concentration of information power in the hands of a few global companies, rather than simply act for selfish gain. For example, hackers argue that there is a deeper injustice in contemporary efforts to extend intellectual property law over the digital world. They maintain that the effort is led by a country, the United States, which was the supreme intellectual property pirate of the nineteenth century (Lohr 2002c). For many years U.S. law only offered copyright protection to its own citizens and residents, not to foreigners, like Charles Dickens, who complained about the theft of his work in the United States and urged the extension of copyright beyond U.S. borders. It was not until 1891, when the U.S. had a thriving publishing industry and literary culture of its own, that it extended protection to foreign work. Similarly, Japan, Taiwan and South Korea based much of their developmental success on weak intellectual property laws. If, as most analysts admit, this was a key to successful national economic development then, why is it wrong for Mexico, India, Brazil, or China to follow this model now? What makes copying CDs in China theft, when copying *Great Expectations* in nineteenth-century America was deemed simply good business practice?

More than one of Hollywood's popular movies in recent years has celebrated the hacker trickster. For example, drawing on what has become a cyber-trickster canon including such films as *Blade Runner* and *The Terminator* and the novels of Philip Dick and William Gibson, *The Matrix* tells the story of two worlds. The most fearsome is the post-apocalyptic material world set in a future dominated by repressive arthropod machines that exploit the human race and live off the energy generated by electrical power produced in what can only be described as fetus farms. The other is the matrix or the world produced by the machines' computer programs that make humans think that they are living in the benign world of our present, where we live out normal lives

virtually, even as the arthropods live by turning us into little more than breathing batteries. The literal human savior is Neo, a talented hacker who becomes the new Prometheus, the one who must bring the fire of wisdom to convince the human race that it lives in an illusion and to inspire a revolution that will free people from the very machines they have created. While it will never win an award for subtlety and nuance (admittedly, few mythic presentations aspire to these qualities), the film demonstrates an appreciation for the dual role of the cyber-trickster; so does its sequel, *The Matrix: Reloaded.*

What countless hackers have said, and numerous novels and films like this portray, is that the trickster faces a powerful double challenge. Not only does the trickster combat a privileged world in order to open the door to a freer flow of its wealth and wisdom; it must also combat the banality of the world from which it springs. The hacker is not just trying to steal from those who would lock up the computer's treasures, but it also must take on a world that is all too minimally troubled by the hum-drum of the daily grind. So the hacker makes trouble for everyone, but this modern-day trickster has a powerful purpose: the realization of a mythic utopia locked up by our stagnating tendencies to freeze revolu-tionary technologies in the ice of outdated social patterns. For the hacker trickster, releasing the "ghost in the machine" means recognizing that since all of life is information and all of information is life, anything is possible. It is all a matter of controlling the code.

Experts on mythology tell us that one of the great strengths of the trick-ster is its ambiguity, whether of gender, loyalty or morality. This life in the nether world of liminal space is one of the hacker's great attractions. For whom are they really working? The 24-year-old Case in Gibson's novel *Neuromancer* was a trickster thief working "for other, wealthier thieves, employers who provided the exotic software required to penetrate the bright walls of corporate systems, opening windows into rich fields of data" (Gibson 1984: 5). He would do whatever it took for the sheer pleasure of being jacked into the rich, virtual world of cyberspace. But like many tricksters, he stepped over the borderline, in this case by steal-ing from his employers only to be subjected to the ultimate punishment. He is drugged with a poison that denies him cyberspace and makes him dependent on his own despised body, at least until, like many tricksters before him, Case reemerges and reenters the matrix of cyberspace.

What happens when the hacker is a legitimate company that makes either mischief or the tools to defend individual rights, depending on your perspective, an integral part of its business plan? That is what a Canadian company called Zero-Knowledge Systems did when it placed a program on its web site that demonstrated how to activate a serial number that Intel embedded in its then new Pentium III processor. Privacy activists reacted with fury when Intel admitted to the number's existence and Intel quickly produced software to hide it. Zero-Knowledge software activated the number and demonstrated that it is virtually impossible to turn it off permanently. Claiming that the serial number is not the gold mine for direct marketers and data miners that privacy advocates fear but simply a way to authenticate e-commerce transactions, Intel counterattacked by alerting a leading anti-virus software company about Zero's "hostile code," which forced a computer to crash, and by warning users about this virus. Zero countered that a crash is an inconvenience necessary to alert people that Intel has not and cannot remove the problem short of removing the number. This may pale in comparison to *The Matrix,* but it demonstrates that there is a trickster quality in some of what passes for business as usual in cyberspace.[18]

This book addresses the myths of cyberspace in the two versions described above: myth as a distortion and myth as an attractive vision or template of perception. I emphasize the latter because it is the more productive of the two. Myths persist in the face of powerful evidence that they do not accurately embody an underlying reality. We persist in believing that history, as we know it, is ending—that we are entering a new epoch. We insist on the death of distance, that geography is releasing its grip. We see cyberspace as transforming politics, perhaps ending the banal mobilization of support, one face at a time, introducing an era of unprecedented electronic democracy and virtual community. It is certainly important to assess the merits of these arguments, but, given their power as forms of perception, we also need to understand how they transcend factual grounding, to provide compelling visions of our age. It is essential to understand this side of the mythic force of cyberspace because the visions it provides, particularly the ruptures it celebrates, make it difficult to focus on another way of seeing, one that would emphasize continuities with the past.

The Metaphorical Computer

In addition to these uses of myth, there is another that should be considered because it is prominent in discussions of cyberspace. This finds its way into discussions of myth as a powerful metaphor shaping popular visions of technology. The strength of this usage lies in metaphor's ability to animate a technology by lifting it out of the world of prosaic machine parts. In this respect, it lives up to the original meaning of the term in Aristotle's *Poetics*. Aristotle described metaphor as "the transport to one thing of a name which designates another." In fact, we are beginning to see the transport of the computer metaphor on a spectacularly grand scale as a model of the universe.

Just as the universe that Newton described came to be viewed as a great clock, subject to the mechanics of a set of interchangeable machine parts, today's universe is increasingly seen as the computer writ large. One press account puts it this way: "In fact, the universe itself can be thought of as a giant computer, orchestrating the movements of the stars, the planets, even the subatomic particles. The goal then is to learn to compute the way nature does." (Johnson 1999b) For a relatively new technology, there is a rather long history supporting this view beginning with Alan Turing's 1937 work that provided the logical foundations for what he called universal computation.

From Turing's time on, developments in science and the science of computing crossed paths with one another and with science fiction to create growing support for the universality of the computer metaphor. For example, in the 1950s, as cybernetic theory gained in credibility and electronic computers expanded their modeling to more and more of the natural world, Isaac Asimov wrote the short story "The Last Question," in which computers expand to encompass the entire universe, including human minds. At about the same time serious thinking began to focus on applying the binary logic of computers to grids of what are called cellular automata. Decisions about whether to fill in these cells (=yes=on=1) or not (=no=off=0) produce patterns, some of which are boring repetitions, some simply random, and others, the focus of much interest, vary in their patternings. Some scientists began to think of cellular automata as providing the patterns fundamental to everything in the universe. Putting it most directly in 1989 was the physicist John Wheeler (noted for coining the term "black hole"): "Its are from

bits. Every it—every particle, every field of force, even the space-time con-
tinuum itself—derives its function, its meaning, its very existence entirely
from binary choices, bits. What we call reality arises in the last analysis
from the posing of yes/no questions." (Kelly 2002)

Stephen Wolfram's book *A New Kind of Science* provides perhaps the
best, certainly the most extensive, vision of the computer as metaphor for
the universe. Twenty years in the making and running to about 1,200
pages, this book by the inventor of the widely used program Mathematica
attempts to fashion nothing short of a fundamental rethinking of science,
and, by extension, the social sciences and the arts as well. It does so by
methodically demonstrating that simple computer programs, when run
over many iterations, yield a fulsome complexity that, for Wolfram, pro-
vides models for all of nature. For him, "just as the rules for any system
can be viewed as corresponding to a program, so also its behavior can be
viewed as corresponding to a computation" (Wolfram 2002: 5). This is
not the place to enter the widespread and often heated debate on how
valid and useful is Wolfram's new kind of science. Rather, his work stands
as the leading case to date of finding in cyberspace what amounts to the
fundamental metaphor for understanding the universe.

Most of the metaphors that populate the language of cyberspace are less
grandiose but more firmly established. Six are particularly prominent
today.

The Digital Library The metaphor of the digital library sees the com-
puter as the storage house of information that is instantly accessible
through any computer at any time. The metaphor is powerful because it
realizes the dream of library visionaries from the time of the earliest
library in Alexandria, which, like many subsequent great repositories,
saw itself as storing, synthesizing and making accessible the world's
stock of information and knowledge.

The Information Highway This metaphor views cyberspace as a great
transmission belt for communication, enabling people to travel the world
at the speed of light. It invokes the question that Microsoft asks in its
advertisements: "Where do you want to go today?" Although still in use,
the highway metaphor has declined in significance partly because
Internet supporters see it as overly rigid and confining for a digital world
and also because references to potholes, fast lanes, and road kill have
been used to excess.

Electronic Commerce Cyberspace has also been viewed as an enor-
mous marketplace where buyers meet sellers across the boundaries

of space and time. This metaphor envisions a world that eliminates the bottlenecks of distribution afflicting sellers and much of the onerous labor that deters shoppers. No one puts the market metaphor better than Bill Gates, who by and large reduces all metaphors to this one when he says: "A different metaphor that I think comes closer to describing a lot of the activities that will take place is that of the ultimate market. . . . It will be where we social animals will sell, trade, invest, haggle, pick up stuff, argue, meet new people, and hang out. When you hear the phrase "information highway," rather than seeing a road, imagine a marketplace or an exchange." (Gates 1995: 6)

Virtual Community Here cyberspace is more than a functional instrument providing information, transmission of messages, or shopping. The virtual community metaphor imagines the development of a genuine social experience on the net, bringing people together to share their lives and build a sense of place and community. The metaphor suggests that one can engage electronically and connect people emotionally as well as cognitively.

Digital Ecology This metaphor grows, in part, from the view that earlier metaphors, particularly of an information highway and a digital library, are too structured, and lack the organic quality of computer communication. In this view, the Internet is "a beautiful garden" that "grows on its own like an ecosystem" (Johnson 1999a: 4–1). It suggests a dynamic system of great reach and structural complexity that nevertheless contains its own fundamental processes, which may differ from familiar physical processes, such as the meteorology of a thunderstorm or a tornado, but which are similar enough to be comprehensible. In this view, cyberspace is an ecological system, an ocean of interconnected surfers.

The Narrative Stream The computer scientist David Gelernter has proposed the metaphor (and built a business from its application) of a story that describes the history, the present needs, and the future requirements of each specific user. Cyberspace is a narrative stream that says "Let me tell you a story." Viewed in this way, the computer presents a three-dimensional stream of electronic documents flowing through time that includes the future, which contains appointments and plans. These flow into the present, which captures current projects, and into the past, where all documents, e-mails, and web pages, as well as all calendars (calendars were once part of the future), are stored and made available. According to this view, "the organization of your digital information reflects the shape of your life, not the shape of a 1940s Steelcase file cabinet" (Gelernter 2002).

These metaphors offer useful visions of how to think about cyberspace but are less than myths because they lack the transcendent and moral force of mythology.[19] They are not so much attempts to deal with the irreconcilable as they are interesting ways to describe the world of cyberspace. This does not diminish the importance of metaphor but rather sees it occupying a different space from myth.[20] This book aims to concentrate on what makes myths different, on their compelling transcendent moral power to stitch together, however strangely and for however brief a time, those powerful, potentially disabling contradictions in life. The next chapter considers one of the most powerful and pervasive myths: that cyberspace will end history.

3

Cyberspace and the End of History

The world was ending then, it's ending still, and I'm happy to belong to it again. (Franzen 2002: 97)

The author of these words, the novelist and essayist Jonathan Franzen, titled his 2002 book of essays *How to Be Alone*. He's not. A check of books published between 1998 and October 2002 and received by the Harvard University Library reveals that we are at the end of agriculture, the American century, anathemas, the art world, the Asian miracle, the Asian model, authoritarian regimes, the beginning, baseball, books, boxing, business as usual, capitalism, certainty, change, cinema, class politics, class war, the Cold War, crime, development, empire (five), economic democracy, economic man, ethnography, Eurasia, evil, fashion, finance, foreign policy, gay, globalization, the growth paradigm, history (four), homework, human rights, ideology, illiteracy, imagination, an illusion, innocence (two), innovation in architecture, internationalism, kings, law (two), man, masculinity, marriage, marketing, the Microsoft era, modern medicine, the modern world, Modernism, money, natural evolution, nature (two), nomadism, North Korea, the oil era, the past, patience, the peace process, philosophy, the poem, political exceptionalism, politics, print, privacy (two), race, the revolution, secrecy, shareholder value, the standard job and family, the story, style culture, sweatshops, theology, time (six), tolerance, torture, utopia, welfare (two), welfare rights, the welfare state, and, last but not least, the world (eight). Certainly the spirit of the millennium inspired much of this outpouring of work on the "end of" theme.[1] But there is more to it than just reaching a new mark on arguably the world's most important calendar. Among other things, it signals a general willingness to entertain the prospect of a fundamental turning point

in society and culture. Nowhere is this more pronounced than in the three areas explored in the next two chapters: the end of history, the end of geography, and the end of politics. Cyberspace has figured prominently in these themes, as computer communication lays the groundwork for mythmaking about time, distance, and power. Although all three matter a great deal in the study of mythology, time plays an especially prominent role for modern societies, as Mircea Eliade, one of the twentieth century's most important writers on myth, concluded in a classic work on myth and modernity (Eliade 1959).[2]

There are few more powerful challenges to what passes for common sense in the contemporary world than the view that there is no fundamental difference between the ancient and contemporary mind. We bristle at Latour's seemingly mischievous but quite serious conclusion that we have never been modern, and at Lévi-Strauss's equally challenging conclusion (1963: 230) that we have always been modern because "the kind of logic in mythical thought is as rigorous as that of modern science, and that the difference lies, not in the quality of the intellectual process, but in the nature of the things to which it is applied." Myth is not a gloss on reality; it embodies its own reality. These views are especially difficult for people to swallow as the chorus grows for the view that we are entering a new age, a time so significant that it merits the conclusion that we have entered "the end of history."

In addition to the commonly held view that we can discern a radical rupture between the Age of Myth and the Age of Science (or Reason, or Fact, or Positivism, or the Enlightenment, etc.), the rise of computer communication marks another departure, the creation of a new time, the Computer Age (or Information Age, etc.), and a new (virtual) space we call Cyberspace. This chapter focuses on the arguments about time, the claim that the computer brings about a new age, indeed an age that ends history as we have known it. Specifically, it examines the relationship between myths of history's end and myths of cyberspace.

Francis Fukuyama and the End of History

We begin with the work of Francis Fukuyama, whose article "The end of history" (1989) and its later book-length expansion (1992) attracted worldwide attention. Although the essence of the argument is contained

in these works, Fukuyama has since written books that expand on the themes of building trust in this new age and on how to deal with its inevitable disruptions (1995, 1999). According to Fukuyama (1992: 2), "liberal democracy may constitute the end point of mankind's ideological evolution and the final form of human government and, as such, constituted the end of history." Why? In short because "while earlier forms of government were characterized by grave defects and irrationalities that led to their eventual collapse, liberal democracy was arguably free from such fundamental internal contradictions" (ibid.). Bear in mind that this is not an argument about government alone; history does not end only because we have perfected the state. The case is far wider and deeper and includes the global acceptance of the free market, the belief in technology, and, perhaps most important, the triumph of empirical science. Fukuyama could not be more direct: ". . . the history produced as a consequence of modern natural science moves in a single coherent direction." (ibid.: 81) At every level, from the organization of armies to the organization of knowledge, the world accelerates toward the singularity of liberal democracy. The end of history is, of course, not about the end of events, nor is it about the apocalypse. Rather, it means that all the fundamental transformations in ways of thinking and acting that marked the great shifts in history are over. Liberal democracy marks the end point in an evolutionary process that has taken people through stages of development (e.g. hunting and gathering, agriculture), modes of thinking (mythic, religious, philosophic), and forms of governance (tribal, feudal, communist, fascist). As we shall see, Fukuyama's views evolved over the years. However, he insisted in a piece written shortly after the attacks of September 11 that the end-of-history thesis remains central to his thought. For him, "history is still going our way" (Fukuyama 2001).

There are many reasons for the attraction of Fukuyama's thesis. It coheres with the enthusiasm that many in the West felt with the collapse of the Soviet Union and China's strong embrace of a market regime. He rejoices that experts on the right and on the left were confounded by both of these upheavals, and he concludes that most people failed to see it coming because of the profound pessimism that understandably marks much reflection on the twentieth century. The right was pessimistic about communism, believing that it would remain a formidable challenge to capitalism well into the future and only a strong realpolitik based on mil-

itary might, containment, and ideological warfare would work. The left was pessimistic about capitalism, believing that endemic crises would keep it from bringing material wealth to the world's masses and certainly would not be able to satisfy emotional, intellectual and spiritual needs. Fukuyama offers an antidote to that pessimism by asserting that despite all the evil that filled the twentieth century, liberal democracy emerged triumphant on all levels. But his work is also attractive because it contains a more sophisticated argument than appears in similarly optimistic work like that of Alvin Toffler. Fukuyama situates his vision of history's end in a reading of the Western philosophical tradition that draws heavily from Hegel, Kant, classical liberal philosophy, Marx, and Nietzsche. He is most influenced by a reading of Hegel, particularly by Hegel's dialectical vision of history and of social relationships.

Fukuyama accepts Hegel's view of the unfolding of reason in history but sees the outcome as less a model of the Prussian authoritarian state, which Hegel favored, and more the state envisioned by Locke, Smith, and other classical political economists who believed that government should be limited to the regulation of property relationships and the management of major domestic and international disputes. But he is less willing to accept their vision of social relationships. Returning to Hegel, particularly to his analysis of the master-slave relationship, Fukuyama rejects classical liberalism's identification of individual self-interest as the primary driving force in human and social development. Rather, drawing from Hegel and Kant, he insists that we must start from our intrinsic social nature and the conflicting tendencies to altruism and conflict that constitute social being. We are socially altruistic because we find satisfaction not in our own self-interested accomplishments but in acting to win the recognition of others. What is called self-interest is actually the socially constituted set of needs and desires that bring the recognition of one's worth or value. But altruism is set against an equally powerful drive that, drawing specifically from Kant, he characterizes, a bit awkwardly, is "social asociability" or the tendency for social relationships to erupt conflict as people struggle over what recognition means, what constites value, and how to achieve it. It is out of these two, often opposing, es, to altruism and social asociability, that history moves to a resolu- n liberal democracy. So there is reason in history, but, holding to his g of Hegel, it is reason marked with a potentially volatile cunning.

Along the way, Fukuyama rejects much of Marx and Nietzsche, claiming that the former's materialism misses the genuine spiritual power of liberal democracy and the latter's nihilism misses the fact that universal social recognition is not the triumph of a slave morality but more the global synthesis of what the master and slave fought over for millennia. Whether or not we agree with these views, even in this capsule summary, one is compelled to acknowledge that they represent more than a simplistic New Age pronouncement or the latest version of "Greed is good."

Fukuyama is also careful to inoculate his mythic vision with acknowledged shortcomings in the overall triumph of liberal democracy. He recognizes that the twentieth century has provided many reasons for pessimism as "the traumatic events of the twentieth century formed the backdrop to a profound intellectual crisis as well" (ibid.: 7). After all, he asks, if education, economic development and culture were not a guarantee against fascism, then what is the point of talking about historical progress? He also does not back off from recognizing that while the strength of totalitarian regimes fed the West's pessimism, the decline of those regimes has not been an unqualified gain. The fall of the Berlin Wall brought enormous turmoil to societies in the former Soviet Union and poses its own dangers for the West. Nor is Fukuyama an unqualified supporter of the new communication technologies. Citing the Ayatollah Khomeini's use of cassette tape recorders that the Shah's modernizing experts brought into Iran, he concludes that "communications technology itself is value-neutral." Certainly they can contribute to progress, but "if television and instant global communications had existed in the 1930s, they would have been used to great effect by Nazi propagandists like Leni Riefenstahl and Joseph Goebbels to promote fascist rather than democratic ideas" (ibid.: 7).

In spite of the care Fukuyama takes to shield his arguments from charges of simplification, it is not particularly difficult to identify serious flaws in his position. I will not emphasize them, my intention being less to debunk Fukuyama than to stress how his ideas provide a mythic umbrella that shelters visions of cyberspace and the end of history. Perhaps the most significant problem with this work is the failure to consider the potential for a profound contradiction between the idea of liberal democracy and the growing control of the world's political economy by the concentrated power of its largest businesses. The freedom embodied

in liberalism and the equality and participation contained in democracy are seriously jeopardized by a world in which key economic, political, social, and cultural decisions are set by a global network of firms, many of which dwarf in wealth and power most of the world's nations. That he does not even entertain this possibility points to the weakness of Fukuyama's own conception of liberal democracy. For him, liberal means the presence of a market economy. For him, markets cannot be more or less free; they are free by definition. Therefore, the very notion of market power (as embodied, for example, in Microsoft) is an oxymoron. As long as a nation, a region, or the world, operates market economies, freedom reigns. Democracy means the presence of representative government, of free elections, and the rule of law. It would be foolish to quarrel with the view that this form of democracy provided a net gain over totalitarian rule. Nevertheless, this conception of democracy is limited to a set of formal rules that are easily contaminated by the power of wealth to influence decisions, elections, and the communication and information systems that mediate these activities. For Fukuyama, the freedom in liberalism and the choice in politics do not include the freedom to choose to oppose the singularity of a global market system, even to the meager extent of opposing by strengthening the nation state, let alone by daring to choose something other than capitalism. His is the freedom to choose after all the major political, economic, and social decisions have already been made.

In addition to the failure to understand the problems that market power poses for even a weak definition of liberal democracy, there are other shortcomings. Fukuyama's argument that totalitarianism has been stopped for good is largely based on his belief that science ("the Mechanism") is inherently democratic and, more important, democratizes what it touches. Although there is a necessary openness to science that fosters a greater reliance on evidence than on authority, there is no substantial evidence that this necessarily leads to a democratic order. Indeed, science has thrived under his twin nemeses, fascism and communism, and it has been a central element in carrying out their programs. Furthermore, the world also now knows that terrorism can accomplish massive destruction when its practitioners master the techniques of science. Fukuyama and others might consider this practice of science to be a perversion of the scientific method, but perversions like eugenics have also been practiced under liberal democratic regimes. In fact, history's most powerful application of

science for warfare is a product of his model for liberal democracy, the United States. So while he recognizes that the end of history does not mean the end of critical problems, Fukuyama does not provide compelling grounds to believe that liberal democracy is the only choice left to the world.

Moreover, this remarkable faith in science ultimately does extend to a faith in the new communication and information technologies. Admittedly, Fukuyama acknowledges that they are value-neutral instruments, but in spite of this inoculation his overwhelming view is that technology and liberal democracy are potent enough partners to end history. Concluding a chapter titled "The Victory of the VCR," he writes: "Our Mechanism can now explain the creation of a universal consumer culture based on liberal economic principles for the Third World, as well as for the First and Second. The enormously productive and dynamic economic world created by advancing technology and the rational organization of labor has a tremendous homogenizing power. . . . The attractive power of this world creates a very strong predisposition for all human societies to participate in it, while success in this participation requires the adoption of the principles of economic liberalism. This is the ultimate victory of the VCR." (ibid.: 108)

Fukuyama's subsequent work is even more triumphalist. In *The Great Disruption* he argues: "A society built around information tends to produce more of the two things people value most in a modern democracy—freedom and equality.[3] Freedom of choice has exploded, in everything from cable channels to low-cost shopping outlets to friends met on the Internet. Hierarchies of all sorts, political and corporate, have come under pressure and begun to crumble." (Fukuyama 1999: 4) For Fukuyama, the link between science and new technology creates the global conditions for the triumph of liberal democracy. Yes, he maintains, there are reasons to fear. In his 1999 book *The Great Disruption*, it is the persistence of fluctuations in the social and moral sphere that can defy the arrow of history. Evidence again of his mythic thinking, what others might consider a tension in the social fabric is raised to the level of a great disruption. Nevertheless, trusting in "the very powerful human capacities for reconstituting social order," Fukuyama envisions "a great reconstitution." Aided by the rise of a technology-based network world, society will rectify itself. In any case, whether disruption or reconstitution, there is no

questioning the end of history, which he reaffirms in the book's last paragraph: "In the political and economic sphere, history appears to be progressive and directional, and, by the end of the twentieth century, has culminated in liberal democracy as the only viable alternative for technologically advanced societies." (Fukuyama 1999: 282)

In 2002, the fear shifts from the vagaries of moral sentiment to biotechnology, which poses a challenge to "our posthuman future." Once again, even in the face of a massive collapse in the telecommunications and dot-com industries, there is no questioning the value of communication and information technologies and there is certainly no call to regulate them. This is because "new forms of information technology (IT) promise to create wealth, spread access to information and therefore power around more democratically, and foster community among their users. People had to look hard for downsides to the Information Revolution; what they have found to date are issues like the so-called digital divide (that is, inequality of access to IT) and threats to privacy, neither of which qualify as earthshaking matters of justice and morality. Despite occasional efforts on the part of the world's more statist societies to try to control the use of IT, it has blossomed in recent years with minimal regulatory oversight on either a national or international level." (Fukuyama 2002: 182) The gap between information haves and have nots, the digital divide, bows to the far more powerful reality of a digital divine, which helps to overcome, almost magically, major divisions and disruptions in the world today. Specifically responding to critics of *The End of History*, Fukuyama reaffirms his central thesis but raises the specter that biotechnology will change the very nature of the human species just at a time when it has developed the capacity to master history. Distinguishing biotechnology from information technology, he calls on governments to regulate the former in order keep the arrow of history on course, pointing directly at the realization of liberal democracy in a digital sublime.

From End to Post: Daniel Bell

To appreciate fully the mythic nature of Fukuyama's work and to build an important bridge to cyberspace, we need to consider another noted theorist, indeed one of the first thinkers of the postwar era to develop the "end of" theme: Daniel Bell. In Bell's three major books, *The End of*

Ideology, The Coming of a Postindustrial Society, and *The Cultural Contradictions of Capitalism,* we have the groundwork for Fukuyama's ideas, a carefully developed and considerably less mythic vision of social transformation, and a potent critique. Fukuyama owes a great deal to Bell's work, particularly to the first two books in this triad. Written during the peak of Soviet and Chinese communist power (the new afterward was written before the fall of the Berlin Wall), *The End of Ideology* nevertheless previews major ideas contained in *The End of History.* From the start, Bell's original theme looks much like Fukuyama's: "In the last decade, we have witnessed an exhaustion of the nineteenth-century ideologies, particularly Marxism, as intellectual systems that could claim truth for their views of the world. . . . Today, these ideologies are exhausted. The events behind this important sociological change are complex and varied. Such calamities as the Moscow Trials, the Nazi-Soviet pact, the concentration camps, the suppression of the Hungarian workers, form one chain; such social changes as the modification of capitalism, the rise of the Welfare State, another." (Bell 1988: 16, 402)

Bell's 1988 afterword to *The End of Ideology* does not back off from this conclusion. Yes, the nearly three decades since the book originally appeared brought with them numerous contenders on both the right and the left for a new ideology, but, Bell insists, the fundamental thesis held. He concludes that "the normative consensus emerging replaced ideological politics; that the dream of organizing a society by complete blueprint was bound to fail; that no comprehensive social changes should be introduced, necessary as they may seem, without some effort to identify the human and social costs; and that no changes in the way of life . . . should be undertaken if they could not be reversed" (ibid.: 402). Here we have the foundation for the view that history, at least to the extent that it is generated by the clash of fundamentally different visions of social life and social change, has ended.[4] One of the fundamental differences, however, between the end of history in Fukuyama and Bell is interestingly captured by Bell himself: "The perspective I adopt is anti-ideological, but not conservative. . . . many intellectuals have begun to fear "the masses," or any form of social action. This is the basis of neo-conservatism and the new empiricism. Inevitably one shares some of these fears. But a repudiation of ideology, to be meaningful, must mean not only a criticism of the utopian order but of existing society as well." (ibid.: 16)

Agree or disagree with Bell's criticism of the existing order, the difference between his thinking and Fukuyama's is evident. Bell, as is demonstrated most strongly in *The Cultural Contradictions of Capitalism,* produced a powerful critique of his own society. Although he does not mourn the end of ideology, Bell is never sufficiently satisfied with the consequences to find much reason for enthusiasm, let alone Fukuyama's triumphalism. Bell may have provided the intellectual grounding for end-of-history accounts, but his work lacks what Barthes called "natural and eternal justification," and a "euphoric clarity" to warrant the mythic laurel.

This conclusion is demonstrated in Bell's next important book, *The Coming of a Post-Industrial Society.* In one respect, this work shares something of the spirit of Fukuyama's because it tends to be affirmative about its object of study, the post-industrial society, and about its central dimensions, knowledge, technology and a new class structure whose most dynamic element was a growing class of knowledge and information workers, the primary workforce of cyberspace. The potential for accelerating growth in the knowledge produced, processed and distributed widely and at once undreamed of speed resonates with Fukuyama's central thesis about the progressive influence of science. But even this generally positive work acknowledges uncertainties and problems. Bell is careful about coming to general conclusions about the age we are entering. Far from the end of history, which he would most likely consider ludicrous, the forces propelling social change lead in reasonably specifiable directions—from goods to services, from industrial to knowledge workers, from inheritance to education, and so on (Bell 1973: 359). But they do not converge on one specific or on a singular historical trajectory. The end of ideology does not mean the end of uncertainty. Can one be more cautious than to spend nearly 500 pages describing the forces propelling social change in America, many of them foreshadowing current discussions of cyberspace, and to conclude that all this is leading to a society that can best be described as post-industrial? Even at that, it is merely the *coming* of a post-industrial society. Unlike Fukuyama, who envisions the end of history, Bell only advances the view that we are moving toward a society different from an industrial one.

Moreover, and perhaps more significantly, this generally optimistic work acknowledges problems in the institution that is at the core of society: the business corporation. What Fukuyama sees as a central force to mobilize

global solidarity, Bell concludes is losing its legitimacy. His words stand up very well today, particularly after the Enron, dotcom, and telecommunications debacles of 2002: "By the end of the 1950s the corporation had established a new legitimacy in American life. Today that legitimacy is being challenged, or at least the tolerant and benign attitude toward the corporation has receded. The paradox is that the ground of the new criticism is no longer size or bigness (though some old populist echoes persist), but performance itself. A feeling has begun to spread in the country that corporate performance has made the society uglier, dirtier, trashier, more polluted, and noxious. The sense of identity between the self-interest of the corporation and the public interest has been replaced by a sense of incongruence." (ibid.: 272)

What makes this criticism particularly sharp is that Bell roots it in a fundamental flaw in mainstream economics: it accepts the individual as its unit of analysis and treats whole societies as the sum total of individual wants expressed in the marketplace. This "economizing mode" works well in measuring economic goods, but it fails when it confronts the social externalities (e.g., environmental pollution) generated by individual acts and indeed is weak in assessing what social groups and societies need. "The economizing mode," Bell writes, "is based on the proposition that individual satisfaction is the unit in which costs and benefits are to be reckoned. This is an atomistic view of society and reflects the utilitarian fallacy that the sum total of individual decisions is equivalent to a social decision." (ibid.: 282–283)

For Bell, what is called for is a fundamental shift in thinking from this flawed economizing mode to what he describes as a sociologizing mode. Indeed the major social challenge ahead will be to gain the "ability to foresee the effects of social and technological change and to construct alternative courses in accordance with different valuations of ends, at different costs" (ibid.: 284). This is strong language from someone whose work has been criticized for supporting the status quo or for providing a neatly paved road to the future. Bell recognized what Fukuyama does not: that there is a clear conflict produced by our capacity to meet individual market wants and our inability to even recognize that this does not account for addressing what society needs. In this regard, Bell is one with that supreme maverick of economists, Thorstein Veblen (a brilliant iconoclast who once subtitled his analysis of the American university

system "a study in total depravity"), when he concludes that we suffer from "the failure to make the necessary distinction between . . . technological and institutional processes" (ibid.: 285). No technological determinist, Bell again recognizes what subsequent myth-makers like Fukuyama do not: that science and technology cannot drive a revolution, let alone lead us to the end of history.

This is certainly brought home in the final piece of Bell's critical triptych, *The Cultural Contradictions of Capitalism,* which delivers a most potent attack on the putative end of history. In this work, Bell finds a growing chasm between the rational, calculating socioeconomic system we know as capitalism, which helped to constitute the characteristics of self-control and delayed gratification that anchored the identity of a business class along with the aspirations of those who would enter it, and the culture of modernism, with its "rage against order," emphasis on immediate gratification, and rejection of control. What is particularly important about this conclusion, and missing from most of the critical accounts that take Bell to task for failing to see how capitalism produces the very culture that undermines it, is that Bell points precisely to the market as the source of its own troubles: "Any tension creates its own dialectic. Since the market is where social structure and culture cross, what has happened is that in the last fifty years the economy has been geared to producing the life styles paraded by the culture. Thus, not only has there been a contradiction between the realms, but that tension has produced a further contradiction within the economic realm itself.[5] . . . On the marketing side, the sale of goods, packaged in the glossy images of glamour and sex, promotes a hedonistic way of life whose promise is the voluptuous gratification of the lineaments of desire." (1996: xxv) These words were written in the foreword to the 1978 edition. Bell's 1996 afterword more than reaffirms his earlier conclusions. Here Bell tracks the progress of the dialectic in the continuing clash between asceticism and acquisitiveness, noting how, more than ever, capitalism requires that its machinery of gratification "is well oiled, usually with cosmetic fragrances" to the point that whether the city is London, Tokyo, or New York, every major department store has cosmetics and fragrances spread across its ground floor (ibid.: 283). Similarly, the tension between bourgeois society and modernism grows and becomes transformed. Out of the exhaustion of modernism emerges postmodernism against which Bell

mounts an even more spirited attack. Finally, but no less important, we find a theme that is only drawn out in this new afterword: the clash between law and morality. In what is an implicit acknowledgment that the sociological challenge posed in *The Coming of a Post-Industrial Society* has gone unheeded, Bell reflects on the triumph of the market, "which has become the arbiter of all economic and even social relations (as in corporate obligations to employees) and the priority of the legal rights of ownership and property over all other claims, even of a moral nature, has been renewed" (ibid.: 284). He notes the clash between the emphatic assertion that law is to be formal and procedural, a set of rules to manage contracts, rather than the arbiter of substantive, moral rights. As a result, "the social realm has been shrinking and the naked economic relation has been assuming priority, especially in the rights of the shareholder . . . as against the stakeholder who may be an individual who has worked for a company for twenty years only to find his or her place wiped out overnight" (ibid.: 285). In this work, the post-industrial society is not Fukuyama's smooth transition to the end of history, but a deeply contradictory society, with clashes between its economic and cultural components as well as in the very soul of its productive engine.

So here we have an intellectual—one acknowledged by both the theorists and the mythologizers of cyberspace—coming to the conclusion that the post-industrial society is no less divided than its predecessors. In fact, we are led in this work to the inescapable conclusion that one ideology, capitalism, admittedly riddled with contradictions, has indeed won out at the expense not only of its systemic opponents, communism and fascism, but against anything that gets in its way, including a moral sensibility or any sense of limits.[6] The post-industrial society is indeed far from a digital sublime.

This discussion of Bell's work suggests several conclusions about the end-of-history debate and its mythic significance. Bell is not a good candidate for someone who might bridge the myth of the end of history with the world of cyberspace. His is the work of a scholar, theoretician and critic, not of a bricoleur. One might criticize Bell's conclusions in this regard, but his vision is too complex, too dialectical, too challenging to leave any room for the purity, luster, and self-justification of myth. We have to turn elsewhere for a cyberspace link to the end of history. Bell's work also demonstrates the fundamental differences between analytical

and mythical thinking. There is no gainsaying the conclusion that analysis enters into mythical modes of thought. But analysis is only the means to the end of serving a transcendent vision, eliminating impurities, and inoculating against harmful forces in order not just to present that vision but to promote it fully and forcefully. For Bell, analysis—in addition to serving as its own justification—contributes to building explanations, subjecting them to criticism, and moving on dialectically to more useful explanations that are rooted not in the transcendent vision but in the banal experience of day-to-day life, with all its impurities, tensions, conflicts, and contradictions. This does not mean that analysis lacks an appreciation of the transcendent. In fact, Bell wraps up his 1996 afterword to *Cultural Contradictions* with a discussion of religion, concluding that "religion is not the sphere of God or of the gods. It is the sense, a necessary one, of the sacred, of what is beyond us and cannot be transgressed." It also "can be cruel and unyielding, as we have seen from the Inquisition to the fatwa of the Ayatollah Khomeini on Salman Rushdie. All embody the claims of believers to absolute and exclusive truths. All invoke the name of God." But here is where Bell and other genuine scholars part company with the project of myth: ". . . the fundamental fact is that we do not know to whom God speaks" (Bell 1996: 338).

In essence, all bricoleurs more or less claim that God whispers, speaks, sings, or in some cases bellows, to them. For Fukuyama, the triumphant message is that we have approached the end of history. In this respect, the comparison of Bell to Fukuyama compels us to think about how far we have come in the course of our thinking about the future within what can best be described as a mainstream discourse. We once debated the challenges posed by thinkers such as Bell, who raised first the specter of the exhaustion of ideas in the last half of the twentieth century, then that of the coming of a different, if ambiguous, social structural formation based on changes in knowledge, technology, and the arrival of cyberspace, and finally that of a fundamental contradiction in capitalism and its clash with a culture it transformed. Today, we are more prone to hear the voices of myth—the voices of Fukuyama, Negroponte, Dyson, and others who display a new history (or unhistory) based on a vision of capitalism triumphant and transcendent, launched on a friction-free adventure into cyberspace (and every other form of space) by the power of new communication and information technologies.

The Noosphere: Cyberspace before the Computer

Since Daniel Bell serves best as the counterpoint to myth, rather than as its embodiment, we must turn elsewhere for a genuine myth that bridges the end of history and cyberspace. Such a choice is available but certainly controversial, if only because when this visionary died there were nothing more than whispers about computer networks, certainly no personal computers, and nothing like the sonorous rhetoric that fills current myths. Before Fukuyama announced the end of history and well before Negroponte taught the need to be digital, Pierre Teilhard de Chardin, then a little-known Jesuit priest, paleontologist, poet, philosopher, and (some say) mystic, wrote about the end of history, about media, and about new technology.

Since his death in 1955, Teilhard has attracted a remarkably substantial following, including Al Gore, who praised him in *Earth in the Balance* and who counts Teilhard, along with Reinhold Niebuhr, Edmund Husserl, and Maurice Merleau-Ponty, among the most influential thinkers in his life (Steinfels 1999). In addition, Teilhard's admirers include numerous computer scientists and physicists, particularly the new cohort of people interested in systems evolution. The United Nations made Teilhard the subject of its first in a series of conferences on "Visionaries of World Peace." *Wired* once proclaimed that "Teilhard saw the Net coming more than half a century before it arrived" (Kriesberg 1995). Even Tom Wolfe jumped on the Teilhard bandwagon in a 1996 piece for *Forbes ASAP*.

In the late 1990s several books appeared that "rediscovered" Teilhard and reinvented him as a cyber-prophet. Mark Dery's *Escape Velocity* drew a sharp connection between Teilhard and a fellow Roman Catholic who received far more attention as a media philosopher: Marshall McLuhan. In 1998 there appeared two books that addressed Teilhard and cyberspace, one on a distinctly religious theme and the other on the mystical and New Age roots of cyberspace (Cobb 1998; Davis 1998). Erik Davis's *Techgnosis* is particularly interesting because it is a wholesale attempt to argue that mystical impulses, at least as much as scientific ones, propel the West's infatuation with technology, especially communication technology. Its 353 pages make no reference to Daniel Bell; however, several pages are devoted to Teilhard, who is described as having "recognized the emergent worldwide electronic and computational

brain at a time when few engineers were even thinking about the possi-
bilities of networked computers" (Davis 1998: 296).[7]

The reaction to Teilhard among students of communication and infor-
mation technology has not been universally favorable. James Carey, a
leading cultural historian, has commented bitingly on McLuhan's appro-
priation of Teilhard's work while "scavenging for support for the notion
of a 'global village.'" For Carey, Teilhard and McLuhan provide a "fatu-
ous happiness," a redemptive vision of convergence and unity outside of
history. Were it not for McLuhan, Carey concludes (1993: 171), Teilhard
would not have enjoyed even the "five minutes of the intellectual sun"
that McLuhan brought about by publicizing the Jesuit priest's book *The
Phenomenon of Man*.

In a series of books that were not published until after his death (partly
because they clashed with Roman Catholic teaching), Teilhard outlined the
theory that has gained him a cult-like following among cyber-enthusiasts.
He starts with what geology knows (or at least what it knew in the early
1950s) about the earth and the evolution of its physical form in order to
claim the approach of a new stage in its development. In addition to the
metallic core, the covering rock or lithosphere, and the fluid skin of water
and atmosphere, the earth was now giving rise to a "noosphere." "Much
more coherent and just as extensive as any preceding layer," he wrote, "it
is really a new layer, the 'thinking layer,' which, since its germination at the
end of the Tertiary period, has spread over and above the world of plants
and animals" (Teilhard 1959: 182). The noosphere arrived with human
speech but it is magnified enormously today because it is carried over ever
more complex networks of human and technology-based communication.
As networks grow they add to the geosphere and biosphere a noosphere,
a literal sphere of thought pressing on the earth and its environments,
exerting increasing force as it becomes more complex and dense with
the arrival of succeeding waves of communication and information tech-
nologies. Over time, the pressure becomes so intense that evolution takes
a new leap into the sphere of pure thought. "Thus," Teilhard concludes,
"we see not only thought as participating in evolution as an anomaly or as
an epiphenomenon; but evolution as reducible to and identifiable with a
progress toward thought. . . . Man discovers that *he is nothing else than
evolution become conscious of itself*, to borrow Julian Huxley's striking
expression." (ibid.: 221)

It is not too much of a stretch to suggest that cyberspace, when it is more than simply the catchall for what people do with computers, *is* the noosphere, the space where networks of thought reside. Long before McLuhan's mythic spirit brought us the global village, Teilhard envisioned cyberspace as the embodiment of what happens when information and energy catch fire and free themselves from material constraints to create a new sphere of life. For Teilhard, this process of knowledge, information and thought liberating itself represents, as it does for Fukuyama, both a new age and the end of history. It creates a new age by giving rise to a new space, the noosphere, that marks a radical disjunction with history and all its coarse materiality. It ends history because, ultimately, the noosphere's growth destroys the material substrate and frees itself to expand in pure thought. That marks what Teilhard calls the Omega Point, the ultimate expression of convergence and the end of time as we know it: ". . . from the grains of thought forming the veritable and indestructible atoms of its stuff, the universe . . . goes on building itself above our heads in the inverse direction of matter which vanishes. . . . By the very nature of Omega, there can only be one possible point of definitive emersion—that point at which, under the synthesizing action of personalizing union, the noosphere . . . will reach collectively its point of convergence—at the end of the world." (ibid.: 272)

This is heady stuff, recalling the eruptive burst of evolutionary transformation in the film *2001: A Space Odyssey* or the explosive finale of one of that film's inspirations, Arthur C. Clarke's *Childhood's End,* a melancholic story about the ultimate generation gap: parents giving birth to offspring who turn out to be the next step in an evolutionary leap that transforms life into a space of pure, interconnected thought.[8] There are certainly important connections between Teilhard's noosphere and Omega point and these and other examples from science fiction as well as contemporary mystical thought. However, the more interesting links are with mainstream thinking about computer communication and the new world of cyberspace. In this respect I depart from the work of Erik Davis and others who maintain that alongside the development of rational, scientific, and technical thought that has brought about the computer age, there is, as in Teilhard's work, a stream of mystical, irrational, and transcendental thought—a gnostic tradition— which occupies its own world, that sometimes challenges science but generally keeps to itself, occupying a separate sphere. Perhaps the better

comparison is between Teilhard's thinking and the musings of well-known cyber-gurus. After all, it was McLuhan who maintained that electronic media would create "the universality of consciousness foreseen by Dante when he predicted that men would continue as not more than broken fragments until they were unified into an inclusive consciousness." The guru of the global village goes on to make the explicit religious connection: "In a Christian sense, this is merely a new interpretation of the mystical body of Christ; and Christ, after all, is the ultimate extension of man. . . . I expect to see the coming decades transform the planet into an art form; the new man linked in cosmic harmony that transcends time and space. . . ." (McLuhan 1969: 72, 158)

Teilhard was a much more self-consciously religious thinker than McLuhan, and the latter was much more conscious of media's role in the creation of his noosphere. But the two men certainly find common ground in their belief that media would create a palpably new form of consciousness that would contribute to the unification of the globe and a new direction in human evolution. Carey recognizes this well in commenting on the one-sided vision of convergence that Teilhard and McLuhan together describe: "We have our noosphere. The earth is now engirdled, thanks to satellite technology, with an organized belt of intelligence. Words and images, converted by the magic of our lingua franca, plus and minus, zero and one, circulate endlessly through space. Pop on a computer, or a television screen, appropriately wired, and such images emerge from everywhere and nowhere; pop it off and they disappear while still circulating in space. . . . Human intelligence has lodged itself extrasomatically, in the very atmosphere that surrounds and supports us. Yet, back at home, we have a surplus of disorder and disarray." (Carey 1993: 172) Teilhard and his followers take the popular notion of convergence to the extreme, raising it from the mundane meaning that concentrates on the connections among different technologies (which converge to enable cyberspace) to a new level—minds converge to form a transcendent noosphere.

Today there is Nicholas Negroponte, who happily announces the end of the world of atoms and heralds a coming age in which we all must learn to "be digital." Again, Teilhard's line of thinking does not just take us into the mystical gnosis of cyberspace. The arrow also points to the heartland of cyber myth. Consider this fascinating column for *Wired,* in which Negroponte demonstrates the value of myth, the importance of

proselytizing, and the power of myth to provide the gloss for a political agenda. The piece is meant to be a letter to then Speaker of the House Newt Gingrich with the explicit purpose of digitizing the Library of Congress, which he refers to as "a giant dumpster full of atoms":

Dear Newt,

Your support of the digital age is deeply appreciated. As we move from a world of atoms to one of bits, we need leaders like you explaining that this revolution is a big one, maybe a 10.5 on the Richter scale of social change. Alvin and Heidi Toffler are dandy advisers; good for you for listening to them! The global information infrastructure needs a great deal of bipartisan cooperation, if only to help (read: force) other nations to deregulate and privatize their telecommunications. As you reach out across the world to evangelize the information age, people will listen. (Negroponte and Hawley 1995: 224)

This is a very interesting piece for several reasons. Like a prayer, it begins by summoning the unquestionable mantra, the movement to the new age, from a world of atoms to a world of bits. Perhaps a 10.5 on the Richter is not as apocalyptic as the noosphere at the Omega point, but, like Teilhard's vision, it provides the necessary explosive. The letter also invokes fellow prophets, the Tofflers, whose work, particularly Alvin's, is full of mythic tales of explosive transformations, tidal waves of change, and wonderful new worlds to come, provided we can endure the shock of change. Negroponte ends the paragraph by making common cause with Gingrich, commending him for his evangelistic work to advance the cause of what amounts to the true faith, promoting the new religion of cyberspace. But what may be the most interesting sentence of all precedes this, as Negroponte calls on Gingrich to build a bipartisan effort to advance the cause of ridding the world of the twin evils of regulation and public control of telecommunications, which appear like the two-headed monsters of myth, standing in the way of our hero's quest for the promised land.

It is tempting to stop and dwell on the irony of Negroponte's crude effort to demonstrate his affinity for realpolitik—"(read: force)." After all, forcing the world to accept policies is an odd way to promote technologies of freedom. But this is beside the point. Myth does not know irony. Rather, the presence of contradictions, forcing the world to accept the new world of freedom, only strengthens the myth, making it more righteous because it is certain of itself even in the face of apparent anomalies. Myth treats these as distractions to be avoided if we are to succeed

in the mission. Academic analysts may quibble over them but evangelists know better. The end of history, the Omega point, the promised land of cyberspace, the arrival of the digital world, all justify whatever it takes—politics becomes a righteous mission.[9] And what a politics! As chapter 6 describes in more detail, the privatized and deregulated telecommunications industry that Negroponte saw as a righteous mission now lies in near ruin. It turns out that deregulation also freed companies to pad demand forecasts, pump up stock values and otherwise "cook the books," leaving shareholders and workers to pick up the pieces (Morgenson 2002).

It is interesting to compare this missionary call, issued in 1995 with a reflection offered at the end of 1998 in Negroponte's last regular column for *Wired* because it conjures the world at the end of history or what he calls "beyond digital." For Negroponte the mission is by and large accomplished. He likens calls for a digital future to the classic scene from the 1967 film *The Graduate* in which an older man advises young Benjamin Braddock to go into plastics: "Of course, plastics are not a big deal, is digital destined for the same banality?" (Negroponte 1998: 288) Now this is an interesting question, as Negroponte explains, because contrary to all the enthusiasm for the digital world, the technology "is already beginning to be taken for granted. . . . Like air and drinking water, being digital will be noticed only by its absence, not its presence." He goes on to suggest that in the future computers will be boring and unidentifiable, as they withdraw into most every element of our lives: "Computers will be a sweeping yet invisible part of our everyday lives: We'll live in them, wear them, even eat them."

The suggestion that computers will become nearly invisible and banal challenges the mythic, sacred, and transcendent vision of computers that fills so much of the rhetoric of cyberspace, including much of what Negroponte has written.[10] It invites us to think about computers in the way that the sociologist Max Weber many years ago taught us to think about charisma. For Weber, charisma was a central distinctive characteristic that gave a leader, whether religious or political, a transcendent magnetic attraction. But what struck Weber most about charisma is that it is short-lived, easily routinized by the banalities of day-to-day life, which wear away at a leader's aura. Negroponte is suggesting that we are beginning to experience the routinization of the computer's charisma. Cyberspace is becoming a banal space. But Negroponte—dissatisfied

with sounding like the singer Peggy Lee, whose signature song looks back on all the supposedly sublime moments of her life only to ask "Is that all there is?"—cannot put down the mantle of cyber-guru; he must continue to spin the myths. So after telling us about the coming banality, which would make for a most interesting discussion, Negroponte re-launches his mission by identifying five fundamental changes that the world beyond digital will experience because of computer communication. And they all turn out to be variations on familiar myths of cyberspace including the ability to completely control our time. History will no longer oppress us with its ceaseless march. We will control it as we control resources like air and water today. "Prime time," Negroponte writes, "will be my time." The specific predictions are not very important, although they all remain optimistic and egoistic. The world of physical things and the world of cyberspace will provide a growing cornucopia of individual pleasure and satisfaction. What is more interesting is the act of seemingly removing cyberspace from mythic transcendence and, in the blink of an eye, returning it right there. It turns out that being digital is no different from beyond digital—both have bid adieu to the world of atoms and both take us to the Omega Point of perfection. The opportunity to reflect on the routinization of charisma, the inevitability of banality and invisibility, is lost. One myth replaces another. The sacred and sublime mission continues.

Negroponte is not the only major current thinker whose work makes one think of Teilhard. There are numerous other examples but one of the more important is Ray Kurzweil, a man whose powerful technical credentials, particularly in the area of artificial intelligence, provide strong ballast for his vision of the information age future, or what his 1999 book calls *The Age of Spiritual Machines*. In the mid 1970s, Kurzweil, with the help and support of the National Federation of the Blind, developed a reading machine for the blind. By using special optical character recognition software, the technology allows blind students access to printed materials with a text-to-speech conversion program. MIT named Kurzweil Inventor of the Year in 1988, and his 1990 book *The Age of Intelligent Machines* won the Association of American Publishers Award for the Most Outstanding Computer Book of the Year.

Kurzweil, like Teilhard and Negroponte, envisions a world beyond atoms. But whereas the Jesuit paleontologist sees a noosphere of media-expanding thought driving humankind to a spiritual destiny at the

Omega point, and the Media Lab utopian conjures a world in which we learn to be digital and move beyond it, Kurzweil provides a set of specific forecasts, timed over the next century, that amount to a series of fundamental transformation in the nature of being. How fundamental? Kurzweil is not shy. At the beginning of *The Age of Spiritual Machines* he announces what amounts to the end of death as we know it. After reflecting on how much of our effort goes into avoiding and delaying death, even as we recognize that its inevitability gives our lives meaning, he announces that "the twenty-first century will be different" because "the human species, along with the computational technology it created, will be able to solve age-old problems of need, if not desire, and will be in a position to change the nature of mortality in a postbiological future" (Kurzweil 1999: 2) As he explains later, human beings will overcome death as we know it by scanning and transferring their minds to computers, literally digitizing themselves as the world of their atoms erode, so that by the turn of the next century, "life expectancy is no longer a viable term in relation to intelligent beings" (ibid.: 280). For Kurzweil, one of history's fundamental problems is that we have been dependent on the "longevity of our hardware," that physical self which he laments through Yeats as "but a paltry thing, a tattered coat upon a stick." History as we know it ends as we "cross the divide" and "instantiate ourselves into our computational technology" (ibid.: 128–129). But as we become digital, the nature of our identity changes. No longer connected to a uniquely identifiable, physical body, though hardware and bodies will still exist, the "I" will reside in a software file, that is itself part of the interconnected software system of the planet and eventually the universe.

Kurzweil acknowledges the technical problems presented by this monumental development, which requires him to advance a theory of evolution involving long periods of slow change marked by accelerations like the one we are about to experience. But he nevertheless confidently assures us that immortality is an inevitable reality of the twenty-first century. The more fundamental questions are how we will cope. Teilhard's seemingly mystical vision of the human mind and spirit melding with the noosphere is now becoming an accepted narrative among lauded leaders of the digerati. The back of the book's jacket carries praise from Marvin Minsky of MIT, from Bill Gates, and from the chairman of the Nasdaq exchange (the major index of tech stocks).

Admittedly, not everyone has signed on. The philosopher John Searle has subjected the book's thesis about the ability of machines to think like humans to a withering critique. Searle maintains that Kurzweil mistakenly identifies advances in computational power, as described in Moore's Law, with advances in thinking and indeed consciousness itself. For Searle, these advances are fundamentally different. Thus, "when it comes to understanding consciousness, ours is not the age of spiritual machines. It is more like the age of neurobiological infancy and in our struggles to get a mature science of the brain, Moore's Law provides no answers." (Searle 1999: 38) Searle is most likely correct, but the fault doesn't lie only with Moore's Law; it also lies with Gore's Law and with the general power of myths to conjure a cyberspace world of uploading brains, the unification of consciousness, unending virtual sex, immortality, and the growing power of the tiny microchip.

Indeed, one can view Moore's Law itself as a myth about the power of the miniature to perform magical feats. It is hard to argue with the view that people have been fascinated with small versions of big things for a very long time. Consider toy soldiers, model trains and airplanes, bonsai trees, even miniature animals like teacup poodles. These are frequently associated with magical powers, as when ancient Egyptians stocked their tombs with tiny models of real life that constituted an early version of the "virtual community" celebrated in so much of contemporary cyberspace lore. Today, people continue to wear "lucky" charm bracelets and, on a more expensive scale, even business corporations with a reputation for an absolute commitment to practical rationality, practice the miniature arts. Browne provides an excellent example from 1996 when an affiliate of Toyota built a working model of a car the size of a grain of rice. Never mind that it cost more than a real car and had no practical value. It fascinated observers and was expected to bring the customary good luck of a rice grain carving. It is hard to know whether "the brain seems to be wired to love miniature things" (Browne 1999). But there is little doubt that people take great pleasure in diminutive things and often assign them great powers. Of course some small things do have significant social impacts that can be traced to observable technological processes. The microprocessor is, of course, a prime example. Though one can acknowledge the presence of social effects from the ritual use of a lucky amulet, arguably more consistently measurable consequences can be detected in the use of a tiny silicon chip.

But *The Age of Spiritual Machines,* with its promise of immortality, spiritual fulfillment, perfect community, and practically every other mythic utopian vision, all based on the power of that little chip, is more than a technical forecast. The extrapolation of Moore's Law is merely an instrument in a larger quest that amounts to turning the law into a spiritual principle and its object into a magical talisman. It is easy to dismiss such actions, as Searle has.[11] Malcolm Browne (1999) has called nanotechnology "just another exhibit in the freak show that is the boundless-optimism school of technical forecasting." But people have always been attracted to freak shows. And that attraction makes it more difficult for people to raise fundamental questions about the myth. These start with basic ones about whether Moore's Law will continue to hold: Can we safely assume the extrapolation principle will apply into the next century? Many scientists argue for a limit that will be reached before we make it to the year 2015. But they extend to broader questions about choices we make. What does it cost to put on a freak show, whether that means building a version of Sim-City in an ancient Egyptian tomb or a computer that can ostensibly defeat a chess grandmaster? What does it cost to support a global vision that the end of history means the end of alternatives to the "boundless-optimism school of technical forecasting" which is propelled by the buoyant spirit expressed perfectly in the words of one of the scientists aiming to push the limits of the chip: "History has shown that if something can be done, someone will find a way to do it."[12] (Wayner 1999)

The thorny questions arising from all the limitations that make us human were once addressed by myths that featured gods, goddesses, and the variety of beings and rituals that for many provided satisfactory answers. Today, it is the spiritual machines and their world of cyberspace that hold out the hope of overcoming life's limitations. They provide what Dibbell (1993:36) calls "the pre-Enlightenment principle of the magic word." Commands entered into a computer do not just communicate; they make things happen. As a result, a cyberspace version of "the logic of the incantation is rapidly permeating the fabric of our lives" (ibid.: 42).[13] In this respect, Silverstone (1988: 27) is correct to conclude that "our high-technology world is essentially a magical one. By whatever mechanism, the boundary between reality and fantasy is constantly being transgressed."[14] And Kurzweil continues to wave his magic wand. In

2002 he turned to the magic of the miniature with presentations on "The Rapidly Shrinking Sensor: An Intimate Merger with Our Bodies and Our Brains" (Feder 2002c). And he is not alone. In 2002, the particle physicist John Polkinghorne, who in 1979 resigned his chair at Cambridge to study theology, won a $1 million prize for advancing spiritual matters. His 2002 book *The God of Hope and the End of the World* suggested that God will preserve souls in the form of information-bearing patterns and eventually bring them back to life, thereby transcending death as we know it. A similar point of view is taken by Frank Tipler, a well-respected physicist at Tulane University. In *The Physics of Immortality* he envisions the universe as a computer. As it eventually collapses upon itself in the final space-time singularity, the universe creates infinite energy and therefore infinite computer power capable of simulating precisely the entire historical universe, thereby permitting the resurrection of all minds and bodies that have every lived. Unlike Teilhard, Tipler is not a religious man, but like the French priest, he calls this the Omega Point.

The Young Will Lead Us

Today's cyber-mission becomes particularly righteous because, supporters like to tell us, children are leading the way. Generational divisions are central to the cyberspace version of end-of-history myths. On one side of history lies a generation or two of well-meaning but old-fashioned people, at best fumbling with the new technology but not quite getting it, at worst acting like curmudgeonly sticks-in-the-mud or like Luddites fighting against the technology and clinging desperately to old, dying ways. On the other side are the children whose instinctual savvy, willingness to experiment, and youthful exuberance draw them to the new technology and the new age it represents. In a book that compares today's young people to their boomer predecessors, a leading computer enthusiast puts it this way: "The Net Generation has arrived! The baby boom has an echo and it's even louder than the original. Eighty million strong, the youngest of these kids are still in diapers and the eldest are just turning twenty. What makes this generation different from all others before it? It is the first to grow up surrounded by digital media." (Tapscott 1998: 1)

The myth that youth has a privileged entitlement to the future is a means of inoculation against criticism from older people. Young people

understand; it's the older generation that complains. Tapscott goes as far as to conclude that "for the first time in history, children are more comfortable, knowledgeable, and literate than their parents about an innovation central to society" (ibid.: 1–2). Whether children are indeed more comfortable, knowledgeable, and literate than adults is arguable. This "first time in history" claim repeats a theme found in popular accounts of other communication technologies, which typically singled out young people for special knowledge. Today's stories of young computer enthusiasts were preceded by similar tales of heroic amateur Radio Boys who linked their home-built stations to create the first true networks and young cable television enthusiasts who pioneered in local access programming. But perhaps most important, the story of young computer wizards fits well with the tendency of cyberspace myths to discount many of the traditional sources of division in the world such as income, wealth, gender, or race, by focusing on the generational divide around technology. According to this view, it is not so much the gap between the haves and have nots that is the source of major division in the world today. That is part of the old story, the old history which is burdensome excess baggage and is thankfully ending. Denying history, as Negroponte and other visionaries do, is a way of staying young, because it is the young who, unlike their elders, are not burdened by the baggage that history's atoms impose upon the world. Negroponte (1995: 230) tells us: "Today, when 20 percent of the world consumes 80 percent of its resources, when a quarter of us have an acceptable standard of living and three-quarters of us don't, how can this divide possibly come together? While the politicians struggle with the baggage of history, a new generation is emerging from the digital landscape free of many of the old prejudices. These kids are released from the limitation of geographic proximity as the sole basis of friendship, collaboration, play, and neighborhood. Digital technology can be a natural force drawing people into greater world harmony."[15]

But it is not just harmony; it is equality too. For Negroponte, "being equal" is one of the central accomplishments of the digital world because "the caste system is an artifact of the world of atoms" not part of cyberspace. After all, "even dogs seem to know that on the net" (1998: 288). And children will be central players. In fact, one of the more interesting turns in the "cyberspace is for the young" myth is the redefinition of the cyber-

child to look more like an adult, but without the imperfections of the world of atoms. In his last regular column for *Wired*, Negroponte looks "beyond digital" and finds that childhood will change fundamentally: "Children will become more active players, learning by doing and teaching, not just being seen and not heard." (ibid.) Be young, be digital, be equal, be free from history.

But there is something not entirely right about older adults like Negroponte or any of the other aging futurists (Alvin Toffler, George Gilder, Ray Kurzweil) preaching from an allegedly dying generation about the New Age connection between youth and cyberspace. It works better when the young themselves produce their own prophets. One good example is Douglas Rushkoff, a younger oracle whose books repeat the theme that the older generation doesn't get it but young people do. In fact, he is paid enormous consultant fees to tell the former how to sell to the latter. Rushkoff, once called a "paid channeler to the mindset of Generations X and Y," is a leader among a growing number of new generation futurists who are hired to "think outside the box" for baby boomers in the media and in the information industry. In addition to writing several books about the meaning of cyberspace, he has lectured film moguls at Columbia and Tristar on the death of the linear narrative, consulted with telephone companies on how to win brand loyalty among young people in a competitive marketplace, and, call it another act in the continuing saga of digital convergence, discussed the Lollapalooza rock tour with computer scientists at the Interval Research Corporation in Silicon Valley. Rushkoff was also an active player in New York's Silicon Alley. One of his attractions, perhaps one that distinguishes young mythmakers from their more self-important elders, is a downright postmodern sense of just what makes him earn his money. He admits: "I'm in a unique position to be a youth-culture enthusiast and translate it into a language baby boomers can understand in a nonthreatening situation. They figure because I have a Princeton education and have written books, I can talk to them." (Gabriel 1996) Information-age companies will go to great lengths to overcome their overwhelming uncertainty about markets, particularly among groups as volatile as the young. One commentator observes: "If it all sounds slightly absurd—a Generation X spokesman lavishly paid to explain grunge lyrics to his

clueless elders—consider it a sign of the high anxiety among many companies today, particularly in the information industries. They feel the terrain slipping perilously beneath them and are under enormous pressure to hold onto old markets and capture new ones." (ibid.) So young people become the icons for a new age, capturing the essence of the successful dotcom: cool. An account chronicling the rise and fall of Silicon Alley put it as follows: "In the early Internet time it used to be that employers wanted to create a cool space in order to attract cool people. Now the cool space and the cool people are the advertisement for their business. If you want to bring someone in and show off: We've got pierced kids working here. Look there's a skateboard leaning against that desk. The kids themselves are for show as much as for work." (Kait and Weiss 2001: 168)

Though it would be easy to exaggerate the insecurity of high-paid executives in the entertainment and information industries, there is some substance to the view that they are losing their footing as their traditional business terrain changes. It would also miss the mark to suggest that they are not genuinely interested in the intelligence that someone like Rushkoff provides about the media habits of his and younger generations. They are; but they want more than facts. They want the myths that build a new, more comforting footing for their businesses and they want to believe that they are among the leading creators of a new age. Myths help them to deal with the contradictions that inevitably come with rapid technological change and, as an additional benefit, myths add a sacred blessing.[16]

Cosmic thinkers such as Teilhard, McLuhan, Negroponte, Kurzweil, and Rushkoff help to provide the prosaic Internet with its sacred canopy. They contribute to the end-of-history myth because they raise the stature of cyberspace to a level that warrants a number of claims. Nothing like it has appeared before in history. Since history provides no precedent, it offers no value for understanding cyberspace. The end of history means the end of history's value. But it also means the end of history as the period before this transformative development made everything different. The end of history means the end of time as we used to know it and the beginning of a new time—the computer age. History, the rough and tumble analog narrative of bodies, classes, and power gives way to a new digital beginning. Or does it?

Reconciling and Recycling Myth and History

Perhaps the myth of the end of history calls for a reconciliation of both myth and history, which, as we have observed, are often considered antithetical modes of thinking and of explanation. This may also provide one way to reconcile the deep divide within history itself, caught as it is between those who, in the words of one historian, "regard history as meaningless . . . and positivist efforts to efface everything mythical from the record" (Hees 1994: 19).[17] Just how to accomplish this is not an easy question to answer. In his "Entwinement of Myth and Enlightenment" Jürgen Habermas (1987: 130) offers one route that foregrounds reason or logos but without eliminating myth: "In argumentation, critique is constantly entwined with theory, enlightenment with grounding, even though discourse participants have to suppose that only the unforced force of the better argument comes into play. . . . Only a discourse that admits this might break the spell of mythic thinking without incurring a loss of the light radiating from the semantic potentials also preserved in myth." The latter include the power of myth to suggest aesthetic meaning through metaphor, symbolism, and allegory. Another historian considers a more complete synthesis, suggesting that, even though the prospects are not bright, "it is possible that a flexible dialectical approach may eventually find a way to raise both to a more comprehensive level" (Hees 1994: 19).

Admirable as this goal may be in advancing a more complete sense of history, one that includes the fullness of symbolism and allegory as tools to make meaning, great care must be taken because myth is not only expressive but also cunning. And in its cunning, it can mask as well as reveal truths. Even as myths of cyberspace reveal the unique power that people attribute to this age, these myths also mask the continuities that make the power we observe today, for example in the global market and in globespanning companies like Microsoft and IBM, very much a deepening and extension of old forms of power. These patterns of mutual constitution between culture and political economy, specifically between myth and power, suggest not a mythic radical disjunction from history, but a strengthening, albeit in a different mythic climate, of old forms of power.

Myth creates the condition for social amnesia about old politics and older myths. Cyberspace myths make it easier to develop "a tin ear for

history" (Johnson 1997: 2). When myth overpowers history, we find the search for truth overpowered by the quest for salvation. "It is," writes Baudrillard (1994: 26), "as though history were rifling through its own dustbins and looking for redemption in the rubbish." Rifling does little for redemption; rather, it suggests a very myth-like activity: the continuous recycling of old forms. Again, Baudrillard offers a powerful counterpoint to Fukuyama's grand linear narrative: "We shall be spared the worst—that is History will not come to an end—since the leftovers, all the leftovers—the Church, communism, ethnic groups, conflicts, ideologies—are indefinitely recyclable. What is stupendous is that nothing one thought superseded by history has really disappeared. All the archaic, anachronistic forms are there ready to reemerge, intact and timeless, like viruses deep in the body. History has only wrenched itself from cyclical time to fall into the order of the recyclable." (ibid.: 27)

But what if the putative end of history also comes with the end of geography and the end of politics?

4

Loose Ends: The Death of Distance, the End of Politics

In fact, one of the most remarkable aspects of this new communications technology is that it will eliminate distance. It won't matter if someone you're contacting is in the next room or on another continent because this highly mediated network will be unconstrained by miles and kilometers.
(Gates 1995: 6)

Today another frontier yawns before us, far more fog-obscured and inscrutable in opportunities than the Yukon. It consists not of unmapped physical space in which to assert one's ambitious body, but unmappable, infinitely expansible cerebral space. Cyberspace. And we are all going there whether we want to or not.
(John Perry Barlow, cited in Cassidy 2002: 86)

The Net Negates Geometry (the Euclidean Variety, at Least)

The end-of-history myth announces a transformation in our relationship to time, ending once and for all our traditional experience of its passage and bringing in a fundamentally new one. The myth of the end of geography tells a similar story about a fundamental change in our relationship to space and place. It is an increasingly popular myth that computer communication ends geography by completing a revolution in the process of transcending the spatial constraints that historically limited the movement of information. The argument is simple. The convergence of computer and communication technologies permits people to meet anywhere at any time, thereby making possible the ubiquitous exchange of information from the simplest two person exchange to the operation of a multinational conglomerate with its vast requirements for moving information and ideas rapidly, efficiently and with close to complete security. In the nineteenth century, spatial barriers meant that news took weeks by packet boat to get from New York to New Orleans. Now, distance is by

and large insignificant and, particularly with the arrival of international systems opening up seamless wireless communication between any points on the globe, soon to be completely irrelevant. In an important sense, the argument goes, all space is becoming cyberspace, because communication is migrating there. But cyberspace is fundamentally different from geography as we know it because this space is almost fully transparent with respect to communication.

Frances Cairncross, a senior editor at *The Economist,* is one of the leading prophets of the end of geography. Her book *The Death of Distance* is one of a series of works announcing the triumph of technology over place, the annihilation of space with technology, the end of geography. Along with the management consultant Kenichi Ohmae, she has sounded a mythic triumphalism about space that matches what we find in Fukuyama about time. The book follows a pattern common in such mythic accounts. We first hear about the revolution: the end of something, in this case, geography. Then we learn about some of the mind-numbing consequences: world peace, massive crime reduction, frictionless markets, a new trust. Finally, the force responsible for it all makes its appearance as we learn that computer communication plays the central role in dealing the death blow to geography and distance.

For Cairncross (1997: 1), the death of distance "will probably be the single most important force shaping society in the first half of the next century." It ranks first among thirty trends her book identifies, second place going to a corollary: the end of location. "No longer will location be key to most business decisions. Companies will locate any screen-based activity anywhere on earth, wherever they can find the best bargain of skills and productivity." (ibid.: xi)

Although the precise consequences of the social alteration that will ensue are "only dimly imaginable," Cairncross leaves no doubt that we will experience a spatial revolution influencing all facets of life as pervasively as did electricity at the turn of the last century. Like those who trumpeted electrification and radio, she envisions massive improvements in crime prevention. The contemporary equivalent of electricity's Great White Way and radio's "communities of the air" will succeed in reducing this scourge to a more than manageable social problem. Today's equivalent of lighting up the night and connecting people through radio is the integrated surveillance system that links computers and video cam-

eras to make crime less profitable: "When sixty remote-controlled video cameras were installed in . . . Norwich, crime fell almost immediately to one-seventieth of its previous level. The savings in petrol costs alone rapidly paid for the equipment. Today, more than 250,000 cameras are in place near trouble spots around the United Kingdom, transmitting information round the clock to one hundred constabularies, with a result for most of a fall in public misconduct. . . . A combination of security cameras and computers will also be a low-cost way to improve driving." (ibid.: 274)

Just as the promoters of electricity envisioned a twentieth century with Cities of Light ushering an epoch of peace, Cairncross imagines that the death of distance will also mean the death of war. Her final prediction is for "Global Peace": "As countries become even more economically interdependent and as global trade and foreign investment grow, people will communicate more freely and learn more about the ideas and aspirations of human beings in other parts of the globe. The effect will be to increase understanding, foster tolerance, and ultimately promote worldwide peace." (ibid.: xvi) Indeed, she is even more emphatic about this at the end of the book which concludes by providing us with three reasons why the death of distance will bring world peace. First, governments will be more informed about what each other is up to and therefore the misunderstandings that often lead to war will be substantially diminished. Second, the commercial bonds that tie countries of the world together will cement positive relationships: "Countries that invest in one another are much less likely to fight one another." (ibid.: 278) Finally, the death of distance means that average citizens will get to know more and more about people in other countries. The book concludes with these words: "Free to explore different points of view, on the Internet or on the thousands of television and radio channels that will eventually be available, people will become less susceptible to propaganda from politicians who seek to stir up conflicts. Bonded together by the invisible strands of global communications, humanity may find that peace and prosperity are fostered by the death of distance." (ibid.: 279)

The end-of-geography thesis has circulated widely. One of the people most responsible is Kenichi Ohmae, a management consultant whose 1990 book *The Borderless World* was one of the first efforts to articulate the thesis. Ohmae took a much bolder approach in *The End of the*

Nation State, which calls for ending the old cartography and adopting a new, global vision: "The evidence, then, is as exhaustive as it is uncomfortable: in a borderless economy, the nation-focused maps we typically use to make sense of economic activity are woefully misleading. We must, managers and policy makers alike, face up at last to the awkward and uncomfortable truth: the old cartography no longer works. It has become no more than an illusion."[1] (Ohmae 1995:19–20)

The primary force responsible for ending this illusion is communication and information technology. The geography of cyberspace, unlike that of any other space, knows no borders. "On old economic maps, the most important cartographic facts had to do with things like the location of raw material deposits, energy sources, navigable rivers, deep-water ports, railroad lines, paved roads-and national borders." (ibid.: 28) But this is all gone now, thanks to the transformation of geography brought about by cyberspace. In contrast with the traditional maps in the days before cyberspace, on today's maps, "the most salient facts are the footprints cast by TV satellites, the areas covered by radio signals, and the geographic reach of newspapers and magazines. Information has replaced both propinquity and politics as the factor most likely to shape the flows of economic activity." (ibid.: 28)

Both Cairncross and Ohmae rejoice in the end of geography because both proximity and politics, the things that some would say make up community and democracy, are considered ponderous, restrictive weights producing gross inefficiencies across societies everywhere. Rid of these harnesses, the world can enjoy what might best be described as the incredible lightness of being, in this case, of being global in cyberspace. It is not difficult to understand the compelling attraction of such a vision. It is also important to appreciate just how radical it is. Yes, the end of geography is a transcendent myth about the death of physical distance. That in itself is an important perspective with all its implications for the political unit, the nation state, which has served as the iconic anchor of the world's political economy and culture for centuries. But the end-of-geography position is even more radical than this. The technologies of cyberspace do not just eradicate political borders, the lines drawn to mark the boundaries of public life. The end of geography marks the end of all borders, including those bureaucratic divisions that have provided the structure for private businesses such as the very transnational corpo-

rations that have begun to eclipse in power many of the world's traditional nation states. For Cairncross the revolution in communication marks the birth of "the loose-knit corporation." In the future, "culture and communications networks, rather than rigid management structures, will hold companies together. Many companies will become networks of independent specialists; more employees will therefore work in smaller units or alone. Loyalty, trust and open communications will reshape the nature of customer and supplier contracts. . . ." (Cairncross 1997: xiii)

Ohmae agrees. As early as 1990 he peered through his organizational microscope and spotted "amoebalike" companies which permit no kings to dominate, no pyramids, not even local ones, to be built. Indeed the borderless world is committed to "tearing down the pyramid" (Ohmae 1990: 99). These ideas of Cairncross and Ohmae have been echoed by countless management consultants who find a constant stream of new words to make the point that all organizational structures are up for grabs and there is little hope for the solid borders erected to create a powerful fortress around large bureaucratic firms. Cyberspace is to be a world of virtual corporations, horizontal organizations, and flexible specialization, the furthest thing from the rigid military structures that governed the factory age.

The end of geography therefore means more than a transformation of territory; it also refers to the annihilation of space within organizations, particularly within the business corporation. But there is even more to the myth than these territorial and structural transformations suggest. The death of distance also includes the annihilation of social space, the boundaries that mark the social divisions that historically separated the world's people. As Ohmae insists, the erosion of political borders is only the start of a vast social convergence that follows in its wake and is even more profound because "political borders may offer little meaningful resistance to invasion by new constellations of consumer taste, but social borders limit their scope and effectively quarantine them within the superficial layers of culture" (Ohmae 1995: 30). This too is changing as "even social borders are starting to give way to the information-and technology-driven processes of convergence that have already turned political borders into largely meaningless lines on economic maps" (ibid.). Specifically, the inexorable power of new media and information

technology will spread a gospel of global tastes and preferences that will mark a new level of world unity. "Global brands of blue jeans, colas, and stylish athletic shoes," Ohmae writes, "are as much on the mind of the taxi driver in Shanghai as they are in the kitchen or the closet of the school teacher in Stockholm or São Paulo." (ibid.: 29) For him, as for others who see the end of geography leading to a social convergence, divisions in income, education, race, ethnicity and gender will ultimately give way to the power of the new technology to accelerate exposure to a global way of life. He could not be more emphatic about what this means for society. It is inevitable: "On this road of discovery, there is no going back. Or going more slowly. Indeed, in recent years, when the Silk Road is no longer a dangerous route through uncharted terrain but merely a degree of access to global media, like Fox TV, the time required for exposure to new dimensions of choice has shrunk to virtually nothing." (ibid.: 29) These words, written with a theological fervor, inviting no response other than "Amen," provide a near-perfect expression of the end-of-geography myth.[2]

Like Fukuyama on the end of history, Cairncross and Ohmae offer a fitting description of the end of geography. Both address the role of computer communication as a driving force bringing down the curtain on space as we have known it. But it is left to others to describe the fullness of what this means in cyberspace. A leading figure in expanding the myth of cyberspace and the end of geography is William J. Mitchell, a professor of architecture and media arts and sciences at MIT. Mitchell's books *City of Bits* and *E-topia* fill out the myth for cyberspace and, in the process, extend the death of distance concept, but they also lead us to consider troublesome elements that challenge, at the level of myth, some of the buoyant optimism of Cairncross and Ohmae. Mitchell begins by following the pattern of mythmaking that we have seen in his counterparts by announcing an epochal transformation. "Massive and unstoppable changes are under way," and central to these changes are the emerging "spatial arrangements of the digital era" that, along with new civic structures, "will profoundly affect our access to economic opportunities and public services, the character and content of public discourse, the forms of cultural activity, the enaction of power, and the experiences that give shape and texture to our daily routines" (W. J. Mitchell 1995: 5). In a word, everything. Yet, even though we cannot stop these changes, we are neither passive subjects nor

powerless to influence them. Cyberspace is the place of adventure and mystery, "the new land beyond the horizon, the place that beckons the colonists, cowboys, con artists, and would-be conquerers of the twenty-first century" (ibid.: 110–111). So there is no turning back, but there is also hope to bend the changes to the public good. Much of Mitchell's analysis is devoted to the spatial transformations that cyberspace brings about and many of these are familiar ones.[3]

The problem for Mitchell is that, whereas Cairncross and Ohmae see computer communication as the logical continuation of Enlightenment rationality, extending the line of progress by using new tools to do more things better, he understands cyberspace as a more complex place. For Cairncross and Ohmae, computer communication makes space and geography more malleable, more subject to human control and therefore better able to serve the Enlightenment vision of steadily building a better world by applying human reason. Though Mitchell agrees with the spirit of this vision, he sees the space of computer communication as far more powerful and therefore more transcendent: "The Net does not just extend geometry: The Net negates geometry. While it does have a definite topology of computational nodes and radiating boulevards for bits, and while the locations of the nodes and links can be plotted on plans to produce surprisingly Haussmann-like diagrams, it is fundamentally and profoundly anti-spatial. It is nothing like the Piazza Navona or Copley Square. You cannot say where it is or describe its memorable shape and proportions or tell a stranger how to get there. But you can find things in it without knowing where they are. The Net is ambient—nowhere in particular and everywhere at once." (ibid.: 8)

This view represents another dimension to the end-of-geography debate, a potentially more radical version. It goes beyond seeing cyberspace as the realization of linear progress in the conquest of space which began with extending communication between tribal settlements, then broadened its scope to regions, nations, and now, amazingly, to the entire globe. For Mitchell, cyberspace is the obliteration, the negation, or, to use a phrase that Karl Marx first offered to convey the revolutionary significance of capitalism, the annihilation of space.[4] As if to emphasize the radical nature of this development, Mitchell resorts to distinguishing the traditional version of space from cyberspace with the language of magic. What uniquely marks cyberspace is that "you do not go to it; you log in

from wherever you physically happen to be. In doing this you are not making a visit in the usual sense; you are executing an electronically mediated speech act that provides access—an 'open sesame.'" (ibid.: 8–9)

This magical transformation of traditional geography has profound social consequences. For Mitchell, traditional geography is destiny constructing identities with "crisp and often brutal clarity." What side of the tracks are you from? "Beverly Hills," "the South Bronx," "South Side Chicago," and "Beacon Hill" convey near-instant images of place and the kinds of people who live there. Mitchell sees the names of places and the names for places within them (financial district, golf club, student ghetto, gay bar) making up a geocode or cultural map that more or less embodies and gives form to the structure of social life. The most radical dimension of cyberspace is that it "destroys the geocode's key": "There is no such thing as a better address, and you cannot attempt to define yourself by being seen in the right places in the right company." (ibid.: 10)

The myth of geography's end starts from the view that computer communication makes space infinitely malleable, the logical extension of a process of freeing people from spatial constraint with all its confining economic and social implications. Your business doesn't have to locate near a major river or a source of raw materials because it is making and moving electronic bits. You are no longer defined by where you come from because you can construct your own electronic identity. But the end of geography is not the logical extension or realization of the Enlightenment's vision of progress. Rather it radically transforms that vision. We not only get more space in which to operate, but space itself is redefined almost literally as the opposite of what it has historically meant. The space in cyberspace has no location. The social beings that once gave it form are disembodied into the shifting identities of aliases, monikers, and personas. The once-disembodied software that connected the dots in the old geography is increasingly embodied in agents, "knowbots," and other programmed entities that do much of the "walking" through cyberspace. This is more than the extension of space as we know it, more than just the frontier of space, the place where electronic cowboys roam. This is an entirely new domain where the rules of traditional geography no longer apply.[5]

Mitchell has a sense of the importance of myth in understanding computer communication. That and a writing style appreciative of irony and

humor, with lots of smiles, nods, and winks throughout the text, distinguish him from the more typical one-dimensional writer. For example, in *E-topia* Mitchell makes the connection between a feature of software and a popular mythic practice in the world of ancient Rome. People in that society of two millennia ago widely believed that every location was populated by a characteristic energizing spirit, a *genius loci,* which would manifest itself in many different forms, such as a snake. Mitchell commends this belief for its imagination, even as he acknowledges that it lacked the software we are now developing to create a real *genius loci.* But he then goes off on a riff of utopian fantasizing that is more interesting for its mythic sensibility than for its predictive value. Our ability to conjure a *genius loci* "has simply become a software implementation task. Lines of code can supply every electronically augmented environment with a tailor-made, digital genius. . . . It can respond to the needs of its inhabitants. . . . It can even enforce ethical and legal norms. Code is character. Code is the law." (Mitchell 1999: 50) Software not only replaces but transcends the snake as the local genius and genie because it will come to control spaces, define character, and embody the law.

The only quality missing in this view of code is the sublime. But this missing ingredient is hinted at in the remainder of *E-topia* with tales of intelligent clothing ("our clothes and accessories will be dense with bits"), electronic networks in the body ("a signal from a medical monitoring device at one location on your body might trigger release of medication at another"), and "telerobots" ("What about battlefield or disaster situations, where surgeons may be too precious to put at risk on the front lines?").

But there is something even more interesting about *E-topia* than the tantalizing presence of the mythical sublime. Mitchell, perhaps demonstrating that he has learned from criticism of his earlier work as unvarnished hyperbole, acknowledges that the traditional places of the material (as opposed to the digital) world will remain and contribute to the richness of social life. He even recognizes the importance of a commitment to public space and admits that the digital world might even threaten its future. Drawing on the work of Manuel Castells, he fears for the technology-driven dual city, divided between haves and have-nots. But when it comes to the conclusion, these caveats appear to be more like inoculations, because his recommendations for urban design, that is, for

how we should construct our future, rest squarely within the world of cyberspace. He calls for "dematerialization," the replacement of physical structures with electronic networks; "demobilization," the replacement of travel with telecommunications; "mass customization," the application of electronic intelligence to production and consumption; "intelligent operation," creation of "highly efficient, responsive markets, for those scarce consumable resources;" and "soft transformation," electronics to "reconnect, repurpose, reboot valued but functionally obsolete urban fabric" (ibid.: 147–155). The end of geography is accomplished with a softer touch here than in his earlier work, but it is no less, and in some respects, more profoundly and triumphally mythic.

Is there a way to more fully comprehend the cultural geography of cyberspace? One that might diminish the existentially upsetting quality of being lost in space? Margaret Wertheim offers an intriguing alternative. In *The Pearly Gates of Cyberspace,* she examines the many different ways of thinking about space and how Western conceptions of the concept have changed over the years. Although the term is a relatively static one, especially as compared with its counterpart "time," space has meant many different things over the years. In the modern era, it has emphatically stood for the physical, material space that the triumphant natural sciences made the centerpiece of every philosophical table. These have certainly known their iterations from the space of Newton's mechanical universe, to the relativistic world of curved space that Einstein conjured, and now the hyperspace of N-dimensional physics trying to square relativity with the strange spaces of the quantum world. But these decidedly positivist descriptions of space have been sandwiched in the West between what she considers two conceptions separated by centuries but remarkably similar in meaning. They are what she calls the Soul Space of the medieval world where people lived in two spaces, the everyday and the spiritual realm that Dante so brilliantly portrayed in *The Divine Comedy,* and our cyberspace where we too move through the round of quotidian material life but also live in what she maintains is the spiritual and transcendent realm of cyberspace. Wertheim concludes by arguing that in a very fundamental sense, the culture of space today is most reminiscent of medieval Europe.[6]

This is a far cry from *Neuromancer* or even *City of Bits,* but Wertheim's argument makes sense when we consider the ontological shift that

marked the decline of medieval thinking and its transformation into what we now call modernity. For all its manifold divisions, medieval Europe was always comprised of two spaces—the space of the world, of the struggle for daily existence and the space of the spirit, the kingdom of God.[7] Although there is considerable debate among medieval scholars about the nature of these two spaces and about their relationship, a relatively consistent picture emerges. It is hard to argue with the view that the space of the spirit was considered the superior of the two. After all, the primary purpose of our short stay on earth was to demonstrate worthiness for eternal paradise by leading a good spiritual life. But this is sometimes misconstrued to mean that the medieval world denigrated the body and material life.

One canonical version of this story is that the Renaissance and the rebirth of natural science in the West rescued both body and materialism from their negative treatment in the medieval worldview. There is ample evidence to maintain that this view is flawed. One of the fundamental grounds for the Reformation was the view that medieval Roman Catholicism overvalued good works on earth at the expense of faith (including, for John Calvin, faith in predestination). Indeed, the medieval world so valued the body that it held firm to the idea that at the end of the world, after the final judgment, the body would be reunited with the soul, to either enjoy or suffer for eternity the result of this last verdict. According to the great medieval philosopher Thomas Aquinas, it was only through the final reconnection of soul with body that the human race could realize the full meaning of creation. Both the body and the soul are valorized and ultimately, for those saved, rewarded in a beatific reunification, majestically described by Dante in *The Divine Comedy*. The soul does not disengage from the body. The body is not tossed off as an encumbrance holding back the true nature of mankind. Rather, it is reunited with the soul: "Body-space and soul-space have been melded into one-space." (Wertheim 1999: 75) The precise way this happens and the nature of the outcome occupied many medieval theologians who ultimately viewed it as a matter of mystery and faith. What the canon of medieval Catholicism would not allow to be doubted was the dual reality of the material and spiritual worlds, their dual significance, and the realization of their primary purpose, unification, at the end of time. As some of the doubters would painfully learn, to deny these fundamental tenets was to court heresy.

The duality of material and spiritual spaces started to change in the fifteenth century as the late medieval and early Renaissance worlds began to explore the fullness of the material dimension and, in doing so, came to slowly diminish, and even later to deny, the spiritual. This story has been told many times over and so there is no need to repeat it here. Suffice it to say that with the rise of the natural sciences and their positivist methods that admitted for serious investigation only what was accessible to the senses, materialism triumphed. Although Western science is typically quick to claim that it is not anti-spiritual but simply committed to a set of procedures that make it agnostic about the spiritual, there is no denying that a fundamental consequence of the eruptions brought about first by Newtonian physics and then by Darwinian biology, is the ascendancy of a uni-spatial worldview. Physical space replaced the dual material-spiritual space of the medieval world. Hardt and Negri put it sharply in their analysis of the Enlightenment project by asserting that its primary task "was to dominate the idea of immanence without reproducing the absolute dualism of medieval culture by constructing a transcendental apparatus capable of disciplining a multitude of formally free subjects" (Hardt and Negri 2000: 78). This project was not always successful, as the later Enlightenment featured attempts to revive the medieval dualities in a "technoromanticism" that Coyne (1999: 37–38) finds useful in his analysis of our contemporary digital world.

For Wertheim the story does not end in the singularity of material space. Wertheim's argument is not like those proffered by other end-of-geography mythmakers who share with their end-of-history counterparts the view that space as a constraint ends with computer communication, just as history as a limitation on human capabilities also parts the stage. Rather, cyberspace opens up a new terrain, fundamentally unlike that of physical space, but not an altogether new dimension. Instead, it brings us closer to the medieval practice of living in two worlds: "After three hundred years of physicalism, cyberspace helps to make explicit once more some of the nonphysical extensions of human beingness, suggesting again the inherent limitations of a strictly reductionist, materialist conception of reality. Again, it challenges us to look beyond physicalist dogma to a more complex and nuanced conception both of our ourselves, and of the world around us." (Wertheim 1999: 252) Dogma or not, when we look beyond

the singular spatial world that congealed in positivist thought, we once again encounter a spiritual realm. Citing a string of cyber enthusiasts and some mere fellow travelers, Wertheim fills out the spiritual nature of cyberspace. These include Kevin Kelly of *Wired,* who sees "soul-data" in the chip, Jaron Lanier, who thinks of the Internet as a "syncretic version of Christian ritual," Nicole Stenger, who believes that with cyborg appendages "we will all become like angels," Michael Benedikt, who describes cyberspace as "a digital version of the Heavenly City," and N. Katherine Hayles, who maintains that "perhaps not since the Middle Ages has the fantasy of leaving the body behind been so widely dispersed through the population, and never has it been so strongly linked with existing technologies" (ibid., 255–263). Wertheim also includes the medieval historian Jeffrey Fisher, who notes the parallel between the Christian vision of the body returning in glorified form and the contemporary computer enthusiast's dream of the body returning in a form that transcends physical limitations.

Admittedly, there is a tendency for cyberspace to ignore or deny the physical. But legal systems that are based on place and geolocation software that permits the tracking of people and their communication make the genuine end of geography a far more complex issue than cyber enthusiasts have allowed. Geography, like history, can be painfully persistent. As David Harvey notes (1996: 19–45), the literary critic and social theorist Raymond Williams liked to invoke the idea of "militant particularism," meaning that solidarities developed in specific places, in local struggles, gave rise to general ideas about benefiting humanity. For Williams (1989), global ideals such as the democratization of social, political, and economic life and the creation of vibrant public spaces were hatched in the tumult of concrete conflicts in communities, factories, offices, and homes. Today others view localism, including the vitality of local economies, as central to our prosperity, if not our survival (Berry 2002).[8]

End-of-geography talk resists this thinking. In this respect it harkens back not to medieval Christianity but to a Pythagorean worship of ideas, particularly the abstract realm of mathematics, and a Gnostic religious impulse to reject the body. Indeed, Wertheim links this tendency to reify cyberspace with the tendency to "cyber-selfishness" which Paulina Borsook criticized in the culture of Silicon Valley (Borsook 2000). "Why bother fighting for equal access to education in the physical world if you

believe that in cyberspace we can all know everything? Why bother fighting for earthly social justice if you believe that in cyberspace we can all be as gods." (Wertheim 1999: 281) Notwithstanding these tendencies, for all but an admittedly important segment of the cyberspace world, computer communication opens the very real possibility of returning to a dual world where the physical and the spiritual enrich human experience. But this is where Wertheim and others who have hinted at the comparison miss an opportunity to deflate the hyperbole and deepen our understanding of cyberspace. The spiritual realm of the medieval period was often far from pure, not without pain, and, while often sublime, far from beautiful in Edmund Burke's sense of the word. Because of this, it offers interesting grounds for comparison with cyberspace adding texture and depth to the world of computer communication which is all too frequently described in the flat tones of utopian or dystopian language. But instead, Wertheim ends her otherwise intriguing analysis with a chapter that lauds computer communication networks for their democratic, community-building potential. Citing a number of commentators known for viewing the Internet with rose-colored glasses, we get an upbeat finish that clashes with the promise of the more nuanced vision that her work promised. It is indeed difficult to step outside the myth.

The End of Politics[9]

One of the more persistent myths throughout the development of communication technology is that it would transform politics as we know it by bringing power closer to people. The computer is certainly not the first technology to carry this promise. In the 1960s there was a great deal of talk about how cable television and the prospect of interactive cable systems might affect politics. Two examples:

Automated home voting can give us a grand new toy. A voting machine in each home would be connected into vote-central, a computer which registers national decisions on key issues. Automated plebiscites; organized anarchy. (Gordon 1965: 91)

With two-way TV, constant referendum of democracy will be manifest, and democracy will become the most practical form of industrial and space-age government by all the people, for all the people. (Fuller 1962: 42)

However, with the arrival of cyberspace, the end of politics means more than that campaigns will be organized online or that voting itself will be

a click away, or even that people will use e-mail and chat lines to short-circuit the traditional political process for lobbying and pressuring officials (Hague and Loader 1999). The end of politics means the end of those fundamental insecurities that traditional politics so inadequately held at bay. These include the threat of external invasion, which, in a nuclear age, can mean the annihilation of entire societies. Complete security is one of those utopian political values that fill many pages of normative political theory but very few of actual political history, until cyberspace put the Strategic Defense Initiative on the political map. The radical rupture in time and space that cyberspace promotes combines with a rupture in the political order, raising the possibility of complete protection from external attack. Here the end-of-politics myth describes the end of the very insecurity that, at least partially, gives rise to political authority in the first place.

The genuine myth of the end of politics in an online world also involves the transformation from a society built for eons on vertical relationships of power to what Lawrence Friedman (1999) calls "a horizontal society" based on the individual's choice of identity. Primordial bonds of family, race, and religion, which evolved into the networks of power that define the state and such private institutions as the business corporation are all founded on vertical lines of authority. The rise of a horizontal society most of whose members are more or less "jacked in" to new communication and information technologies, to networks that link people in more than the traditional top-down vertical ways, will, the myth teaches, transform power as we know it. Even a veteran of more than a few power struggles appears to be sold on the idea. In a review of Friedman's work that admittedly worries about the looseness of the thesis, the sociologist Todd Gitlin (1999: 32) writes: "The drift of the horizontal society is in many ways more powerful than the overt ideologies of our time—or, rather the tendency toward horizontal relations is the master ideology beneath all the rival options. . . . Because of technology, relentless horizontal momentum is irreversible. The vertical cannot hold. Restoration movements only succeed in adding more horizontal bands to the general tendency. Roll over, authorities—the culture of the next millennium is not going your way."

Cyberspace myths feed talk of the end of politics partly because computer communication is not supposed to be about face-to-face social relationships. In fact, much of the enthusiasm builds from the ability to

replace these relationships. Some of this is justified from the savings that computer communication is supposed to create from decreased travel, but there is also the seductive aura of freedom from the mutual responsibilities that genuinely interdependent social relationships create. "If one is afraid of intimacy yet afraid of being alone," Sherry Turkle writes in her revealing study of heavy computer users (1995: 30), "even a standalone (non-networked) computer offers an apparent solution. Interactive and reactive, the computer offers the illusion of companionship without the demand of friendship. One can be a loner yet never be alone." To suggest that successful computer communication, whether in business or home, must be connected to a strong system of interpersonal ties is to challenge one of the genuine goals of computer myths: to live and work in the world without having to live and work with people.

This section concentrates on cyberspace myths about the end of politics by providing a specific analysis of how these are manifested in two important substantive exemplars. The first of these is the rebirth of the Strategic Defense Initiative (SDI), which promises to safeguard at least Americans from nuclear annihilation. This is a powerfully attractive vision because it promises near complete security from a massive nuclear strike. Its allure is made all the more compelling because everything is done, as they say, "by computer." The second exemplar is the rise of the Progress and Freedom Foundation (PFF), a think tank and lobbying organization whose intellectual and administrative direction has been provided by George Gilder, Alvin Toffler, and Newt Gingrich, among others. Together these individuals launched a "New Magna Carta" in 1994, and they continue to ensure that the PFF's influence and ideological presence is still being felt. Whereas the Strategic Defense Initiative promises to create the security of a computer-controlled umbrella that will end politics by protecting American society (and perhaps the world) from the threat of nuclear attack, the PFF offers the undeniably seductive promise to advance the cause of ending politics by creating a network society based on horizontal relationships. SDI proposes to end politics as we know it by ending a major source of political insecurity. The PFF proposes that cyberspace will compel an electronic democracy and an end to hierarchy, to replace the iron fists of bureaucracy and oligarchy with the nearly invisible hands of code. There is one person who connects the two efforts. George Keyworth is chairman of the PFF. As Science Adviser to President

Reagan and Director of the Office of Science and Technology Policy from 1981 to 1985, he was one of the architects of SDI. As a nationally recognized physicist (he once directed the physics division of the Los Alamos National Laboratory), he provided scientific legitimacy to a program whose feasibility met with substantial criticism from the scientific community right from its earliest days. But SDI and the PFF are linked by more than the people who have gravitated to both. They also share in the myth that cyberspace can end politics as we know it.

The Strategic Defense Initiative: A Myth in Three Acts—Epiphany, Annunciation, Rebirth

The social transformation marking the end of politics gains unprecedented expression in the security and protection of the Strategic Defense Initiative. Simple events that rise to mythic status often carry with them myths of origins. SDI is no exception. In fact, one can point to two such events that mark the program's early days: an epiphany myth and a myth of annunciation. These helped propel an SDI policy which, in 1980, according to one historian of the program, was not only unknown to most people, it had "virtually no constituency in the Pentagon or indeed almost nowhere in the defense community" (Fitzgerald 2000: 114). This does not mean that SDI lacked a history. For more than 30 years before the Reagan administration, the U.S. military tried, with little success, to develop weapons systems that would knock incoming missiles out of the sky. Indeed, one of the genuinely remarkable qualities of the Reagan initiative was its ability to break from this banal history with its own mythic account.

The epiphany took place on July 31, 1979, when Ronald Reagan, soon to be a presidential candidate, visited the NORAD base buried deep beneath Cheyenne Mountain in Colorado to learn how this nerve center for a global network of surveillance against surprise attack actually worked. The setting for the epiphany was itself myth-like: a vast room inside a mountain featuring a giant screen of IMAX proportions that flashed the state of nuclear deterrence. This was a scene right out of Hollywood, and Reagan, according to the story, played his role impeccably. What would be done, he asked innocently, to stop an attack detected on the big screen? The answer, of course, was that nothing could be done

to halt the attack, but instead, detection would initiate a deadly retalia-
tory strike, the foundation of the political strategy know as deterrence
based on mutually assured destruction. Reagan was apparently shocked
to learn this. According to the aide who accompanied him on the trip, "he
couldn't believe the United States had no defense against Soviet missiles.
He slowly shook his head and said 'We have spent all that money and
have all that equipment, and there is nothing we can do to prevent a
nuclear missile from hitting us.'" (Fitzgerald 2000: 20) According to the
story, he vowed from that time on to pursue a genuine defense against
nuclear attack and encouraged his aide, an economist with the Hoover
Institution, to prepare a brief on how to make SDI a reality.

It is hard to say precisely how much of this is accurate. Most accounts
agree that it took place, but it is nevertheless difficult to accept that the
man who would be president of the United States did not know 18
months before he took office that the U.S. lacked a functioning defense
against nuclear attack. But, like many aspects of SDI, including much of
the debate that would ensue about its technical feasibility, this is beside
the point. It is a myth, and whether it is true or false matters less than
that it was given life in Reagan's epiphany at Cheyenne Mountain.

The myth did not actually reach its genuine birth for almost 4 years.
On March 23, 1983, Reagan surprised most of his cabinet and his advis-
ers with the announcement that he would embark on a program to end
the politics of mutually assured destruction by making nuclear weapons
obsolete. The annunciation asked for an initial outlay of $26 billion to
fund SDI along with a Strategic Computing Initiative (SCI) required to
produce the enormous computing power necessary to manage a system
that would be capable of tracking thousands of incoming missiles, many
thousands more of decoys, separate the actual missiles from the decoys,
and launch the range of devices that would destroy each incoming missile
carrying nuclear weapons (Roland and Shiman 2002). Reagan's speech
generated a great deal of debate but much of it was conducted at a tech-
nical level. It rarely addressed how the promise of SDI could work at a
mythic level by providing a grand story of complete security from the
uncertainties of the nuclear age, offering a sacred canopy of protection at
least for the United States and, most likely, for its allies too. Indeed, the
president was enormously skilled at connecting SDI to both religion and
to a religion of technology. Smith (1987: 23) quotes him as follows: "I

told Gorbachev that SDI was reason to hope, not to fear; that the advance of technology, which gave us ballistic missiles, may soon be able to make them obsolete. I told him that with SDI, history had taken a positive turn. I told him that men of good will should be rejoicing that our deliverance from the awful threat of nuclear weapons may be on the horizon, and I suggested to him that I saw the hand of providence in that."[10]

The interweaving of computer technology and nuclear weapons with the mythic language of deliverance and providence embodied Reagan's approach to SDI. He admitted to knowing little about how it worked but was convinced that a generous, indeed divine, spirit was behind it, providing the means to fundamentally alter history. In essence, Reagan presented SDI as a shaman would conjure a solution from nature, only for Reagan, the answer lay not in nature but in technology. Jhally (1989: 229) describes it as follows: "In modern industrial society the link with nature has been shattered; nature is viewed only as a resource that is there for human consumption. Our defining relationship is with technology. Rather than the spirits of nature invading the body of objects (as in older fetishistic belief systems), in the mythical universe of advertising it is the spirits of technology that invade the body of the commodity and supply the basis for a belief in its power. . . . it would not surprise us to see this pattern everywhere we look, from SDI to car commercials, cloaked in magical and supernatural modes of representation."

Reagan's mythic call to end the politics of fear with a politics of technological hope won enormous support, cost $60 billion in government allocations, and produced no credible system. Nevertheless, the myth was so successful that most Americans responded to surveys in the 1990s with the conviction that the United States already possessed a working system for defense against ballistic missiles. One auto engineer reacted as follows when informed that the U.S. lacked such a system: "You couldn't pay me enough to believe you. After all you see it in the movies." (Fitzgerald 2000: 493) Moreover, with continued spending and continued testing throughout the 1990s, and despite little in the way of technical success, the Clinton administration and the Democratic Party generally supported the development of modified versions of SDI. The epiphany and the annunciation may have technically produced a stillbirth but they also gave rise to a genuine rebirth in a renewed effort to continue the program into the new century.

Debate continues on technical feasibility, specifically about how large a protective umbrella can actually be built. There is a great deal of doubt that a missile defense system can actually distinguish genuine incoming missiles from the many, perhaps thousands, of decoys that will accompany them (Broad 2000). One of America's foremost physicists put the doubt most eloquently: "In seeking to deploy a national missile defense aimed at an implausible threat, a defense that would have dubious effectiveness against even that threat, and that on balance would harm our security more than it helps it, the Bush administration seems to be pursuing a pure rather than applied missile defense—a missile defense that is undertaken for its own sake, rather than for any application it may have in defending our country." (Weinberg 2002) The system remains mired in controversy with scientists charging falsification of test results to support deployment and the Pentagon redefining a successful test launch. With new "success parameters," a $100 million December 2002 test was officially declared a success even though an interceptor warhead failed to separate from its booster, missed the intended target by hundreds of miles, and burned up in the atmosphere with no damage to the mock enemy rocket (Broad 2002, 2003). In spite of these problems, the SDI myth lives on, and there is arguably more widespread and bipartisan support for this "pure" defense today than there was in the Reagan years. Some have argued that this is because the Democrats have learned that it makes good political sense to provide a program that delivers billions to satisfy major defense contractors and avoids the risk of having Republicans label them soft on defense (Hartung and Ciarrocca 2000).

It is testimony to the power of the SDI myth that, with nearly two decades of demonstrable technical failure, it continues to live on in American political mythology. As one leading American historian has noted, today's politicians are attracted to SDI "because they, like Reagan at his most ethereal, continued to imagine a world in which the United States could stand alone, impervious to the needs and interests of other nations" (Brinkley 2000: 7). This point could stand as well as any for a genuine definition of the end of politics—to be able to act without having to account for the needs, interests, or actions of others. In 1999, Congress authorized an additional $6.6 billion to deploy a missile-defense system with practically no debate. Under the Bush administration, that figure expanded significantly, surpassing $8 billion by 2002.

Furthermore, in a decision that stirred little debate, overshadowed as it was by the events of September 11, President Bush, backed by some of the same people responsible for Reagan's plan, committed his administration to deploying the first piece of an antimissile defense system, ten interceptor rockets at a base in Alaska, by 2004 (Glanz 2001). This action leads to the inescapable conclusion that SDI's promise of an end of politics is very much a myth, in the deepest sense of that term—alive, if not particularly credible.

A Magna Carta for the Cyberspace Age

The myth of the end of politics is also exemplified in the Progress and Freedom Foundation, whose rhetoric and mission owe a great deal to the contribution of Alvin Toffler. Perhaps most famous for his theorizing about the "third wave," Toffler offers an optimistic vision of the human race riding a wave of change brought on by the information revolution which follows in the wake of the first wave of agriculture and the second wave of industry. The PFF has taken up Toffler's challenge specifically asserting that its primary mandate is to wrest power from dominant power brokers with the goal of reinvesting this power in the people through new communication technologies. For the PFF, the notion of the end of politics, however, actually means a new form of politics that seeks to recover a lost sense of community and public life. This section considers how the PFF vision is conjured and given life. Much can be learned about this exemplar of the end of politics by examining those who constitute this myth's most powerful soothsayers.

From its web site (www.pff.org) we learn that the Progress and Freedom Foundation studies the impact of the digital revolution and its implications for public policy by conducting research in fields such as electronic commerce, telecommunications, and the impact of the Internet on government, society and economic growth. It also examines general policy issues such as the need to reform government regulation. It takes a very laudatory view of the digital revolution, and a very negative one of "second wave" bureaucracy and "old" ways of governing. With the help of information technology, capitalism is presumed to have the power to end all injustice and create a world where all are equally free to pursue life as entrepreneurs. With injustice gone, the state is made superfluous

and will crumble under the weight of its own uselessness. The PFF can be seen as a lightning rod for the third wave ideal of a successful, indeed sublime, marriage between information technology and capitalism. Before considering the substance of the link between the end-of-politics myth and PFF ideas, let's draw on a simple political economy of the PFF to provide an introduction.

The origins of much of this agenda lie in one of the first documents that brought the PFF into the public consciousness, "Cyberspace and the American Dream: A Magna Carta for the Knowledge Age."[11] Published in 1994, this manifesto's authorship is attributed to Esther Dyson, George Gilder, George Keyworth, and Alvin Toffler. Dyson has authored *Release 2.0* (and *Release 2.1*), subtitled *A Design for Living in the Digital Age*. She runs EDventure Holdings, which publishes monthly computer-industry news, and, as chapter 2 described, was once the chair of ICANN, the Internet Corporation of Assigned Names and Numbers, the private international agency that sets policy for the Internet's technical standards and the Domain Name System. Gilder is notable for his books *Life after Television* (1994), *Microcosm* (1989), and *Telecosm* (2000). A deeply committed Christian and an enthusiast of ESP, he has also viewed the Internet in spiritual terms, once referring to it as "the Gothic Cathedral of our Times" (Cassidy 2002: 42). Keyworth, apart from being a constant presence at the helm of the PFF, serves on the boards of directors of the Hewlett-Packard Company, General Atomics, and several emerging high-technology companies. He was also the primary adviser to Ronald Reagan on his Strategic Defense Initiative. Toffler has authored or co-authored *Future Shock* (1970), *The Third Wave* (1980), *Power Shift* (1990), and *Creating a New Civilization* (1995). Together, this group of people are among the foremost proponents of the revolutionary potential of computer and communications technology to advance a generally libertarian agenda emphasizing choice, customization, individuality and freedom in the use of the media, and indeed in the refashioning of new rules of everyday life.

The PFF is also a political organization whose life extends far beyond its philosophical origins, embodying in one organization the value of pursuing the mutual constitution of culture and political economy. Incorporated on April 5, 1993, as a District of Columbia nonprofit corporation, it was originally operated out of the office facilities of the

Washington Policy Group (WPG), partly provided by GOPAC. This is consequential since GOPAC (or Grand Old Party Action Committee) is the political action committee dedicated exclusively to electing Republicans to state and local offices. In the 1980s, Representative Newt Gingrich transformed it into a powerful political tool. Jeffrey Eisenach, who is president, Senior Fellow, and co-founder of the PFF, has previously headed up GOPAC, as well as the Washington Policy Group. He also served on the faculty of the George Mason University Law School, where he has taught a course on the law and economics of the digital revolution.

The institutional connection between Gingrich and other key figures in the PFF goes all the way back to 1982, when Gingrich headed the Congressional Space Caucus and George Keyworth served as President Reagan's Science Advisor and as the White House Director of Science and Technology Policy. Gingrich himself has a long-standing connection to the Tofflers, including writing the preface to their 1995 book *Creating a New Civilization*. Since stepping down as Speaker of the House in January 1999 and resigning from Congress, Gingrich has continued to endorse the notions of "future shock" and "third wave" thinking 30 years after the Tofflers started promoting these ideas. This can be seen in his work as a Silicon Valley consultant and also in the rhetoric of his Toffler-inspired "Age of Transitions" project. He formed a consulting firm, The Gingrich Group, in June 1999, and was appointed a distinguished visiting fellow at the Hoover Institution, a public policy research center at Stanford University, where his role is to study the policy implications of science and technology research. The PFF helped to promote Gingrich's national exposure by underwriting a televised talk show which Gingrich co-hosted and by supporting a broadcast college history course which he designed. It is therefore not surprising that Gingrich would fully support the PFF's "New Magna Carta."[12]

This document originally evolved out of a conference in 1994 that was also attended by John Gage, Director of Sun Microsystems' Science Office, and Jerry Berman, the executive director of the Center for Democracy and Technology. Berman also chairs the advisory committee to the Congressional Internet Caucus. He was a past director of the Electronic Frontier Foundation and chief legislative counsel at the American Civil Liberties Union. Notably, Eisenach is also on the latter board of directors. Major support for the conference was provided by the Competitive Long

Distance Coalition, with additional funding coming from *Wired*. At their fourth annual conference in 1998, the PFF attracted Ira Magaziner, senior advisor to then President Clinton and Lawrence Lessig, a law professor who was appointed "special master" in the Microsoft antitrust case.

The PFF's 2003 list of financial supporters finds 33 of the 53 located squarely in the media and information technology industries including Amazon.com, AOL Time Warner, BellSouth, the Cellular Telecommunications & Internet Association, Cisco Systems, Comcast Corporation, the Consumer Data Industry Association, the Consumer Electronics Association, Disney, EchoStar Communications, Gateway Computer, the Hewlett-Packard Company, IBM, ICO Global Communications, Intel, the Interactive Digital Software Association, Intuit, MGM, Motorola, the National Cable & Telecommunications Association, The News Corporation, Oracle Corporation, Qwest Communications, SBC Communications, Sony Music Entertainment, Sun Microsystems, the Telecommunications Industry Association, the United States Telecom Association, VeriSign, Verizon Communications, Viacom, Vivendi Universal, and Western Wireless. For an organization seeking to dispel old means of doing politics, the PFF is very skilled at practicing the old politics of fundraising and lobbying.

How then does this organization imagine the end of an old politics and the birth of a new? Here we return to the cultural and mythic realm. Its foundational myth lies in a form of Enlightenment politics—a presumed ascendant triumphalism of the individual spirit, a faith in the rational ability to think and act correctly, and an embrace of the idea of progress. A large part of a "new means of doing politics" is the instrumentalization of direct democracy. Significantly, though, the claims for the politics of the third wave go far beyond calling for specific technological initiatives based on purposive-instrumental rationality.[13]

What is more important about the PFF's version of the end of politics is its interest in a wholesale transformation of social relations. While political mythmaking and utopianism of the past relied upon the vision of a new community whose benefits accrued to all, the utopian strain of the PFF's end-of-politics rhetoric relies upon a retreat from any such communalism. The liberalism of Toffler's second wave gives way to a third wave of one diffuse sentiment: liberation "from all the old second wave rules, regulations, taxes and laws laid in place to serve

the smokestack barons and bureaucrats of the past" (Toffler and Toffler 1995: 79).[14]

What then is the locus of politics in this new environment? The claims for the end of politics converge around some key distinctions usefully characterized as a set of dualisms.[15] Across all these dualisms is a concern with a new political topography that privileges the virtual and politicizes the local. This is grounded in a discussion of locale and made manifest alongside a new rhetoric of locality—the phenomenology of neighborhood, community, and personal responsibility. Each attempt to distinguish a third wave way of life from those of the past opens the door to mythmaking about communications technology and the politicization of everyday life.

The first dualism to consider distinguishes between Newtonian and quantum practices. A good place to start is the PFF's Magna Carta, a document that aims to redefine for the Knowledge Age all of the following: the meaning of freedom, the structure of self-government, the definition of "property," the nature of "competition," the conditions for "cooperation," a sense of community, and the nature of "progress." The very first sentence asserts dramatically that "the central event of the twentieth century is the overthrow of matter." We are told to prepare ourselves for nothing less than "quantum"-scale change coming about as micro-level changes in our orientation to the world will bring about macro-level social transformation. Colloquially, the Tofflers state that "humanity faces a quantum leap forward" and they subsequently speak of an emergent civilization that has "its own ways of dealing with time, space, logic and causality" (1995: 19–20). Even more directly, on his web site (www.Newt.org), Gingrich advises us to learn as much as we can about quantum mechanics because, as a field of study, it is integral to nanoscience which, summoning the myth of the miniature, he believes will change our world in the next quarter century just as computers have in the past 25 years.[16]

Indeed, the space and time of modern life have been variously described as having a character that echoes classical Newtonian physics. Seen as a simple, invariant container for urban and social life, this sense of time also implies an unproblematic sense of duration and succession (Lash and Urry 1994: 237; Giddens 1979: 202; Emberley 1989: 745). Along with this classical sense of progression comes a picture of a reasonably certain

future, a predictable reality that is governed by a centralized, mechanistic bureaucracy meant to improve efficiency, effectiveness, power and control. However, new information technologies with their mythical ability to triumph over time and space, open the door to questions about these mechanical notions of flow. This is very much the thrust of two political commentaries that pursue this tack and provide the foundation for PFF's commitment to a "quantum politics." Becker (1991) has produced a volume on the subject that challenges "Newtonianism," the view that the world is a rational machine, and advances a politics based on a "quantum" vision of society. Slaton (1992) follows this perspective and applies quantum theory which she sees as positing the essential interconnectedness of seemingly unrelated events. She is very interested in how to make use of the principles of randomness, probability, and interactivity in order to understand and act in the political world, suggesting that old Newtonian models of liberal democracy are made antiquated by new technologies, newly aware citizens, and new kinds of mediational roles between citizens and their representatives.

Still, the computer's quantum challenges to cyberspace that the PFF proffers extend far beyond attempts at direct democracy. Indeed, they augur transformations in the entire political, economic, cultural and social firmament. While politics can never really end or disappear entirely, the new direction that politics can take is like a quantum mechanical state, permanently in flux, as different possible events and repercussions exist in what amounts to coterminous superimposed realities. For the PFF, this entails the end of an old politics that keeps the citizen at a distance and seeks to evoke a limited and predetermined response. In its place, the new politics is meant to involve everyone in its production as emancipatory new technologies are implemented to usher in a surfeit of new opportunities and infinitely malleable and flexible political and social practices.

This dualism of Newtonian and quantum practices overlaps another dualism—that of the city-network. Since Plato, definitions of the city have been essentially political economic. A place became a city by virtue of its legislative autonomy, and its economic power and complexity (Raban 1974: 159). Now, however, a new vision of politics in cyberspace necessitates a new connectivity, one that supplants such autonomy. New economic power rests in looser structures, systems with nodal points whose

power derives not from their geographical supremacy but from net-
worked interdependence and flexibility. Real-time and 24-hour networks
of information flows overthrow the physical city and the nation state too,
creating new laws by which politics must comply or be threatened with
extinction. We are told to expect the same revolutionary change in our
politics as is underway in the meaning of our physical structures. There is
no room for the traditional, or the old, only the constantly circulating and
the new. There is an anti-urbanism underfoot here that leads to positive
predictions of electronic interactions in "electronic spaces" that do not
necessarily require urban spaces, certainly not public spaces, to succeed.

As the city dissolves, so too do the traditional connections in our taken-
for-granted political life. Moreover, as the city base for politics is replaced
by a network, it is presumed that hierarchies associated with these earlier
bureaucratic structures will explode into a set of new horizontal linkages.
A "hard" city of facts, figures and determinate relations will be replaced
by a "soft city" of information, aspiration, imagination and, indeed, myth.
This assertion of a politics of everyday life that takes place on different
levels outside the formal, professional political sphere implies the politi-
cization of hitherto minimally political parts of society. However, its pro-
motion by the PFF is more distinctly suburban than subaltern. In reality,
this new politics arguably occurs at the expense of the "public sphere,"
which prompts discussion of another dualism: public versus private.

The conjectured erosion of public space in cities is seen as part of a shift
to a "society that expects and desires only private interactions, private
communications and private politics" (D. Mitchell 1995: 121). This vision
is one that suggests that cyberspaces become the new frontier of public
space. The PFF's position on the public/private distinction is clear. Its tech-
nocratic position may even be seen as anti-political, questioning collective
action, characterizing people as living individually, if not anarchically, and
promoting vacating the public sphere. Fred Dewey classifies this style of
techno-social commentary as celebrating the "cyburban." "Private space,"
Dewey writes (1997: 263), "is regarded as the only place where anything
can endure, the only thing that can secure possibility. It is the only place
where the dream is safe. Only there can imagination immaculately renew
itself, in privacy."

This refashioning of politics means that communication does not
serve only as a conduit to achieve societal goals. Instead, communication

provides us with the very basis of politics. The public no longer exists as an entity inasmuch as it is a collection of discreet individuals who are serviced. Under the auspices of efficiency, individuals reign triumphant as a corporatist ethic provides the road map of social design. This vision of people and their interests is akin to a post-Fordist regime with customized interests, niche markets, and the narrowing and increasing specification of issues which speak to a narrowcast rather than broadcast mentality. The public becomes, then, a questionable claim, little more than a holdover annoyance of second wave politics, rather than a leading force in the new politics. In fact, the tone of the new private idealism obviates the need for the public altogether. We are left with a new sense of the political, an individualistic populism suffused with elite ideals. *Res publica,* synonymous with the commonwealth, the state, the republic, and the public business, recedes where it is not entirely subverted to private interests. The PFF's Magna Carta states: "Unlike the mass knowledge of the Second Wave—'public good' knowledge that was useful to everyone because most people's information needs were standardized—Third Wave customized knowledge is by nature a private good." This privatization of both public space and public interest reaches a new level. It has, to use a favorite PFF term, taken a quantum leap. But in making this assumption, the PFF reveals the intertwined nature of culture, politics, and economics.

This privatization ethic also speaks to another important dualism, that of government and business. In the third wave, government will either disappear or operate like a business. "Like a long-married couple, government and business eventually must take on some of each other's characteristics." (Toffler 1990: 259) Rather than being less democratic, this shift away from traditionally bipartisan politics purportedly represents a move toward new democratic values embodied in the marketplace. The end of inertial politics takes place through the annihilation of the distinction between government and business interests.

Also related to the public/private divide, end-of-politics reasoning has repercussions for the dualism that distinguishes the community from the individual. Like the mythic discourse that has surrounded previous technologies, the PFF's claims for cyberspace depend upon a new vision of community. However, the radical pluralism that the PFF envisions is also tied to a need to valorize and celebrate social diversity. The cyberspatial

reconstitution of democracy in third-wave terms depends upon quantum communities and quantum citizens, never exactly sure of their status as it relates to others. In the new vision, the Internet and other advances in communication bring about a great number of small, diverse communities. In this mode of politics, individuals are imagined to have more possibilities to communicate their views and to possess greater access to those who represent them in the political system. Given more information about issues, decisions, and pending legislation, they are able to exercise greater influence over this system. The communication scholar Kevin Robins has called this "the invocation of community without the production of a society" (Kitchin 1998: 89). But, accurate as this criticism may be, it is somewhat beside the point of the myth, whose general attraction comes from conjuring community without having to do much of the hard work (often one face-to-face encounter at a time) that used to be required to construct traditional neighborhoods and communities. With the dawn of a new quantum reality of civic participation along an infinite number of points in the space-time continuum, both communal solidarity and politics as we have known it become more dispersed but easier to realize.

Similar to these previous dualisms, the debate over new technology and political recourse suggests that a politics consisting of battles over access to state power between classes is being replaced by a new politics of providing security for individuals. In a post-traditional world, the accepted bonds of class and regimes of economic organization, and the hierarchies that go with them, give way to a more loosely defined, shifting, transactional network-based affiliation. The very existence of these networks or webs of affiliation means that, unlike the constant of social class, they have significance only insofar as their linkages continue to reap dividends. These webs exist as social units of analysis only by virtue of the connectedness that they are able to provide. Rather than any relatively stable class position, the direct involvement of citizens in democratic participation is undertaken on the basis of an identity whose nature may be only a by-product of their temporary condition of being connected. In this capacity then, the new web-based networking of society allows at least the dream of a new politics of interdependence and integration, flexibly functioning across boundaries. The class struggle ends with the triumph of indeterminate webs of communication.

This brings us to the final dualism that sums up the nature of the new "post-political" landscape just as the Newtonian/quantum dualism clarified its philosophical foundation. Here the distinction is between a closed system with a rigid political space and an open architecture with a fluid space. In an infinity of cyberspaces, information, it is contended, wants to be free, and politics necessarily follows in this direction. The network space envisioned by the PFF is transparent and ubiquitous, connecting each user to every other. The old political order, by contrast, is seen as restricting access, defining property and establishing the proper pipes through which information should flow. The new politics embodies open architectures whose recombinant culture adapts to constant changes in the information environment. Proprietary architecture, on the other hand, perpetuates the notion of private property in a digital culture and encourages the idea that certain types of behavior are preferred over others. The dream of cyberspace, then, is not a multidimensional data grid from which one picks where one wants to go today and how best to get there. Rather, the chaotic, disorganized realm of plural cyberspaces has no highways or interchanges and no direction; it is just a vast universe of interconnectedness.

One of the ways of understanding this distinction is found in Lawrence Lessig's description of the regulation of computer software products as "code." Lessig (1999) maintains that "code is political" and that therefore the citizens of a democratic cyberspace should be the ones to choose it. In this vein, Microsoft and other companies are criticized for what is seen as their practically closed control over code, a practice that implicitly threatens political freedom. In a very real fashion, what the PFF is advocating is a regulatory regime where the force shaping behavior and molding opinion in cyberspace will be technological code rather than traditional legal regulation. Consequently, it is assumed that the benefits of open social and computing architecture will spill over to the public.

Toffler and the PFF see the virtualization of political and economic infrastructures as a worthy end of politics. For them, this technological transformation in social relations is not just a laudable goal, it is an absolutely essential end to be achieved. In effect, this means an end to politics, the demise of political relations as we know them, to be replaced by a new cyberspace-based technological orientation. While push-button fantasies and the idolatry of new media and communication tools are all

necessary to bring about the PFF's vision, they are not sufficient. As the Tofflers themselves proclaim (1995: 11), "the Third Wave is not just a matter of technology and economics. It involves morality, culture and ideas as well as institutions and political structure. It implies, in short, a true transformation in human affairs."

The myth of the end of politics, supported by a new communications infrastructure, produces new types of citizens and new types of social relations. It also sows the seeds of its perpetuation, further entrenching itself as the only legitimate way to do business. The Internet, for instance, is both an instrument for and a result of the institutionalized practices that use it. For Gingrich and his PFF colleagues, the Internet is not just a corrective to democracy; it is democracy.

The end of geography and the end of politics deepen and extend the mythic universe of cyberspace. Along with the end of historical time, we encounter a vision of how space and social relations are fundamentally transformed by a revolutionary new technology. Cyberspace is indeed a radical disjunction in the human experience, made all the more compelling by the sublime vision of what lies ahead. But, as the next chapter describes, this is very much an ever-ending story. For it tells the story of how the end came several times before the birth of cyberspace. The telegraph, electricity, the telephone, radio, and television were accompanied by their own versions of the end of time, space, and social relations, their own promise of revolution.

5

When Old Myths Were New: The Ever-Ending Story

Almost every wave of new technology, including information and communication media, has brought with it declarations of the end. They represent what Armand Mattelart (2000) has called "the ideology of redemption through networks." Since these tend to take place with no reference to similar proclamations in the previous wave, one cannot help but conclude that the rhetoric of technology, the technological sublime that David Nye so perceptively identifies, is powerful enough to create a widespread historical amnesia. One of the more useful ways to understand technological myths, including myths of cyberspace, is to excavate the tales that accompanied the rise of earlier "history-ending" technologies. This chapter takes on this task, concentrating on the telegraph, electrification, the telephone, radio, and television. These are not the only possible examples (motion pictures could be included), but they serve as good ways of demonstrating that there is indeed a remarkable, almost willful, historical amnesia about technology, particularly when the talk turns to communication and information technology.

One of the reasons why variations on the "end of" myths are so popular is because we collectively forget the myths that surround the history of technology. Cyberspace enthusiasts encourage us to think that we have reached the end of history, the end of geography, and the end of politics. Everything has changed. So we can apply the mute button to whatever has come before. After all, history has nothing to say to us because it knows nothing of cyberspace. But quite to the contrary, history is filled with mythmaking about technology and has more to say than ever before about how we invent myths whenever we invent technology. Then why do people so willingly acquiesce, indeed actively affirm, myths of the end? From a political economic perspective, powerful forces play

important roles in compelling belief and action. These forces include visionaries promising an electronic utopia, the mass media looking for a good story, politicians wanting to be identified with the next new thing, and businesses, public relations firms, and advertisers eager to market the latest promise to transform life as we know it. These are, no doubt, important forces in compelling belief and action. However, as a cultural perspective maintains, active affirmation does not just come from external pressure. There is something powerfully compelling about the culture of today's communication technology, including the digital sublime, but this magnetic power extends back in time to earlier examples of the electrical sublime and further back to the technological and the natural sublime. Consequently, we need to understand political economic pressures within the cultural context of meaningful myths that lift us out of the day-to-day and designate us as a special, perhaps even a chosen, people. Put simply, we want to believe that our era is unique in transforming the world as we have known it. The end is preferred to more of the same; the transcendent to the routine; the sublime to the banal. So we not only view our age as revolutionary. We forget that others looked at earlier technologies in much the same way. It is only when we see cyberspace as mutually constituted out of a culture that creates meaning and a political economy that empowers it that we can fully understand why it is that over and over again, people have encountered and believed in a genuinely living end.

History, geography, and politics ended in the 1850s when the telegraph was introduced. They ended again a few decades later when electrification lit up the cities, but the myths were largely forgotten when electricity literally withdrew into the woodwork. The end came once more when the telephone brought about a renewal of these myths. But who now refers to our era as The Age of the Telephone? In the 1920s, the arrival of radio brought along its own cast of mythmakers who saw it marking a radical change in time, space and social relations. In the 1950s, television changed the world and then changed it again in the 1960s with the multichannel world of cable television. Is it any wonder that cyberspace was hyped as bringing down the curtain on history, geography, and politics? In what amounts to an understatement, one philosopher of technology has concluded: "The structure of the history of technology itself is such as to encourage particular philosophical attitudes. Most commonly the particular philosophy involved is an opti-

mistic, not to say triumphalist view of both the history of technology and the nature of man." (Mitcham 1973: 169)

Looking at the history of technology literally puts us in our place by suggesting that rather than ending time, space, and social relations as we have known them, the rise of cyberspace amounts to just another in a series of interesting, but ultimately banal exercises in the extension of human tools. They are potentially very profound extensions, but not enough to warrant claims about the end of anything, other than the end of a chapter in a seemingly never ending story. Indeed, the history of technology suggests that this would be far from the first time that we have laid claim to the end of history, the end of geography, and the end of politics. Practically every substantial technological change has been accompanied by similar claims. The chant goes on: This changes everything. Nothing will ever be the same again. History is over, again and again and again.

The Telegraph

History was also over back in December 1868 when a room full of banquet guests enjoying the feast at Delmonico's restaurant in New York raised their glasses to Samuel F. B. Morse, whose new invention, their toastmaster proclaimed, "annihilated both space and time in the transmission of intelligence" (Standage 1999: 90). Or perhaps it ended a decade earlier in 1858 when the British ambassador rose to toast another contributor to the success of the transatlantic telegraph, Edward Thornton: "Steam was the first olive branch offered to us by science. Then came a still more effective olive branch—this wonderful electric telegraph, which enables any man who happens to be within reach of a wire to communicate instantaneously with his fellow men all over the world." (ibid.) This was followed by a toast to the telegraph as "the nerve of international life, transmitting knowledge of events, removing causes of misunderstanding, and promoting peace and harmony throughout the world" (ibid.: 90–91). These stories document some of the clear similarities between the telegraph, which brought not only its own "end of" rhetoric but also early versions of hacking, virtual sex, and fears of information overload. Writing about the telegraph launched a particularly intense period of technological utopianism. It was propelled by the newspapers, as well as by book-length parables such as Edward Bellamy's *Looking Backwards: 2000–1877*.

Standage is correct to note the connections between today's Internet and its Victorian counterpart, but he does not go far enough to demonstrate the rapture that greeted telegraphy's arrival. As Susan Douglas documents (1986: 37), "reporters responded to wireless telegraphy with unprecedented awe." "Our whole human existence is being transformed," one magazine exclaimed; another envisioned telegraphy creating its own land: "It would be almost like dreamland and ghostland, not the ghostland cultivated by a heated imagination, but a real communication from a distance based on true physical laws." (ibid.: 40) In 1857 the *New York Evening Post* pronounced that, should telegraph lines extend across the seas, as they would in fact a decade or so later, they would "make the great heart of humanity beat with a single pulse." According to another journalistic account, telegraphy would bring diplomats together around a global electronic table: "Wars are to cease; the kingdom of peace will be set up." (Gordon 2002: 75)

In 1905, as if to capture this spirit, a New York company outfitted an automobile with a wireless telegraph to transmit stock quotes from curb markets to brokers' offices. With "Wireless Auto No. 1" painted on its side, the car made its way down Broadway with the latest information on the financial markets. The first cars had hardly made their way out of their inventors' shops when they were equipped with the wireless technology that would further realize their distance-transforming promise. Admittedly, as one book written at the time suggested, the telegraphy-equipped automobile was "something of an oddity, built chiefly to show the possibilities of wireless telegraphy" (Houston 1905: opp. 106). One of the overwhelming attractions of this new technology was its genuine post-industrial promise. It was seen as the first major technological effort to overcome the divisive social and economic consequences of industrialization by genuinely bringing people together, as they had once been together in the admittedly idealized communities of a village past, but now far more expansively since the new telegraph, particularly in its wireless form, would extend the village, as *The Century Magazine* put it, "from pole to pole" (Douglas 1986: 37).

The telegraph would end the divisions among classes and races that the industrial age brought about by bringing a new cohesion and harmony to society. Telegraphers were turned into heroes. One account of an American infantryman features as a frontispiece an image that dra-

matically depicts a slain telegrapher with the caption "Dennis, lying under the telegraph line, his left hand still grasped the instrument" (Brady 1899). As Carey (1992: 201–230) notes, starting with the telegraph we observe a renewed triumphalism asserting that every improvement in communication would end isolation, link people everywhere, realizing in practice the "Universal Brotherhood of Universal Man." Two mid-nineteenth-century bricoleurs connected this triumph to the telegraph as follows: "How potent a power, then, is the telegraph destined to become in the civilization of the world! This binds together by a vital cord all the nations of the earth. It is impossible that old prejudices and hostilities should longer exist, while such an instrument has been created for an exchange of thought between all the nations of the earth." (ibid.: 208–209)

Electrification

Before considering other such precursors of cyberspace, such as the telephone, radio and television, it is useful to reflect on how, shortly after the telegraph made its triumphant entrance, the technology that powered it and subsequent history-ending media elicited enthusiasm and awe. Here is how one magazine described its magical power to light up a dark sky and the central exhibition hall at a World's Fair: "Look from a distance at night, upon the broad space it fills, and the majestic sweep of the searching lights, and it is as if the earth and sky were transformed by the immeasurable wands of colossal magicians and the superb dome of the structure that is the central jewel of the display is glowing as if bound with wreaths of stars. It is electricity!" (Nye 1990: 38) The reporter is describing one of the many spectacles of light, this one at the Chicago fair of 1893, that the promoters of electricity used to build public support for lighting up cities and towns, creating one after another magically illuminated Main Street. It was not just the big cities that sponsored fairs to celebrate the electrical sublime. As Carolyn Marvin describes (1988: 165), the First Greater American Colonial Exposition, held in Omaha, produced a display of 45,000 lights that a journal of the time described as creating "a veritable fairy city . . . a fairy scene, fleeting and unreal as the shadows of a dream." This may seem distant from the digital sublime, but the similarity to William Gibson's first description of

cyberspace as a "consensual hallucination" is striking. Enormous planning went into many of the fairs and exhibitions, with great attention to making the most out of the rhetorical and didactic potential of the new illumination. Consider this proclamation by an observer of the Buffalo Pan-American Exposition: "As the sculpture symbolizes the progress of the race, the coloring represents in epitome the growth of the color sense. Thus the strongest, crudest colors are nearest the entrances. In the coloring of the buildings there is a progression from warm buff and ocher walls . . . through more refined and brilliant hues to . . . ivory white, delicate blue, greens, and gold." (Nye 1990: 36)

Writers turned to the language of myth. For example: "The shadows of the past are materialized and . . . the castles of Spain, the romance of Arabia realized. It is electricity that whirls the chariot wheels—the thunderbolts are harnessed at last." (ibid.) One writer was moved to compare the sight favorably with Athens at its peak of classical power: "In a moonless night Athens hid her beauties. . . . Not so, however, with this modern Athens, for night is the time of her greatest splendor. Thousands upon thousands of incandescent bulbs trace in delicate threads of light the outlines of the facades. . . . Blinding searchlights seem to make iridescent living things of cold, dead statues. The lagoon becomes a sea of dancing lights, edged by a ribbon of dazzling brightness. It is a fairyland, an enchanted place." (Marvin 1988: 172) Writers drew not only from classical imagery and mythology but also from the Bible as they groped to find adequate words to express the transcendent spectacle of this major leap to overcome the seemingly inevitable blackness of night as in this descriptive account: "And now, like great white suns in this firmament of yellow stars, the search lights pierced the gloom with polished lances, and made silver paths as bright and straight as Jacob's ladder. . . . The white stream flowed toward heaven until it seemed the holy light from the rapt gaze of a saint, or Faith's white, pointing finger!" (ibid.: 172–173)

But these were not just technological reminders of a mythic past. Electricity pointed to a new way. New York's Herald Square, Madison Square, and Times Square served as models for the new way of life that electricity would bring about, literally abolishing darkness and opening the city to continuous daylight. In fact, one of the reasons for drawing on the language of myth was the belief that electricity was so revolu-

tionary that it could only be understood as a challenge to the gods. In an address to one of the many Electrical Clubs that sprung up, one would-be poet reported on how the god Jove reacted when he learned that mortals learned the magic art of electricity. Assembling his fellow immortals, Jove warns that their days may be numbered:

Fame would wrest from us our mighty powers,
And make the elements their servants like to ours,
And seek to give the widest of publicity
To all the hidden powers of electricity. (ibid.: 54)

According to Marvin, scientists and electricians bought into the mythic and magical nature of electricity with uncharacteristic enthusiasm. In 1887, a representative of the Edison Company ended a lecture in Boston with a séance. According to one account, "bells rung, drums beat, noises natural and unnatural were heard, a cabinet revolved and flashed fire, and a row of departed skulls came into view, and varied colored lights flashed from their eyes" (ibid.: 57).

Although many observers turned to the language of magic to account for the practically inexplicable and overwhelming powers of electricity, most viewed the new wonder as good magic. Indeed, electricity became the white magic of science, helping to win the battle against both the darkness of night and the evil darkness of black magic. Electricity represented a new force but a largely beneficent one, at least for those positioned properly on the wave of change that electricity was sweeping over the world. Some might have feared what one observer exclaimed on looking at the newly illuminated Niagara Falls: "strange . . . so like some unearthly and unexplained magic" (Nye 1990: 58). Others worried whether the accelerating demands made on the great natural sources of electricity, diverting water from Niagara and its lesser sources, would "cause the falls to run dry" (Houston 1905: 16). These and other fears that electricity might actually create a new darkness occupied the attention of some. But most people saw only the bright light. This was especially the case for white North Americans and Europeans for whom electricity acutely embodied their superiority, as evidenced in the "ethnological" villages which the great fairs would arrange in ascending order from the most "primitive" African, Latin American, and Asian villages to the most "modern" illuminated cities of the West. "Electrification," Nye concludes (1990: 36), "thus became embedded in a social Darwinist ideology of

racial superiority. Only the most advanced societies had electrified machines and lighting. Darkness was a metaphor for the primitive; light was the exemplification of Christianity, science, and progress." But, true to the egalitarian ethos accompanying this and other new technologies, observers almost universally agreed that the white light would eventually spread and illuminate the entire world in progress.

From 1900 to 1920, cities across the United States and in Canada lit up their downtowns to create versions of the Great White Way, almost always at public expense, thereby demonstrating the new technology's transformative power.[1] "The inauguration of each new White Way became a community event with speeches, a parade, and extensive newspaper coverage. Lighting specialists and important citizens of nearby communities often then decided to emulate or surpass it." (Nye 1990: 57) In this way, communities across the continent participated in a spectacle of progress with the lights of downtown its magical marker. Practically overnight, electricity reclaimed buildings and streets from the drab banality of daily life, blessing them not only with a new light but with a new life as well.

Although on balance the mythical power of electricity was beneficent, the magic was not always white. Numerous cases of strange and awesome powers connected to the force filled the pages of local newspapers and magazines at the turn of the century. Typical was the tale of Willie Brough, an eleven-year-old California boy whose body was so "overcharged with electricity" that he was able to set objects on fire with his intense stare (Marvin 1988: 133). Stories like this one inspired carnivals to feature acts like the "Traveling Electrical Boy," whose powers included the ability to literally shock customers, with the help of a conducting zinc strip concealed beneath carpeting.

The mythic computer whiz, typically a young boy who "rules" in cyberspace, had his predecessors in the heyday of electrification. Adults were increasingly goaded into learning more about this wonder of the age from such books as Edwin Houston's *Electricity in Every-day Life*: "It is no longer a matter of choice whether or not one shall become acquainted with the general facts and principles of electric science. Such an acquaintance has become a matter of necessity. So intimately does electricity enter into our everyday life that to know nothing of its peculiar properties or applications is, to say the least, to be severely handi-

capped in the struggle for existence." (Houston 1905: 1) Houston's book is a guided tour of how the world has come to be transformed with electricity. He takes us through a day in the lives of a lawyer, a physician, a bricklayer, a mechanic, a naval officer on a warship, and finally a farm boy in the American midwest, demonstrating that whatever the profession, however stamped with a specific historical mold, electricity has transformed it fundamentally. Some of these descriptions carry an unintended irony. The description of electricity in a steel plant is pictured in the before and after fashion with a pre-electrified room packed with many men filling an open-hearth furnace with the materials to be melted and the "after" photo with but one worker (ibid.: opp. 514). Perhaps even more powerful is the photo of a newspaper's composing room organized around Mergenthaler typesetting or linotype machines run by electric motors. Now, at the beginning of the twenty-first century, the composing room and its workers are gone; editors have taken over the job of laying out the pages on computer screens. But the linotype photo in Houston's 1905 book also resembles the present with its rows of workers sitting in front of what look remarkably like contemporary computer keyboards (ibid.: opp. 490).

As the telegraph and electricity demonstrate, the new world of cyberspace is not the first to be christened with magical powers to transcend the present and institute a new order. But early technologies also demonstrate that transcendence is not easy to sustain. Just as the telegraph faded into the woodwork of routine commerce, electricity lost its allure: "Electrical novelties faded quickly and became 'natural.' In 1880 one arc light in a store window drew a crowd; in 1885 a lighted mansion still impressed the multitude; in the 1890s came the first electric signs. Each in turn became normal and hardly worth a glance." (Nye 1990: 57)

The routinization of electricity's mythic and magical power did nothing to diminish its physical might. Electricity would become a central force in global power networks involving almost all technologies but particularly the communication media that marked much of the twentieth century. However, few people, particularly in the developed world, continue to treat it as a sublime force inspiring reverence and spectacle. The allure of electricity, like that of the telegraph, moved on to newer technologies. Its magic remained only in those places yet to receive it. At a church meeting in the 1940s, a poor Tennessee farmer announced: "The greatest thing on

earth is to have the love of God in your heart, and the next greatest is to have electricity in your home." (Samuelson 2000)

The Telephone

If the telegraph's lightning wires made it the Victorian Internet, then the telephone's pairs of twisted copper made it the Internet of the Gilded Age and the Roaring Twenties. Early promotion of the telephone described the characteristics of "a new social order" that the device would bring. It would be both a "business savior" by permitting distant shopping and a liberator of "women slaves," since telephone shopping would lighten the load of homemakers. It would guard against "nervous strain," provide "safety for your family," reduce "household fatigue," and make writing an anachronism. In short, it was the device that could "save the Nation," and so the decision to lease a telephone was considered more than a voluntary consumer choice but "a moral obligation for a considerate husband and a good citizen" (Martin 1991: 37). According to Marvin (1988: 209), "perhaps more than any other communications invention, contemporaries considered the telephone the bellwether of a new age." Marvin cites *Electrical World*'s enthusiasm for the telephone as "the voice crying in the wilderness, announcing the speedy coming of electrical illumination, power transmission, transit, and metal working" (ibid.).

The telephone could, conceivably, transmit a single voice to be heard at the time it was spoken at any point on the face of the earth. It could send multiple voices over vast distances, giving any citizen of the world the opportunity to hear the greatest orchestras, orators, or educators. Just as the great worlds fairs and exhibitions lit up the night with illuminated electricity, they also provided powerful evidence of the telephone's magic. One such example was the Paris Exposition of 1881, which for 6 months provided patient lines of listeners with the opportunity to hear live opera performances transmitted through microphones over telephone lines. By the 1890s it was not unusual for wealthier subscribers to enjoy a direct line to their favorite symphony hall or theater.[2] But it did not take long for "nickel-in-the-slot" versions to bring popular entertainment to the less affluent and provide timely news accounts via the "telephonic newspaper" (Marvin 1988: 210; Martin 1991: 138).[3] In addition, the telephone would eliminate the need for obtrusive and

expensive status symbols like fancy clothing or formal rituals of meeting and address because the speaker or speakers could give voice from any location. This would lead to an acceleration of democracy in politics and social life since we are all equals on the telephone. While some worried that this would provide opportunities for the wrong people to become too familiar, others welcomed the likely breakdown in class and family boundaries. In either case there was little question that unbridled use of the telephone would end life as we have known it. A 1909 advertisement placed near pay phones called the Bell System "The Sign Board of Civilization" (Fischer 1992: 243).

The telephone became one of the central icons of modernity, the medium that marked the turn of the twentieth century, just as the computer is arguably the technology most closely associated with the arrival of the twenty-first. But it is again important to note how quickly it is that icons fade into the woodwork, or, for that matter, the desktop. Fisher documents this for the telephone in interviews with generations of early users. The older of the interviewees, people who began to see phones in use in the 1890s, "described the telephone in tones suggesting awe" demonstrably moved by the act of hearing a distant voice and responding to it immediately. But this did not last for long, as those who took up the phone after the turn of the century attest. Statements like "Seems like we always had a telephone" and "Telephones were no big deal. It wasn't like you never saw a telephone" are common among those born just a few years later. For Americans, the awe and aura of the telephone disappeared after 1910 (Fischer 1992: 243). But it would reappear a short time later with the arrival of radio.

Radio

It now seems odd to associate radio with myth, magic, and transcendence. After all, radios are the most ubiquitous consumer electronics product in the homes of people throughout the developed world. Americans alone bought 58 million radios in 1998, and most homes have at least eight. With the average 1999 price of a radio around $17, eyebrows were raised when one company launched a national advertising campaign hoping to sell a clock radio for more than $350 by appealing to what now sounds like a rather banal promise to deliver "the world's

best-sounding radio" (Brinkley 1999b). In 2002, a few buyers were drawn to pay that much for a radio plus a $10 a month subscription charge to receive a package of satellite-delivered digital radio channels. Even so, when was the last time we heard a political speech that lauded the wonders of our Radio Age? Hard as it may be for us to imagine, just 10 years after the hoopla about the telephone dissipated, it reappeared in the 1920s, now associated with a sound so full of static that it was variously described as the "hiss of frying bacon" and the "wail of a cat in purgatory" (Koppes 1969: 363). But amid the cacophony one could discern voices and music delivered magically through the air without wires and, in the darkness of night, over vast distances, giving people the impression that something divine was at work. In an article titled "This magic called radio," Bruce Barton described radio as such an improvement on the once-magical telegraph that the latter's first message— "What hath God wrought?"—should be modified at the start of every radio program with the message "What is God working?" and "What will God work?" (ibid.: 365)

The magic of messages transmitted through the air with no evidence of their passage was more than just the work of God, it was the medium of God's work. In 1922, Secretary of Commerce Herbert Hoover, a phlegmatic man ordinarily not prone to hyperbole, remarked on the wonder of "wireless fever" and said that radio had to be "one of the most astounding things [in] American life" (Douglas 1987: 303). The president of the Radio Corporation of America, General James G. Harbord, captured the history-making and history-ending power of radio with an analogy to the invention of printing that sounds more like a prayer than an observation: "Radio broadcasting, I devoutly believe, is the greatest force yet developed by man in his march down the slopes of time. Since Gutenberg devised his crude wooden type and made printing possible, nearly five centuries ago, there has been no single invention which so closely touches human interest and human welfare as this miracle of the ages." (Koppes 1969: 365)

Many of the same promises made about the telegraph, electricity, and the telephone were applied to this latest "miracle of the ages." Like the others, it would serve as a potent force for social cohesion and world peace. One can understand that the president of the General Electric Company would see radio "as a means for general and perpetual peace on earth." After all, General Electric owned the Radio Corporation of

America (RCA) and had a huge stake in the development of broadcasting. One can also understand that Marconi, widely described as the "father of wireless," would see radio as "the only force to which we can look with any degree of hope for the ultimate establishment of permanent world peace." But even some disinterested individuals expressed utopian visions. The Episcopal bishop of Washington, D.C. said: "I believe the radio will be a potent factor in making the twentieth century the age of the brotherhood of man. More and more I have come to feel that this growing feeling of brotherhood may result from the intimacy and fellowship created through the medium of the air." (ibid.: 365) Comments like this fed a "radio boom" in the early 1920s and led writers of the time to find nothing in history to compare. One commentator put it as follows: "In all the history of inventing, nothing has approached the rise of radio from obscurity to power." (Douglas 1987: xv) Those searching for historical precedents reached back to ancient Greece and Rome: "Perhaps oratory may flourish again as it did in the days of Greece and Rome. What a success Demosthenes would have been in these days of broadcasting!" (Koppes 1969: 366)

Other observers felt that radio would effect an epochal transformation in political life by making direct democracy possible. In arguments that are strikingly like those we hear today about cyberspace, it was suggested that radio would allow the listening audience direct contact with those in power. In *The New Republic*, it was said that radio "has found a way to dispense with political middlemen. In a fashion, it has restored the demos upon which republican government is founded. No one will capture the radio vote unless he faces the microphones squarely and speaks his mind fully, candidly, and in extenso." (ibid.: 366) Radio would also strengthen the quality of political oratory. "There is no doubt whatever," one commentator asserted, "that radio broadcasting will tend to improve the quality of speeches delivered at the average political meeting. Personality will count for nothing as far as the radio audience is concerned. Ill-built sentences expressing weak ideas cannot succeed without the aid of forensic gesticulation. The flowery nonsense and wild rhetorical excursions of the soap box spellbinder are probably a thing of the past if a microphone is being used." (Lappin 1995: 218)

Many of the arguments of today's proponents of "virtual education" in cyberspace were foreshadowed in radio's early years. In the early

1920s, the first radio courses prompted the magazine *Radio Broadcast* to forecast "the advent of the 'University of the Air'" (Koppes 1969: 366). "The lid of the classroom has been blown off," one enthusiast declared, "and the walls have been set on the circumference of the globe." (ibid.: 367) "Every home," another suggested, "has the potentiality of becoming an extension of Carnegie Hall or Harvard University." (ibid.) Drawing on the American tradition of mass education, supporters of the new medium envisioned a national system of radio study for all, including older people (who will "feel no embarrassment by reason of advanced years") and the young (who will find in radio the freedom to learn at their own pace so that they will "be in no danger of chafing at rules and restrictions") (ibid.: 367). In 1936, the Chairman of the Federal Communication Commission exclaimed: "Radio, properly used, can become an even greater instrument of instruction[4] than the printing press." (Marsh 1937: 18)

In short, radio was destined to become "an autonomous force, capable of revolutionizing American culture" (Douglas 1987: xv). It would end history as we knew it. "It was a machine that would make history. It was also portrayed as a technology without a history. . . . Radio was thus presented as an invention not burdened by a past or shackled to the constraining conventions of the established social order, but as an invention free to reshape, on its own terms, the patterns of American life." (ibid.)

America's young people were considered crucial to this transformation. Today's computer visionaries tell us that one of the major divisions in cyberspace is between young people, who are drawn to computers and adept at using them, and older people, who struggle to adapt and keep up (Tapscott 1998). Notwithstanding their claims to the uniqueness of this particular divide (Tapscott considers the cyberspace generational divide a historical first), back in the first two decades of the twentieth century young people (especially young boys) were portrayed as the group that genuinely understood the technology and its future. One writer describes them as "a community spearheaded by thousands of precocious young Americans" and an "iconoclastic virtual community within the static-plagued nether world of the broadcast ether" (Lappin 1995: 177). These were the Radio Boys, heirs to the tall tales told about the Electrical Boys. Examples include Bob and Joe, the heroes of the novel *The Radio Boys with the Iceberg Patrol,* who use the new tech-

nology to rescue orphans, round up convicts, and save ships at sea (Douglas 1986: 46). Fictional accounts like this one, along with magazine stories and advertisements, beat the drums for the new technology by encouraging a new generation to invest their childhood dreams in this new miracle of the age. And, as Douglas demonstrates, they were rewarded with a legion of followers—boys who took up the hobby of amateur radio, building receivers, improving their equipment, expanding their signal networks, and, in the process, constructing a primitive national and indeed international system of radio communication. An article in the magazine *Wireless Man* put it as follows: "An audience of a hundred thousand boys all over the United States may be addressed almost every evening. Beyond doubt this is the largest audience in the world. No football or baseball crowd, no convention or conference, compares with it in size, nor gives closer attention to the business at hand. . . . This was an active, committed and participatory audience."[5] (Douglas 1986: 49)

Concerned parents, it was said, had no reason to fear radio. In addition to the technical training that might produce the next Edison, "the new art does much toward keeping the boys at home, where other diversions usually, sooner or later, lead him to questionable resorts. . . . Well-informed parents are only too willing to allow their sons to become interested in wireless." (ibid.: 47)

Radio was for the young, and almost exclusively for young men. Indeed, the only major difference between the radio boys and their counterparts today is that radio was considered practically a universal good, with few if any demons lying in wait for unsuspecting children. Today, cyberspace stalkers, as well as pornographic and violent images, lure young people, and authorities struggle to find solutions that will preserve free speech. Radio was pure, indeed pure magic.

But it would not be long before the forces of banality would undermine the magic. Douglas sees bad omens by the end of second decade of the twentieth century as first the military and then large corporate interests began to recognize the value of the new medium and lobbied to push off the air the young amateurs, educators, and others who envisioned a utopian future for and with radio. For Koppes (1969: 368), the visions expanded into the late 1920s, when "it became apparent that the story would not have the happy ending that had been predicted." The arrival

of advertising and big business, with its interest in transforming the high-minded University of the Air into nothing more than Vaudeville on the Air, led serious writers of the late 1920s to question whether radio would succeed. In 1927 *The New Republic,* which had predicted that radio would create a new democratic age, complained: "It turns to propaganda as easily as the aeroplane turns to bombing; it sows its seeds with a wider throw." (ibid.: 369) By 1930, *The New Republic* could only conclude that "broadly speaking, the radio in America is going to waste" (ibid.: 374). Lee de Forest, one of radio's founding inventors, concluded that radio was no longer able to scale the mythic heights; it was now just "a stench in the nostrils of the gods of the ionosphere" (Barnouw 1968: 234). Once very optimistic about the technology he had helped to create, de Forest complained bitterly in a letter to the 1946 meeting of the National Association of Broadcasters: "What have you done with my child? You have sent him out in the streets in rags of ragtime, tatters of jive and boogie woogie, to collect money from all and sundry for hubba hubba and audio jitterbug. You have made of him a laughing stock to intelligence . . . you have cut time into tiny segments called spots (more rightly stains) wherewith the occasional fine program is periodically smeared with impudent insistence to buy and try." (ibid.)

Television

As radio joined other communication technologies that promised but failed to end history, geography, and politics, television captured the popular imagination and attracted the hyperbole that earlier technologies had lost. It is probably best to view television's promise in two stages, because the hope for the medium was repeated in two forms. In essence, television's initial encounter with "end-of-everything" promises came with broadcast television, which spread widely, beginning in the early 1950s. Its second "revolution" arrived with cable television, which in the late 1960s and the early 1970s inspired dreams of a "wired nation."[6] The first period of television's promise viewed the medium in terms familiar to anyone who heard about how radio would realize democracy, world peace, social harmony, and the transformation of mass education. At the 1939 New York World's Fair, David Sarnoff,[7] the founder of RCA, boasted that television would provide "a torch of

hope in a troubled world" (Kisselhof 1995: 51). It would do so by guaranteeing "a finer and broader understanding among all the peoples of the world" (Fisher and Fisher 1996: 350). Few people's expectations rose higher (or ultimately sunk deeper) than those again of Lee de Forest, inventor of the audion, a type of vacuum tube that was essential for the development of radio and later television broadcasting. In 1928, voicing what one author calls "the expectations of the nation," de Forest expounded on the medium of television, which he was helping to create: "What thrilling lectures on solar physics will such pictures permit! . . . What could be a more fitting theme for a weekly half-hour of television than a quiet parade through some famous art gallery, pausing a moment before each masterpiece while the gifted commentator dwells briefly upon its characteristics, explains its meaning, recounts the story of its creation, its creator? . . . Can we imagine a more potent means for teaching the public the art of careful driving safety upon our highways than a weekly talk by some earnest policy traffic officer, illustrated with diagrams and photographs?" (Fisher and Fisher 1996: 91)

Television was the new tool for transforming the educational system. Commentators often drew analogies to the land-grant colleges that were created after the Civil War. These great experiments in public higher education would be matched and overtaken as educational television filled the airwaves. Others predicted that the problems of basic education, from teacher shortages to reaching the poor, would be solved through the new medium. Indeed television's "pre-eminent function," as William Crawford Eddy put it (1945: 285), "will be to introduce into the educational process those visual methods and techniques which will make education more entertaining and appealing to the pupils of the world." A similar, but less cautious, vision is offered by Lee de Forest, who, not appearing to have been chastened one bit by the banality of radio, imagined a day when "from a central studio competent lecturers, authorities in their special subjects, may reach simultaneously large school audiences, giving visual demonstrations of experiments in physics, chemistry, mechanics" (de Forest 1942: 347). The president of Colgate University went as far as to suggest that television will question the necessity of formal universities with their brick and mortar classrooms. Indeed, television will likely make "the attendance of classes in any one place . . . as obsolete as the buggy of twenty-five years ago" (Dunlap 1932: 261).

There is little doubt that television, "the hero of the hour," would introduce "radical changes" that would "speed the tempo of a slow-pulsing industrial world" (ibid.: 260). In addition to a transformation in education, television offered a war-torn world a way out of the century's seemingly unlimited violence. For Orrin Dunlap, the medium held out nothing short of "magic possibilities" to influence world affairs, making it likely "to bring with it a new era in international relations" (Dunlap 1932: 224). Much of this would result from the ability of the medium to present "images of statesmen and their friendly gestures" as they carry on world affairs. As a result, "television will usher in a new era of friendly intercourse between the nations of the earth" (ibid.: 229). Military leaders weighed in to agree. According to Major General James G. Harbord (who also happened to be the Chairman of the Board of RCA), images of war will certainly fill the airwaves. But "when such imaginings flit through our minds, it is pleasant to think that television in times of peace will take its place beside sound broadcasting as an influence toward international understanding and goodwill, and toward making war less likely" (ibid.: 264). In his book *Television: The Revolution*, Robert Lee tosses aside the images of war that filled the press in 1944 and conjures a new world for television: "Telecasting will make provincialism almost impossible. We're going to find a much greater awareness on a worldwide scale, thanks to sight broadcasting. Sound radio started this tendency. Sight radio will accelerate it to the 'nth' power." (Lee 1944: 221)

The new medium was predicted to be so potent that writers began to speak of a "pre-television" era and admonished those who were foolish enough to cling to the "habits of thinking" that characterized this time as "trapped in another anachronism" (ibid.: 221). The television era would be one of idealism. Why? According to Lee, "it is our most effective means for brewing thoughts in men's minds." Hedging his bets a bit ("if the people of television hang on to their principles") we will maintain a commitment to postwar internationalism, prevent "reactionary backsliding" into a pre-television negativism, and generally "keep idealism in style" (ibid.: 224). Following a popular, if downright mythic, thesis that the more communication, the better, Lee concludes that television can make us "better citizens" not only of our own nations but of the world. How? First, the idea of "things foreign will vanish." This is

because "you can't consider a man a foreigner who has sat down to chat with you as a guest in your own living room—albeit electronically. The barriers dissolve." Moreover, television will make us wise judges of the world because "from the fluorescent screens of our video receivers we will glean the knowledge to judge wisely." It will probe every social injustice so that "every twenty-four hours, the telescreen can provide rigorous calisthenics for sickly social consciences" (ibid.: 225).

Television held out a promise not experienced since the arrival of the electric light and the automobile. All three are mythologized in an early work on television which declares that the new medium "is bound to have a marked effect on home life, on education, business enterprises, religion, literature and to play a diversity of roles in art, science and entertainment. It will cast a spell over theaters. . . . The advent of the television era can be compared in importance with the arrival of the electric light that dimmed the glory of candle and kerosene lamp; with the arrival of the automobile that relieved the horse, sped up travel and introduced good roads that linked the former with the city." (Dunlap 1932: 224) Dunlap's reliance on the language of myth and magic leads us to wonder whether we are witnessing the birth of a scientific invention, the product of a rational, inquisitive mind, or the spirit of the conjurer's art, the white light from the dark ritual. Television "is the magic that transforms pictures of people and places from light into electricity, from electricity that flows on a wire to radio that spreads through the air. But in the twinkling of an eye the ethereal phantoms are all changed into a festival of light as if touched by some master showman's wand that reaches stealthily down from the sky." (ibid.: 251) In short, television is "the wizardry of the age"[8] (ibid.: 258).

Even religious leaders saw great spiritual potential in the new medium. According to the Right Reverend James E. Freeman, Bishop of Washington, "Anything and everything that can render religion more articulate must give freshened demonstration of the value of that which the Church stands for. Radio and television must quicken the appetites of men for things spiritual." (ibid.: 263) As in the days of the Radio Boys, television would offer special opportunities for the young. Arguably the earliest such paean showed up in an advertisement for the *Land and Peoples Encyclopaedia* that predicted that television would put children on a magic carpet that would "enable them to 'see by wireless' any part of the

world" (Smith and Paterson 1998: 40). Indeed, Dunlap (1932.: 226) views television as "a promised land for youth endowed with a scientific mind or a talent in research and showmanship." For Robert Lee (1944: 225), television will provide our children with an "electronic Baedecker": "To our children no way of life, however distant from our own, will seem absurd or unfriendly. Television will encourage more sympathetic and generous understanding among people of all nations." It would also enrich the political process because "it cannot but stir the nation to a lively interest in those who are directing its policies." Even more specifically, it will stimulate "more intelligent, more concerted action from an electorate." Why? Because "the people will think more for themselves and less simply at the direction of local members of the political machines" (Dunlap 1932: 264).

World War II did little to deter Dunlap from continuing to predict great things for television. In 1942, as the Nazis swept across Europe, he published *The Future of Television,* which welcomed the medium as an instrument that would protect us from ourselves. Never choosing to make a connection between communication media and the destructive events of the twentieth century, Dunlap (1942: 179) sees radio as the force that, in the wake of World War I, began "to rip down old barriers and bring the peoples of the earth within earshot as never before." When war came again, American radio beamed "the 'Voice of Freedom'" that "called to oppressed people everywhere to keep up their courage and preserve their faith" (ibid.). But radio merely laid the groundwork for television. "Now, out of the second global conflict, science promises a new mechanism—television—to help spread the realization of a great vision, the maintenance of peace and freedom for all. Television is no instrument of imperialism. It belongs to the people as does radio. It comes at a time in history when the world needs to have an eye kept upon it for the welfare of civilization." (ibid.) For Lee (1944: 230), television will transform the world with "freedom: from the social diseases and maladjustments which wrack us. Freedom to escape the reality which is a lie to achieve the ideal which is truth. And the realization—in concrete terms—in every nation on the planet—of the Four Freedoms defined by the leaders of the democracies." Early television was viewed simply as a "miraculous new resource"[9] (Barnouw 1990: 142–143).

The enthusiasm only grew with the promise of cable television. In fact, there was arguably much more of a sense that cable TV would bring an epochal transformation in communication than was the case with broadcast TV. Television held out great promise, but it was hard to argue with those who saw it as largely a video extension of radio. But cable television was something completely different because it had the potential to link every home and workplace in a fully connected system. It is no wonder that one of the period's more popular books on the subject was titled *The Wired Nation—Cable TV: The Electronic Communication Highway* (Smith 1972).[10] In fact, almost everything that is now ballyhooed about the Internet was said about cable television. The "information highway" analogy was well worked in discussions of cable. As they do today, people differed about how to build it, but there was no mistaking the need to do so. Smith (1972: 83) put it in language that will be familiar to even the casual Internet user: "In the 1960s, the nation provided large federal subsidies for a new interstate highway system to facilitate and modernize the flow of automotive traffic in the United States. In the 1970s it should make a similar national commitment for an electronic highway system, to facilitate the exchange of information and ideas."

Smith's account is one of the more sober analyses of the new medium because it recognizes the problems that such a revolutionary medium might pose for established entrenched powers who would make it likely that "short term commercial considerations will dictate the form of the network" (ibid.). Nevertheless, in all the talk of rules and regulations there are familiar echoes of earlier technological promise. Once again, education is prominent. For example, to make the case for the public-service potential of cable television, Smith turns to the example of an early system located in Henderson, North Carolina, a town kept from receiving broadcast television by its mountainous terrain. Henderson turned to Cablevision, a private company, to put together the town's service, including hiring a program director and a young assistant from the local high school "with an interest in radio, as a control room trainee." In another example that evokes the accounts of amateur "Radio Boys" of the 1920s and the young cyber-wizards of today, Smith tells us that the young assistant "learned everything in three days," and that this prompted the hiring of five more students who "learned with equal speed." The story continues with buoyant accounts of how these

students and the community came together to produce meaningful local programming supported by local advertising. Further along, we learn that in Wayne, New Jersey, William Paterson College is planning to broaden its mandate by broadcasting courses from a college studio and by producing refresher courses for doctors, and that in Overland Park, Kansas, a two-way cable system permits disabled and homebound children to learn and to communicate with teachers, who can now handle more children because their travel time has been eliminated.

For Smith (1972: 11–16), "such applications are only a bare beginning of the cable's potential." Additional examples give new hope for community television in low-income areas, for direct contact with candidates for electoral office, and for a transformation in the quantity and quality of citizen communication with government officials. Smith tries to be careful about the hyperbole and worries about entrenched interests— particularly the broadcasting lobby and cable companies, which he feels are mainly concerned with using the new technology to expand commercial coverage. But a similar utopian, if not mythic, quality fills his account. The telephone and radio might not have brought about a new experience of time, space, and politics. But surely, cable television would be another matter.

For an even more mythic account, one can turn to a 1969 document endorsed by R. L. Smith and produced by the Electronics Industry Association. The EIA saw cable TV as leading a revolution that would transform society[11] and used the report to pressure the Federal Communications Commission to act immediately. The EIA called for the development of a national cable system that, at the start, would provide electronic delivery of mail, access from the home to the world's libraries, comprehensive video surveillance to curtail crime ("Within a community, streets and stores can be kept under surveillance from a central source"), and electronic shopping and banking. These are familiar themes in forecasts about the Internet.[12] Some of the specific promises do change, although the expectation of declining crime rates seems to accompany every new communication technology. Cable television gave these promises the specific inflection of the time, including the fear that America's urban ghettoes would continue to explode into violence. This helps to explain why Smith proposed a cable system to help the riot-torn Watts section of Los Angeles to strengthen its sense of community. It also helps

to explain why the Sloan Foundation, one of the leading think tanks on public policy issues at that time, highlighted a similar potential in its 1971 report on cable TV ("the television of abundance"). The report describes a set of cable services that would also improve community life for the Bedford-Stuyvesant section of Brooklyn, another ghetto neighborhood ravaged by violent upheavals. Among the community cable television services that the Sloan Foundation's report proposes to help this devastated area revitalize are the following:

Job-a-Rama: job opportunities, instruction in job interview techniques and preparations of application, other employment services
Children's Playhouse: a light educational background for pre-school children
Area Center Parade: explanation, documentation and advertisement of community center activities, transmission of special programs instituted by the various community centers
Street Scene: a roving-reporter presentation of "what's going on in the community," as a means of building community identity
Kings County Hospital: to create wider attention to endemic health problems and to assist in methods for their eradication
Brooklyn College Journal: to provide training, on the cable, in all phases of broadcasting from administration to production
The Drug Scene: documentaries pointing out the dangers of addiction and roads to rehabilitation.

Another proposed program would deal with "The Black Man." There would be a "Gospel Hour," English instruction for Spanish-speaking viewers, and art lessons from the nearby Pratt Institute (Sloan 1971: 100–102). These suggestions and others offered in the Sloan Foundation's general report are notable for their similarity to projects advanced in connection with earlier communication technologies. All see the potential to build community, advance education, ameliorate crime, and improve health. Yes, they bear the mark of the times. Bedford-Stuyvesant erupted in violence, and so it and other ghetto hot spots became the focus of attention for many of cable television's advocates. And they vary in the degree to which they are also serving a selfish interest. The Electronics Industry Association was certainly not without a major stake in the debate over building a national cable television system. But they contain the same interest, consistently demonstrated in the experience of earlier technologies, to use the media for social transformation and social betterment. Notwithstanding the caveats that occasionally qualify this position, they retain the same powerful and profound faith in the myth

that technology can accelerate positive social change, and an equally profound historical amnesia with regard to promises made about earlier technologies.[13]

This is not to suggest that all analysts were committed to this faith. Some books and some articles raised genuine fears that cable television would go the way of earlier technologies. For example, Price and Wicklein's *Cable Television: A Guide for Citizen Action* (1972), which generally advances the cause of citizen action to make cable television an instrument of community development, is not especially hopeful about the prospects: "Unfortunately, experience with public access cannot help but arouse pessimism about the prospects for access on cable. Bona fide efforts of over-the-air television to provide outlets for community expression have often had negative results. There have been countless hours during which UHF stations, in particular, have made time available to community groups, but no one has come forward to use it." (ibid.: 35) Putting it more succinctly, one television critic concluded that forty-channel television (then the rough limit on cable channels) "could be forty times as bad as television is now" (Maddox 1972: 158). But these voices were certainly in the minority. Moreover, even when critical, their attacks were directed at the view that the transformation would begin if only everyone were to plug in the cable. Almost everyone acknowledged the general promise of the medium. People differed in their opinions as to the extent of the changes that would make it work for social progress, but it was generally agreed that cable television, like the telegraph, electrification, radio, and broadcast television, would accomplish miracles. The mythic promise of cyberspace is many things, but it is certainly not new. Nor is the historical amnesia that led many people to believe so fervently in a digital sublime that they created one of the greatest stock-market booms in American history. In January 2000 few believed that they would so soon see the end of this story.

6

From Ground Zero to Cyberspace and Back Again

For almost a year and a half after the April 2000 Nasdaq crash, there would be a marked reluctance to accept that the long boom had come to an end. . . . Even in the early summer of 2001, when economic growth had practically ceased, consumer spending would increase at a healthy clip. It wasn't until the terrorist attacks of September 11 2001, that Americans would finally acknowledge that the 1990s were truly over, and that a darker, more uncertain future had dawned. (Cassidy 2002: 296)

The buoyant optimism and triumphalism that pervaded much of the United States at the turn of the millennium, accentuated by the union of AOL and Time Warner in January 2000 and the continued climb of the stock markets, was shattered in March of that year, when the stock market and the dotcom industry collapsed. Whatever was left of "new economy" fever ended in September of 2001 with the attacks on the World Trade Center and the beginning of the war on terrorism. History, geography, and politics returned with a vengeance.

I began this book with a myth of Thor, who, painfully for Sven, encouraged us to see vigilantly with both eyes. I followed Thor's advice by telling the story of cyberspace through the cultural lens of myth and, to a lesser degree, with an eye on political economy. The main purpose was to take a cultural perspective by explaining the nature of myth, describing its value for understanding cyberspace and connecting myths of cyberspace to wider myths about the end of history, the end of geography, and the end of politics. It also provided some historical context for cyberspace myths by examining similar myths about the telegraph, electricity, the telephone, and broadcasting. We are not alone in conjuring and acting on myths that celebrate various forms of the sublime. As Baudrillard (1994) reminds us, the end happens over and over again and

we continue to recycle these endings today. It is very much a living end. Alongside the starting point of myth, political economy provided a sub-text to deepen and extend the cultural analysis. It was called on to address the relationship between myth and power by specifically describing some of the mechanisms by which myths are established, are sustained and grow. In subsequent chapters, the book returned to political economy to address how some benefit from advancing calls for the end of history, the end of geography, and the end of politics. For example, the end of politics is a powerful myth that is sustained by the widespread desire to overcome hierarchy, the bureaucratic state, and the endemic insecurities of a world constantly threatened by local, regional and global military aggression. It is not hard to understand why people would believe, contrary to all the empirical evidence, that the United States does not just need a foolproof defense against nuclear weapons, it already has one. The myth is alive because it embodies values of electronic democracy and electronic security that meet deeply felt needs today. But there is more to the myth than this. The end of politics also underlies a neo-liberal philosophy, embodied, as was described, in the call to deregulate and privatize the world's telecommunications systems. Myths are self-sustaining but embody, or mutually constitute, political economic interests as well.

This chapter takes up some of the same themes but does so a bit differently. It starts, as do other chapters, by identifying a general and broadly influential myth of cyberspace, post-industrialism, generally the shift from a goods producing to a service economy; from a modestly to a highly educated, indeed, technologically skilled workforce; and from a society led by elites in finance capital to a more egalitarian society led by knowledge workers. But, it moves from the general myth to its material embodiment in a concrete local setting—New York, particularly lower Manhattan, and, even more specifically, the World Trade Center, arguably the first physical manifestation of the post-industrial ideal. In this respect, the chapter follows one of the central contributions of cultural studies, one which directly responds to the "grand narratives" of political economy and other overarching perspectives, i.e. the need to ground research in the local or what Raymond Williams called "militant particularism." Cultural studies has given special attention to the historical sources and contemporary manifestations of concepts, ideas, and myths in specific

local settings. These are not only local but often decidedly subjective accounts that aim to describe what a concrete set of experiences means for a specific group of people. Indeed cultural studies has taken the phrase "location, location, location" out of the lexicon of real estate brokers and put it directly at the center of cultural analysis. Following this guidance, this chapter starts with the birth and development of one of the mainstays of cyberspace mythology, post-industrialism, in the specific location of lower Manhattan and in what is now known as Ground Zero.

In addition to this local turn, the chapter places more attention on political economy. Indeed, if the first five chapters built a bridge from culture to political economy, then this chapter describes what is at the other end of that bridge. Therefore, after starting with a cyberspace myth—post-industrialism and its emergence in lower Manhattan—the chapter turns to political economy to examine what is left out of focus or indeed completely unattended when a great deal of attention is paid to myth. What does myth, in its tendency to seize the terrain of meaning and identity, obscure and leave out?

The chapter makes the connection between the world of myth that encased computer communication in a protective bubble and the political economy of the Internet by focusing on three interrelated trends: the digitization and commodification of communication, corporate integration and concentration in the communication industry, and the deregulation of that industry. Next, it examines challenges to these trends arising from the decline of the telecommunications and dotcom industries and the rise of new social movements in opposition to the process of globalization. The book concludes by returning to Ground Zero for reflections on the post-9/11 world. It ends, as it began, with a different turn on an old myth.

The Myth of a Post-Industrial Society Is Born at Ground Zero

New York's World Trade Center was arguably the first material manifestation of the post-industrial society idea which was first hatched intellectually a short subway ride away in the offices of *Fortune,* where Daniel Bell was a labor writer. The World Trade Center and especially its twin towers was a first attempt to create a hub for what Manuel Castells

(1989) has called The Informational City, a space of flows or portal that simultaneously produces, manages and distributes data, messages, and ideas. People began to call New York a Global City to describe its ability to command and control the international production and distribution of resources, particularly information (Sassen 1992).

Born at Ground Zero, the concept of post-industrialism took root, later on, further up the subway line from the towers, at Columbia University, where Daniel Bell became a professor of sociology. Scholarly attention to the concept of a post-industrial society has understandably focused on the idea and its history, but, particularly in light of the September 11 attacks, it is important to reflect on its physical birth in the twin towers. As Eric Darton eloquently describes it, the World Trade Center project was wrapped up in the "dawning awareness of political and business leaders of the beginning of a service economy. . . ." Not only would its construction add office space to lower Manhattan; "its emergence on the skyline would broadcast the news that New York had . . . wrenched itself free of its murky industrial past. . . . the towers would serve as symbols of the financial center's manifest destiny and would secure the city's position as the vital hub of the coming post-industrial world" (Darton 1999: 74–75; Doig 2002). It would indeed provide the first genuinely utopian space of the information age.

As captured in two types of accounts, the World Trade Center itself embodied the technological sublime. The first is the mythic history represented in Angus Gillespie's *Twin Towers,* a book written before 9/11 but reprinted and distributed widely after the attacks, which contains several themes that lend transcendence to the process of building them and to the structures themselves. The story of their construction is one of overcoming all obstacles, from the political wrangling between governments to the use of new design and engineering concepts, each of which challenged the view that, as chapter 2 of Gillespie's book announces, "It Can't be Done." If the process is embodied in the Against All Odds myth, then the structures themselves are rendered in the glow of a populist myth: although elite critics universally disliked them, they were beloved among ordinary folk. "Pick up almost any serious book on American architecture," Gillespie tells us, "and you will look in vain for mention of the World Trade Center. The few books that do mention the building do so with disparaging language." (Gillespie 2001: 162) And

yet, it "is recognized by ordinary people as an icon for the City of New York" (ibid.: 179). Put simply, in the subtitle of his chapter on architecture, it was "beloved by all except the experts." In spite of all the difficulties, including the savage criticism of an architectural elite, the towers succeeded. Expected to be a White Elephant, the project turned into prime real estate. These were no mere office buildings; they embodied the populist myth of the American Dream.

Michel de Certeau provides a different sense of the mythic sublime, less the mythic history and more the mythic spectacle, in his essay "Practices of Space." From the perspective of the 107th floor of one tower, he finds that "On this concrete, steel, and glass stage, bounded by the cold water of two oceans (the Atlantic and the American) the tallest letters in the world create this gigantesque rhetoric of excess in expenditure and production. To what erotics of knowledge can the ecstasy of reading such a cosmos be connected?" He goes on to admire "the pleasure of looking down upon, of totalizing this vastest of human texts" (de Certeau 1985: 122). The spectacle summons the language of vastness in geography and discourse, a language of eros and cosmos, to capture the totalizing force of the vision from the near heavenly perch of the observation deck. Sublime or not, New York was singled out by Peter Huber, a telecommunications analyst and believer in the revolutionary potential of the Internet, as the "Capital of the Information Age" (Huber 1995).

Notwithstanding the mythic discourse, the World Trade Center was born in the tumult of social conflict and the banality of political economy. The project grew out of a fierce debate in the 1950s and the 1960s, when a dispute about what to do with lower Manhattan effectively became the first surrogate for an argument about the meaning and significance of a post-industrial society. In brief, on the one side were proponents of strengthening the existing mixed economy of blue- and white-collar labor and affordable housing. On the other were supporters of a post-industrial monoculture of office towers and luxury housing. The latter, led by David and Nelson Rockefeller, won out over a movement that included the noted urban specialist Jane Jacobs (1961) and other critics of the view that New York City would inevitably lead the way to a post-industrial service economy (New York City Planning Commission 1969; Regional Planning Association 1968).

New York City once provided one of the best examples of a diverse socio-economic order of the kind that would come to be called "post-Fordist," led by small and medium-size enterprises and a strong public infrastructure, long before Piore and Sable (1984) made the so-called second industrial divide popular and before scholars and planners flocked to Bologna to document the success of "The Third Italy" (Best 1990). All this ended between 1959 and 1975, when New York lost 440,000 of 990,000 manufacturing jobs. By the early 1990s the total of industrial jobs eliminated rose to 750,000. In 1967 alone, as Danny Lyon (1969: 3) documents, over 60 acres of buildings in lower Manhattan were destroyed, an area four times the size of the site of the World Trade Center. As a result, lower Manhattan, including the World Trade Center and the luxury housing complex Battery Park City, which literally rose out of the Hudson River from material dug out of the ground to create the towers, became the icon for a post-industrial society (Darton 1999; Doig 2002; Fitch 1993).

Before construction of the World Trade Center, the area it came to occupy was mainly filled with light manufacturing firms, primarily electronics shops and the businesses serving them, giving the area the informal designation of "Radio Row" or the Electrical District, bounded by the Wall Street financial area on the east and a thriving port on the south and the west. Today, one online reference work looks back on the area in the pre-Trade Center days and calls it "seedy."[1] Indeed, Trade Center lore suggests that the towers were built to redevelop and revitalize lower Manhattan, but there is another view, based on a different approach to urban development, which questioned the need to build the towers and argued that they did more harm than good.

Radio Row, that "seedy" electrical district, was a major Manhattan employer. In fact, the "clearance" required to build the towers eliminated 33,000 jobs and small businesses from the region. Seedy it may have been, at least from the perspective of the pure, clean spaces of glass encased in the towers and their surrounding structures, but Radio Row was also "one of Manhattan's most vibrant shopping areas." In fact, as commentators describe, the protest against the World Trade Center development project from merchants, trade unionists and social activists based in Radio Row was unprecedented in both its strength and, even more so, in the nature of the coalition that mounted the resistance (Glanz

and Lipton 2002b: 36). Protesters formed a coalition that was also backed by a small number of powerful New Yorkers—including Lawrence Wien, one of the owners of the Empire State Building, who established the Committee for a Reasonable World Trade Center—a body that attacked the proposed towers as excessive. In 1964 Wien raised the now chilling warning that an airplane might someday strike the Center with disastrous consequences. Sometimes operating independently, sometimes joined by Jane Jacobs and the Radio Row protesters, Wien's group was a formidable opponent to the Rockefeller interests who pushed for the full Trade Center.

It is impossible to calculate precisely the consequences of losing Radio Row. One of the leading historians of New York City, Mike Wallace (2002), suggests that the loss of this center of the city's electronics industry may very well be one reason why Silicon Valley sprouted in California and not in the city of AT&T and RCA, the city that gave birth to the telecommunications and broadcasting industries. Moreover, the firms based in Radio Row were part of a wider district that included the docks, rail freight yards, and associated markets that made up what Robert Fitch (1993) calls "the infrastructure of blue-collar New York." In turn, this district was characteristic of the New York City economy as a whole, which, reaching a peak in the 1950s, was made up of a diverse mix of manufacturing and service industries, many small and medium-size enterprises, and a varied strata of blue- and white-collar jobs which grew organically in agglomerative districts. Affordable housing dotted these areas which led to retail shops that added further diversity to the mix. But instead of advancing New York's version of diverse, flexible specialization, of mixed land use and support for blue- and white-collar families, the city's power brokers and planners decided to dismantle it (Doig 2002). SoHo was one of the few areas spared the redevelopment wrecking ball thanks in part to Jane Jacobs's successful movement to stop Robert Moses's plan to build a lower Manhattan expressway. Facing a power elite of New Yorkers who were driven to realize the post-industrial society myth, she was not as successful when it came to the World Trade Center.

The World Trade Center was built to open a second major office district comparable, if not larger and more important, than the one in midtown Manhattan and thereby literally cement the city's claim as the capital of

a post-industrial world. It was a centerpiece of David Rockefeller's re-development plan initiated in 1958 and was executed by his creation the Downtown Lower Manhattan Association. The project would eliminate manufacturing firms, working-class housing, the civic associations and retail outlets that served them, and replace them with financial services and related firms, along with upper-class housing. The World Trade Center construction vastly expanded the district's office space and land-fill from the site was dumped into New York harbor to extend Manhattan island for a World Financial Center and upper-income housing in what came to be called Battery Park City (Gordon 1997). To attract residents, a state-of-the-art park was built on the Battery Park waterfront, at a time when most of New York's parks were suffering from neglect, and one of the city's premier public high schools, reserved for the best of the city's students, was moved into the district and placed in a brand new build-ing costing $300 million, at a time when New York's public schools were also suffering from years of dereliction.

In spite of the Rockefeller family's leadership and the support of the banking and other services sectors, there was some public skepticism about the strategy of building office space. Not everyone bought into the post-industrial myth, choosing to hold onto and indeed breathe new life into an alternative myth, a vision of industrial society renewed through new forms of customized manufacturing and worker cooperatives. For example, in 1955, John Griffin, a City University professor, rattled the city's elites, in part because his research received Rockefeller Foundation support, by publishing a study that criticized city planners for failing to provide support for manufacturing companies beginning to leave the city. Griffin called for the revitalization of blue-collar industry, particu-larly in lower Manhattan, where new and second generation immigrants lived and depended on manufacturing jobs. Challenging the reigning wis-dom of elites that industrial clearance and office construction were the solutions, a strategy that meant moving the working class out of Manhattan to find jobs in the outer boroughs and the suburbs rather than bringing the jobs to them, Griffin set out a plan for industrial renewal in lower Manhattan, including the development of industrial cooperatives.

Furthermore, a series of studies produced by a group of Harvard University researchers, particularly Hoover and Vernon's *Anatomy of a*

Metropolis (1962), demonstrated the strength of the city's flexible manufacturing base and further argued that the city would not benefit from what amounted to the office monoculture that elites had in store for much of Manhattan. Ignoring the evidence in these studies and protests led by Jane Jacobs, local small businesses, trade unions representing manufacturing workers and neighborhood associations, the city went ahead with its plans to support the evisceration of manufacturing and the construction of office space on a massive scale. Post-industrialism would win and a diverse mixed economy specializing in high end manufacturing would leave New York. From then on, it would be left to others, for example Bologna and the celebrated "Third Italy," to take the lead in creating the alternative to post-industrialism.

The ten volumes of research produced by Vernon's Harvard team, commissioned to provide the basis for the city's master plan, were instead shelved and replaced with studies and recommendations provided by the city's Regional Planning Association and the noted urban planner William H. Whyte, which contended that blue-collar jobs and the city's working class would naturally decline and that the city should prepare for a post-industrial shift to white-collar work (Regional Planning Association 1968). All this was cemented by a close political alliance of New York City's mayor, John Lindsay, New York State's governor, Nelson Rockefeller, and the governor's brother, the banker David Rockefeller. The city's 1969 planning document put all the plans together, including the clearance of businesses, particularly manufacturing firms remaining on the lower west side of the city, and elimination of the docks, one of the key elements of New York's global trade infrastructure, as commercial enterprises. It also called for development of Battery Park City and construction of the World Trade Center (New York City Planning Commission 1969). With manufacturing firms eliminated and no port to transfer goods out of the city, New York ended its long run of economic diversity in favor of office and upper-income residential construction.

The redevelopment of the WTC district was widely touted as a victory for free markets and private enterprise. However, this attempt to directly connect post-industrialism on the ground with the myth of the market was severely strained because most of the project was driven by government agencies with considerable financial help mainly in the form of

government bonds and real estate tax abatements. Moreover, these were not just any government agencies but new forms of public-private partnerships, led by the New York and New Jersey Port Authority, which combined public finance power with limited accountability, and the power to expropriate land and property. The Authority used its public status to raise funds to finance major projects, but was not subject to the same public responsibilities as were traditional government agencies (Doig 2002). In effect, the Port Authority, which today remains owner of the WTC site, has represented the major real estate development interests in the project, which since he leased the site from the Port Authority in 1999, have been led by developer Larry Silverstein. Furthermore, businesses benefited from significant real estate tax abatements at the World Trade Center and adjoining properties such as Battery Park City. From 1993 to 2001, city budget documents reveal, real estate tax abatements to the World Trade Center totaled $595.5 million ($66.2 million per year), and Battery Park City enjoyed $788.3 million in abatements ($87.6 million per year) (Statement of the Mayor, April 25, 2001, City of New York Office of Management and Budget: 39). Over this period, these two adjacent sites enjoyed the most substantial tax abatements of any areas in New York City.

Power politics certainly had a great deal to do with why the World Trade Center was constructed. The story of how Nelson Rockefeller stacked the Port Authority with family and party loyalists after his election as governor in 1958 is a classic case study in brute political power (Darton 1999: 82). But it was always encased in a supportive mythology as well. Much of this had to do with purifying and cleansing the perceived blight of lower Manhattan and, specifically, Radio Row. For the World Trade Center's primary architect, Minoru Yamasaki, it was simple and downright Manichean. On the one hand was his design of the towers evoking in his mind "the transcendental aspirations of a medieval cathedral." On the other was Radio Row, in his words, "quite a blighted section, with radio and electronics shops in old structures, clothing stores, bars and many other businesses that could be relocated without much anguish." With thoughts of translucent towers filled with people running the digital world, he concluded that "there was not a single building worth saving" (Glanz and Lipton 2002b: 38). There is something here reminiscent of Margaret Wertheim's discussion of the dual

spaces of the medieval era, as cathedrals were built to purify the real but flawed space of everyday life by making room for a spiritual space that would cleanse the blight of banal, day to day life with a transcendent, indeed sublime, structure. But there is a difference. The medieval cathedral could cleanse and purify the soul but acknowledged a world, however corrupt and sinful, outside its doors. Supporters of the post-industrial myth were not interested in either business or architecture sharing space with different forms. Post-industrial business would purify Fordism by eliminating its need to exist, at least eliminating that need in the major cities of the world's richest nations. Post-industrial design would do the same by purifying, i.e., destroying, the spaces that got in its way. Not everyone lined up on the side of the "posts." For example, architecture critics did not quite get the cathedral metaphor in the World Trade Center design. Perhaps because Yamasaki had to bow to the pressures of his financial backers and increase their height from his proposed 90 stories to over 100, critics lambasted the design as "graceless," a "fearful instrument of urbicide," and, as for the bit of ornamentation at the base, it was viewed as "General Motors Gothic" (ibid.: 39). Even today, after the attacks that re-purified the World Trade Center, architecture critics continue to assail the structures with one referring to their design as "one of the more conspicuous architectural mistakes of the twentieth century" (Goldberger 2003: 78).

Construction of the World Trade Center, which began in 1965 and ended in 1973, was not without more banal political controversies that would later influence its fate. The Port Authority gave the contract for fireproofing the towers to Louis DiBono, who, until he was gunned down on orders of John Gotti in 1990, was reputed to be a leader in the Gambino crime family.[2] DiBono's company, Mario and DiBono Plastering, applied a wool-like sheathing to the steel skeleton, but the material was fundamentally flawed and most of it was stripped away by rain during construction. Later applications were found to be inadequate to properly fireproof the building. Numerous lawsuits and investigations resulted and, while some doubt whether any degree of fireproof work could have saved the towers from collapse, early investigations at Ground Zero convinced experts that the failure of the original fireproofing has to be considered in determining why the buildings failed (Glanz and Moss 2001; Glanz and Lipton 2002b: 43).

The structural soundness of the buildings was also the subject of extensive debate. In essence, the engineering team chose a radical departure from standard skyscraper construction that would make the buildings as light as possible and maximize the amount of usable office space. In order to accomplish this, engineers had to substantially reduce the structural steel and other durable materials, like masonry and cement, that would normally provide tall buildings with stability. They also introduced significant design changes that again traded away stability for more office space. Eager to combat published fears that an airliner crashing into the buildings would bring them down, the Port Authority claimed that an engineering study demonstrated that the towers could withstand a jetliner moving at 600 miles an hour. In fact, no such study had been done. The only calculations that appear to have been carried out were on a jet going about one-third that speed, and no estimate was made of what would happen in the likely event that such a crash would lead to major fire damage. The project's chief engineer said after 9/11: "Should I have made the project more stalwart? And in retrospect, the only answer you can come up with is, Yes, you should have.[3] . . . Had it been more stalwart, surely 1, 2, 50, 100, 1,000 people might have gotten out." (Glanz and Lipton 2002b)

The most significant problem facing Trade Center supporters was not whether design critics and the public would accept it as a mythic icon of a post-industrial society or whether stories featuring financial barons and Mafia hit-men would lead to new myths. Rather it was the more banal problem, foreseen by planning activists like Jane Jacobs and a handful of real estate interests: how to fill more than 10 million square feet of office space. From the start, city, state and federal agencies made up for the huge shortfall by moving in entire departments to fill the towers' empty spaces, particularly in the late 1970s when economic problems, which would eventually bankrupt the city, significantly depressed the commercial real estate market. Fifty floors of one tower were occupied by New York state offices, and the Port Authority occupied some of the other tower. "The Trade Center," one analyst concluded, "never had enough tenants in international trade to be worthy of its name." (Goldberger 2002: 91) The general office glut would continue even as the construction, sparked by subsidies and tax abatements, also continued throughout the 1980s. Between 1988 and 1995 New York City lost 57,000 jobs

in banking alone, and by the mid 1990s there were 60 million square feet of empty office space in the downtown area (Wallace 2002: 15–16).

Things got better as lower Manhattan benefited from the dotcom boom and a high-tech district known as Silicon Alley emerged in the late 1990s to occupy some of the office space vacated by financial services and related firms after the major economic restructuring of the early 1990s (Longcore and Rees 1996). New Internet companies filled office buildings left vacant by financial services firms that relocated and replaced workers with new technologies. Once again, New York City, out of bankruptcy but also out of manufacturing alternatives, enjoyed a post-industrial economic allure. Indeed, Silicon Alley embodied a cyber version of the phoenix myth: in this case the city reborn from the ashes of its industrial past.[4] Even so, it also propelled a transformation of urban politics and power as corporate-controlled bodies like Business Improvement Districts remade public spaces into private enclaves and rewrote the rules of policing, civic activity, and public spectacle. Moreover, much of the private new entrepreneurial spirit, now the subject of books such as *Digital Hustlers,* was made possible by government financial subsidies that opened prime rental space at well below market prices and helped to retrofit older buildings with the technologies necessary to run an aspiring dotcom firm.[5] All this took place in the name of connectivity, in this case referring to the connections among the convergent computer, communication, and cultural sectors in Manhattan and to the market potential of an industry built on enhancing electronic connectivity worldwide.

Centered at 55 Broad Street, a block from Wall, Silicon Alley succeeded for a time in incubating new businesses, particularly dotcom firms associated with the advertising (Doubleclick) and media businesses (AOL-Time Warner's Parenttime.com). For a time, the growth of Silicon Alley revived lower Manhattan, bringing as many as 100,000 new jobs into the area and its appendages, through 5,000 new media firms. By 1997, journalists were calling it a "juggernaut" (Chen 1997; Mosco 1999). But by 2001, Silicon Alley practically vaporized in the dotcom bust leaving the new media industry in New York to the familiar conglomerates like AOL-Time Warner and IBM which could withstand the bust better than any of the many small firms that gave the city its hip attitude in the 1990s (Kait and Weiss 2001). With the dotcoms disappear-

ing and the economy declining in the first 9 months of 2001, the office glut returned and visionaries now turned to biotechnology to provide the next boost to the city economy, repeating a story spreading in cities whose dotcom hopes were turning into vaporware (Varmus 2002; Pollack 2002). On the day before the towers fell, there was 8.9 million square feet of vacant office space available in lower Manhattan alone. The goal of turning lower Manhattan into an office monoculture was failing even before two jetliners struck the towers. In the months that followed, in spite of losing 13.45 million square feet in the attack, the amount of available downtown space actually grew, the result of a declining economy and fears of new attacks.

The Myths of Cyberspace Meet the Political Economy of Computer Communication

The vision of a post-industrial society, created in New York and literally cemented into the twin towers, grew into a powerful myth that helped define the city and the age. In the 1980s and the 1990s, with the arrival of global computer communication, post-industrialism broadened into a set of myths connecting cyberspace to the end of history, the end of geography, and the end of politics. Myths can be understood for what they reveal, for example, the desire for identity and community, but also for what they conceal. In this case the myths of cyberspace are primary examples of what Barthes meant when he defined myth as depoliticized speech. But they can also open the way to a renewed politics, particularly when the cultural analysis of myths is connected to political economy.

Myths conceal a great deal about the politics of cyberspace and in order to appreciate the significance of this point, to understand more precisely why urban planners pour their dreams into concrete, it is useful to turn to the political economic relationship between digitization and commodification. They are central points on the bridge between the culture and the political economy of cyberspace. These two processes provided the foundation for the technological sublime that grew out of "magic places" like Silicon Valley and Silicon Alley and the grounding for the belief that we are entering the end of history, geography, and politics. The World Trade Center was built from their promise and before returning to Ground Zero and the talk about ruin and renewal, it is

important to clear the ground that cyberspace occupies by addressing each and their relationship.

Digitization refers to the transformation of communication, including words, images, motion pictures, and sounds into a common language. Providing the grist for cyberspace, it offers enormous gains in speed and flexibility over earlier forms of electronic communication which were largely based on analog techniques (Longstaff 2002). The latter physically mimicked communication by putting it into a form suitable for electronic processing and transmission. For example, on an analog system, the voice of a telephone caller creates a series of vibrations whose characteristics are sent over a wire and, provided they are amplified at regular intervals, transmitted to a receiver. A digital system literally translates that voice signal into the familiar code of ones and zeros which have become the common language of electronic communication. Rather than the multiplicity of mechanical analogues that were employed to process oral, verbal, and image signals, digitization enables one language to govern practically all electronic media. The fundamentals of translating, processing and distributing electronic communication no longer distinguish among a page of newspaper copy, a radio news broadcast, a CD recording, a telephone call, a television situation comedy, and an e-mail message. Each can be sent at high speed over various wired and wireless networks.

Adopting a common, universal language for electronic media makes digitization enormously attractive. But another characteristic produces an additional significant leap in efficiency and flexibility. Digitization processes and distributes signals in packets that vary in size depending on the nature of the network. A digital telephone network does not send out an entire voice message, as did the old analog systems, but rather packages the message in groups for transmission. Each group or packet is provided with a discreet digital address which identifies it before transmission. Breaking up telephone calls, or television signals for that matter, into identifiable packets enables them to be shipped over different network routes on their way to reunification at the receiving end. In effect, one piece of a telephone signal may be followed by a piece of a television signal, with another piece of that same telephone call sent over another network. This provides significant gains in the efficiency of communication networks which used to become congested with traffic that could not be

rerouted easily or broken up for efficient transmission. Communication is also made more effective because redundancy can be built into messages enabling multiple ways to correct for errors at the processing and distribution stages. Varieties of what is called "packet switching" thereby combine the universalizing tendencies of digitization with intelligent customization of communication packets to greatly expand the efficiency and effectiveness of electronic communication. Viewed in this way, digitization combines elements of generalization, by applying one process or one language to electronic communication, with customization, by packaging its "inventory" of communication into micro units that produce the most efficient flow through networks. As earlier chapters described, mythmakers jump from here to the view that the world of atoms is morphing into a virtual utopia and it sometimes leads urban planners to confidently remake entire regions—with destruction and dislocation a small price to pay for what amounts to an inevitable and necessary transformation in social life.

Digitization takes place along with the process of commodification or the transformation of use to exchange or market value. The expansion of the commodity form provides what amounts to the material embodiment for digitization. It is used first and foremost to expand the commodification of information and entertainment content, enlarge markets in the audiences that take in and make use of digitized communication, and deepen the commodification of labor involved in the production, distribution and exchange of communication. Digitization takes place in the context of powerful commercial forces and also serves to advance the overall process of commodification worldwide. In other words, commercial forces deepen and extend the process of digitization because it enables them to expand the commodity form in communication. From a cultural or mythic perspective, cyberspace may be seen as the end of history, geography, and politics. But from a political economic perspective, cyberspace results from the mutual constitution of digitization and commodification.

Digitization expands the commodification of content by extending opportunities to measure and monitor, package and repackage entertainment and information. The packaging of material in the paper and ink form of a newspaper or book has provided a flexible, if limited, means to commodify communication by offering a useful form in which to measure the commodity and monitor purchases. Challenges arose

when what Bernard Miège (1989) calls "flow" communication systems arose, most significantly, television. It forced the question: how does one package a television program for sale to a viewer? Initially, commodification was based on a relatively inflexible system of delivering a batch of channels into the home and having viewers pay for the receiver and for a markup on products advertised over the air. This system did not account for different use of the medium; nor did it make any clear connection between viewing and purchasing. It amounted to a Fordist system of delivering general programming to a mass audience which was marketed to advertisers for a price per thousand viewers. Each step along the way to the digitization of television has refined the commodification of content, allowing for the flow to be "captured" or, more precisely, for the commodity to be measured, monitored and packaged in increasingly more specific and customized ways. Early cable television improved on commodification by charging per month for a set of channels. As this medium has become digitized, companies now offer many more channels and package them in multiply different ways, including selling content on a pay-per-view basis. Material delivered over television, the Internet or some combination of these and other new wired and wireless systems can now be packaged and repackaged for sale in some related form with the transaction itself measured and monitored by the same digital system. There are certainly limitations on this process. People have been leaving newspapers in cafés, sharing books, and otherwise confounding the precision of the commodification process for as long as the mass media have been around. So it comes as no surprise that music file sharing has become a way to avoid the high price of a music CD. But companies now have tools available to fight back with the support of governments more intent than ever to enforce media ownership rights and with technologies that increasingly provide what is being called the "digital armor" that significantly constrains the capacity to copy and share digital media. The process of commodifying media, along with the back and forth which defines its extent and limitations, describes something far more banal than the end of history, but there is considerable power in this banality.

Enhancing this power, the recursive nature of digital systems expands the commodification of the entire communication process. Digital systems which measure and monitor precisely each information transaction

can be used to refine the process of delivering audiences of viewers, listeners, readers, movie fans, telephone and computer users, to advertisers. Companies can package and repackage customers in forms that specifically reflect both their actual purchases and their demographic characteristics. These packages, for example, of 18–25-year-old women who order pop music concerts on pay-per-view television, can be sold to companies, which spend more for this information because they want to market their products to this specific sector with as little advertising wasted on groups not interested or able to buy. This refines the commodification of viewers over the Fordist system of delivering mass audiences to advertisers and it is being applied to almost every communication medium today. The applications are not always successful, as almost anyone trying to market the Internet version of the "University of the Air" will attest. Applications often meet with more than a little resistance because they are too demanding (program my VCR? interact with my TV set?) or too intrusive (why do you really need to know my age and income?) or simply don't do what they are supposed to (you call that jumpy little picture on my desktop a video?) Nevertheless, there is also great power, even if not that of sublime mythology, in the commodification of audiences.

The labor of communication is also being commodified as wage labor has grown in significance throughout the media workplace. In order to cut the labor bill and expand revenue, managers replaced mechanical with electronic systems to eliminate thousands of jobs in the printing industry as electronic typesetting did away with the jobs of linotype operators. Today's digital systems allow companies to expand this process. Print reporters increasingly serve in the combined roles of editor and page producer. They not only report on a story, they also put it into a form for transmission to the printed, and increasingly, electronic page. Companies generally retain the rights to the multiplicity of repackaged forms and thereby profit from each use. Broadcast journalists carry cameras and edit tape for delivery over television or computer networks. The film industry is now starting to deliver digital copies of movies to theaters in multiple locations over communication satellite, thereby eliminating distribution of celluloid copies for exhibition by projectionists. Rather than break down Hollywood's rigidly concentrated power structure, as some forecast,[6] digitization and commodification strengthen it.

Companies sell software well before it has been debugged on the under-standing that customers will report errors, download and install updates, and figure out how to work around problems. This ability to eliminate labor, combine it to perform multiple tasks, and shift labor to unpaid consumers further expands the revenue potential (Hardt and Brennen 1995; McKercher 2002; Sussman and Lent 1998). Workers have responded to this with their own form of convergence, one that brings together peo-ple from different media, including journalists, broadcast professionals, technical specialists in the film, video, telecommunications and computer services sectors, into trade unions that represent large segments of the communications workforce. The goal of one big union in cyberspace may be a mythical ideal but there is no doubting the trend toward labor and trade union convergence in the communication industries (McKercher 2002; Mosco 2002).

Corporate Integration and Concentration

The mutual constitution of digitization and commodification contributes to the integration of the communication and information technology sec-tor and the concentration of corporate power within it. The adoption of a common digital language across the industry is breaking down barri-ers that separated print, broadcasting, telecommunications and the infor-mation technology or computer data sectors. These divisions have been historically important because they contained the legal and institutional marks of the particular period in which they rose to prominence. The print publishing industry is marked by a legal regime of free expression, limited government involvement, and local ownership.

Broadcasting and telecommunications rose to prominence alongside the rise of powerful nation-state authority and national production, dis-tribution and exhibition systems. Western legal systems placed a greater regulatory burden on radio, television, and telephone systems, going as far as to create publicly controlled institutions in these sectors, in order to accomplish national objectives such as reflecting a national identity and building a national market. National firms were more likely than their more local print predecessors to control commercial broadcasting and telecommunications systems. The information technology or com-puter data industry took off in the post-World War II era and embodies

the trend away from nation-state regulation, except to advance the expansion of businesses, and toward control by multinational firms. There are numerous legal and institutional struggles within this sector, but it arguably began from the premise that, unlike the broadcasting and telecommunications sectors, the computer industry would face little or no public-interest or public-service responsibilities, no subsidized pricing, no commitment to universality of access, and no expectation that national firms would be more than one step on the way to multinational control (Schiller 1999; McChesney 1999). This has become the model for the convergent communication industry.

The growing integration of communication sectors into a consolidated electronic information and entertainment arena explains much of why there has been an unprecedented acceleration in mergers and acquisitions. Communication systems in the United States are now largely shaped by a handful of companies including U.S.-based firms: Microsoft, AT&T, General Electric, Viacom, the Walt Disney Company, AOL-Time Warner, and the Liberty Media Corporation. There are others, including non-US-based firms like News Corporation, Bertelsmann, Vivendi Universal, and Sony. Each of these firms also has a significant transnational presence through outright ownership, strategic partnerships, and investment.

Concentration is far from just an American phenomenon. Consider Canada, whose communication arena is arguably even more highly concentrated with four firms in the most dominant positions. These include BCE, Rogers Communication, CanWest, and Quebecor. (Some might add a fifth firm, Shaw Communication). BCE alone has spread over a wider terrain than even its admittedly larger American and European counterparts. The company's former chair and CEO boasts about what would be the U.S. equivalent of BCE: "Start by combining the telephone businesses of Verizon Communications and SBC Communications. Then add Verizon's wireless operations, and America Online's Internet customers. Fold in ABC's television network, the ESPN cable sports network and the Direct-TV satellite service. Finally, tack on the *New York Times*." (Simon 2001) Marveling at Bell's ability to dominate the Canadian industry, a correspondent concludes that American antitrust officials and regulators would not permit such a conglomerate to be assembled in the United States (ibid.). Whether this is true is debatable, but the combina-

tion of growing concentration and diminishing regulation certainly leads some, including Sunstein (2001), to fear that cyberspace will shrink from its mythic potential to advance democracy and become little more than a commercial space with less than adequate room for diversity and the clash of ideas.

The transformation, however, is far from complete. Canadian communication firms, like their counterparts in the United States, Europe and elsewhere face enormous pressures toward regional and global integration (Mosco and Schiller 2001). In order to advance transnational corporate communications services in general, and communication services in particular, nationally controlled institutions would have to be eliminated or at least marginalized, and public-service principles would have to be sharply reduced. U.S. corporate and political leaders lobbied intensively during the 1980s and the 1990s to advance these changes within broader efforts to liberalize trade and investment rules. Playing important roles in this process were government initiatives, private economic diplomacy, bilateral negotiations between states, and multilateral organizations such as the World Bank, the International Monetary Fund, and the World Trade Organization. The Free Trade Agreement, which brought together Canada and the United States, and the North American Free Trade Agreement, which added Mexico, made up significant initiatives within this larger movement. Each was perceived as a prelude to a broader push for liberalization of global trade and investment within the organizational context of the frameworks established by the General Agreement on Tariffs and Trade and the World Trade Organization.

Tensions and Contradictions

Media concentration is a powerful force, but, as the dotcom and telecommunications debacles reveal, it often does not produce the synergies that companies anticipate and sometimes results in content that does not succeed in attracting audiences. Focusing as it typically does on the corrosive consequences of media integration, political economy tends to give inadequate attention to this point. At worst, the presumed power of media giants takes on its own mythic characteristics. Digitization is not a flawless process and technical problems have slowed its development. Furthermore, we can observe significant political contradictions. Arguably

the dominant political tendency today is neo-liberalism, which was
founded on the retreat of the state from vital areas of social life, includ-
ing communication, where the state was once very significantly involved
in building infrastructure, establishing technical standards, regulating
market access, and providing services. According to neo-liberalism, such
functions are best provided by the private sector with minimal state
involvement. Specifically, neo-liberalism aims to customize state func-
tions, tailor them to suit business needs, and thereby avoid what its sup-.
porters contend is the stalemate created by excessive public demands for
state services.

The communication arena demonstrates that it is not so easy to
accomplish this feat. Consider first the development of technical stan-
dards. Digitization needs common technical standards to harmonize
the processing, distribution, and reception of digital signals. It is one
thing to turn audio, video, and data streams into digital packets; quite
another to ensure their flawless flow through global grids. To accom-
plish this, it is essential to set a wide range of standards for the equip-
ment necessary to encode and decode signals and for managing the
data flows through networks. Achieving such agreement is normally
quite difficult since competing firms are reluctant to cooperate because
it requires sharing sensitive and economically valuable information.
Societies have traditionally dealt with this problem by establishing gov-
ernment agencies or private-public partnerships to serve as independent
standards arbiters. Almost a century and a half ago, at the birth of
the electrical sublime, competing telegraph interests established the
International Telecommunication Union, a global body made up mainly
of government organizations and managed on a one-nation, one-vote
basis to set global standards for the new technology. Over the years,
the ITU expanded its role as each new communication technology came
along. Primarily, it set standards for the telephone, allocated broadcast-
ing frequencies, and eventually the orbital locations of communication
satellites.

However, as the number of nations grew, including former colonial
societies eager to create standards that would help them to expand wide-
spread access to communication technology (and not just the profits of
communication companies), conflict grew at the ITU. As a result, core
industrial powers, led by the United States, began to consider alterna-

tives. These included, first, political bodies, like Intelsat, a global communication satellite organization whose rules permitted Western control and more recently, private corporations, such as the Internet Corporation for Assigned Names and Numbers (ICANN), which helps to establish technical standards for the web. The goal of these organizations has generally been to set business-friendly standards, but to do so without sacrificing global credibility.

The problem for defenders of this system is that it is increasingly difficult to maintain both business support and global credibility. One reason is that digitization is now global and the competition to dominate markets for the short term by controlling one phase of a rapidly changing system or for the long term by setting an important standard (such as for a computer operating system) is intensifying (Paré 2003). Furthermore, the number of global interests is expanding so that even something as seemingly innocuous as setting a country code for a web address becomes a political question when, to cite one particularly fractious case, it is Palestine petitioning for ".ps" (Clausing 1999). Should ".union" join ".com" on the list of acceptable suffixes, as one public-interest group proposed? Private businesses expect to depoliticize these issues by setting up Western controlled private or only quasi-public standards organizations. But they are actually only displacing tensions and contradictions.

In 2002 ICANN ultimately succeeded in eliminating democratically elected members of its board, but even this neo-liberal stroke does not guarantee smooth functioning (Jesdanum 2002). The decision got rid of elected board member Ken Auerbach, who had tried to democratize ICANN but had consistently run up again major bureaucratic and political problems. In frustration about trying to obtain ICANN financial records, Auerbach once complained: "We know more about how the College of Cardinals in Rome elects a pope than we do about how ICANN makes its decisions." (Associated Press 2001a) Auerbach met ICANN executives' refusal to provide him with the organization's records by turning to a judge, who supported the dissident director's request. ICANN responded by eliminating Auerbach and other elected board members (Geist 2002a). One telecommunications analyst now calls for the elimination of ICANN, charging that the agency sunk to a new low by meeting in locations distant from most of the activists who

have been pressing for change in order to keep them from showing up at meetings. The decision to eliminate elected board members was made at an ICANN meeting in Shanghai, hardly a bastion of democratic communication. Critics contended that it was also a site that would press the budgets of ICANN's dissidents (Weinstein 2002). They wonder about the irony of an international organization set up to address the needs of the new online global community, appearing to do what it can to keep its representatives as far away as possible. Returning to the world of myth, one is tempted to wonder, perhaps with tongue in cheek, if this is what the end of geography really means.

In light of the numerous disputes, often very acrimonious, one should therefore not be surprised that ICANN's legitimacy has suffered. Moreover, it should come as no surprise to learn that savvy computer users are, to use geek lingo, developing "workarounds" for the ICANN problem. A 2001 report found more than 500 top-level domains operated around the world by some 200 administrators, all outside the official domain name system (Weiss 2001). How many more rogue networks will be added to that total as ICANN loses more of its legitimacy? One seemingly ironic consequence has been a stepped-up effort to shift international decision making power over domain names to the grand old regulatory body, the ITU, which in October 2002 approved a resolution on managing multilingual domain names and one analyst has gone as far as to suggest that the ITU will likely emerge as "the governance leader" (Geist 2002b). Nevertheless, this alternative, setting up genuinely public, national or international regulatory authorities, a central feature in the expansion of communication before post-industrialism became the reigning myth, risks turning this arena into a highly contested terrain.

The contradiction between the desire to free business to act in its own interest and the need for government regulation has also marked debates about how to expand access to technology in order to build markets and about how to ensure some measure of privacy to create consumer confidence in the technology. For example, in the early days of radio, business felt that it did not need government to regulate frequencies (after all, this was the end of history). But the result was near chaos, as broadcasters poached each other's frequencies and the airwaves were filled with worthless static. Businesses responded by supporting government regulation to bring order to the chaos and government generally succeeded.

However, this private arena was now opened to the wider public which used the opportunity to fight for public broadcasting and the regulation of private station content. The technology has indeed changed, leading some to re-imagine revolutionary transformations, but the political economic dynamic has not and so the same tensions and contradictions mark the world of digitization and the digital sublime.

Consider the shocking burst of the telecommunications bubble. Former industry giants, including Nortel, Cisco, Lucent, and now WorldCom (this icon of the telecom boom was bounced from the Nasdaq and S&P 500 in 2002 and had its credit rating reduced to junk status), shrank into economic obscurity. Between 2000 and 2002, Nortel and Lucent lost 98 percent of their stock value and, between the two alone, shed 148,000 jobs out of a total of more than 500,000 lost in the U.S. telecommunications industry. WorldCom's demise is extraordinary even in the context of the most substantial crash in the history of the telecommunications industry. Once America's second largest telecommunications carrier, the company filed for bankruptcy in July 2002. With $107 billion in assets, it was the largest such action in U.S. history. By October 2002 the company had been charged with $7.4 billion worth of accounting irregularities. Building its capitalization on a variety of shady practices, including its proclamation that Internet traffic was doubling every 100 days (shades of Gore's Law), a claim dignified in government reports that repeated it, WorldCom appeared to be the new model for the Internet-savvy telecommunications industry. Aided by the Telecommunications Act of 1996, which diminished scrutiny over the company, WorldCom enjoyed what amounted to a blank check from regulatory authorities. By March 2003 the company had to write down its assets by $80 billion, including lowering the value of its tangible assets from the $44.8 billion paid down to $10 billion. This led one industry analysis to conclude: "So Worldcom paid $1 for assets that are now worth 2 cents. At last we know how gross was the misallocation of capital in the telecommunication industry in the late 90s. And how deep is the telechasm." (Morgenson 2003) A former deputy general counsel at the FCC put it this way: "The agency was oblivious to the enormous accounting fraud at WorldCom." (Sidak 2002) Sidak now calls for stripping the company of the licenses and certifications it needs to do business. But WorldCom, though arguably the worst case, was hardly alone. At

the end of 2001, the eight largest telecommunications companies collectively owed $191 billion and, with demand flat, there was little prospect of debt repayment (Goodman 2002). This was partly because even AT&T and Sprint, which have not been accused of offenses comparable to WorldCom's, faced enormous pressure to meet the quarterly results that WorldCom appeared to be generating. Unable to do so legitimately, they saw their stock value pummeled, and even these companies were forced to restructure operations and replace senior management (Schiesel 2002).

Beneath these sobering facts lie what some fear is a fundamental change in the nature of research in these industries. The most telling example is the case of J. Hendrik Schon, who worked for Lucent Technologies' Bell Labs. The microelectronics community was rocked in 2002 when an expert panel determined that Schon, who had risen to the status of science superstar for his work on molecular-level transistors, fabricated data and altered experimental results for work published in the field's most prestigious journals including eight in the journal *Science*. Under intense corporate pressure to produce breakthroughs in nanotechnology, Schon and some of his colleagues cheated. The views of the theoretical physicist Paul Ginsparg, a MacArthur "genius" grant winner, are telling. In response to a question about what the Schon case means, Ginsparg didn't hesitate: "The demise of Bell Labs by becoming corporate. People just assumed that there's no way that institution would allow this to happen. And let me tell you, years ago this never would have happened at Bell Labs. The heads of departments would have kept tables. The investigating committee asked Schon, Where are your lab notebooks, and he didn't systematically keep them. Raw data? Didn't keep them." (Weed 2002: 27)

Fearing the loss of some of America's fundamental communication equipment providers, the chairman of the Federal Communications Communication actually resorted to a speech pleading with the telephone companies and other telecommunications operators to buy more equipment. The chief procurement executive for Verizon (a major telecommunication operator that continues to cut its own workforce) responded: "We're not to the point where we are going to reach in and send a check to support them." (Feder 2002a)

The overall decline in the dotcom and telecommunications industries, and, most important, the chasm between the glut of high-speed, long-

haul information lines and the shortage of high-speed, local access connections, can be directly traced to the almost religiously driven neo-liberal strategy that the market would do a better job of regulation than traditional forms of state intervention. Indeed, cyberspace fed a powerfully compelling myth of the market that insisted we have reached a point where policy can do away with government regulation. Friction-free capitalism, as Bill Gates called it, was at hand and Washington would take the lead by eliminating many of its own responsibilities. So with few regulatory, political or social policy checks on investment decisions, cemented into law in various forms, in the United States it was the 1996 Telecommunications Act, firms went on a long-haul building binge. Once the Bush administration came to power in 2001, key regulatory agencies like the Securities and Exchange Commission and the Federal Communications Commission weakened regulatory oversight and enforcement even more. The building binge was carried out by large as well as small firms. Assets mattered little because Wall Street was flush with "new economy" fever (after all, this was the end of history) and capital was easy to raise.

Even liberals bought into this view with their own mythology: If you build it, they will come. Well, as it turns out, to summarize a government report of September 2002, despite the fact that almost all U.S. families live in areas where a high-speed Internet connection is available, many see no compelling reason to pay extra for it (Office of Technology Policy 2002). People who once envisioned the "broadband revolution" now predict a slow evolution with declining annual growth rates resulting in, at best, one-third of U.S. households with broadband by 2006 (Romero 2002b). Similar results documenting the persistence of cyberspace "choose-nots" have been found in Canada (Reddick 2002). Some have even come to doubt the economic value of combating the "digital divide" between rich and poor nations (Kenny 2003). This has not stopped people from trotting out version after version of the myth. "Perhaps," one technology reporter suggested, "it is time to update the old adage: 'If you give me a fish, you feed me for a day. If you teach me to fish you feed me for life.' Maybe it should now say: 'If you give me information, you answer one of my questions. If you get me online, you let me answer my questions for myself.'" (Thompson 2002) Even a report from a liberal think tank, published in the midst of the most substantial decline ever experienced by the telecommunications industry, calls for diminish-

ing regulation of telephone companies (referred to as "regulatory sym-
metry") to enable them to speed up the production of broadband net-
works (Pociask 2002). Nevertheless, by the end of 2002 it remained the
case that, aside from eBay, which also has it doubters on Wall Street,
and, to an even lesser degree, Amazon, the only businesses actually mak-
ing money from the web were, as one article gingerly put it, those
"appealing to baser interests or making use of questionable business
practices." Among these were sex-related businesses including subscrip-
tions to image and video sites and businesses promising enhanced sexual
prowess (Schwartz 2002a; Tedeschi 2002).

Caught in the crunch, industry leaders are not particularly optimistic.
An AT&T executive put it this way: "I think that approach of 'build it
and they will come' has been a disaster for the industry. I don't think
we're ever going to see it again." (Howe 2002) Not everyone agrees with
this point of view. Michael Lewis, author of *The New New Thing,* a best-
seller praising the Internet, argues that the boom was far better than the
current wave of "retribution" would admit. Sure, companies overbuilt
the telecommunication system adding unnecessary capacity, "which is a
bit wasteful—we don't need it yet"; however, this was "not a total waste:
we will need it one day soon" (Lewis 2002: 49).

One company that persists in this view is Global Crossing, once touted
by George Gilder as a solid contender to dominate the telecommunica-
tions industry in the new century. This firm, led by a protégé of the junk-
bond felon Michael Milken, managed to raise $750 million almost
overnight, went public, reached a value of $30 billion, built a transat-
lantic fiber network valued at much less and with a glut in capacity,[7] col-
lapsed in January 2002. The company's share value declined by 99 percent
to 13.5 cents a share, and it filed for bankruptcy in January 2001, the
largest one by a telecommunications company until WorldCom's bank-
ruptcy in 2002, joining other high fliers like 360networks, which Gilder,
in another one of his influential prognostications, claimed would battle
Global Crossing for telecommunications supremacy in the twenty-first
century (Romero 2002a; "The Great Telecoms Crash," *Economist,* July
20, 2002: 9). Fearing a case of "Enronitis," the Federal Bureau of
Investigation and the Securities and Exchange Commission launched
investigations of the company in February 2002. As it turns out, Global
Crossing was literally connected to the icon of corporate malfeasance

Enron in a complex deal brokered by a third party which enabled both Enron and Global Crossing to circumvent accounting rules, allow both firms to book revenue, and Global Crossing to hide a loan (Barboza and Romero 2002).[8] This appears to be part of a wider practice whereby Enron and other energy companies sought to demonstrate that they were comers in the broadband communication business by trading broadband capacity back and forth with one another, thereby pumping up the appearance of major activity in the broadband market (Barboza 2002). These firms were the real magicians of the marketplace, confounding the known laws of economics and physics by making something appear from nothing and making their top executives very wealthy in the process.

Comparing the telecom situation to Enron, one business correspondent concluded in March 2002 that "a tragedy of identical plot, but with far more damaging implications," is playing out in telecommunications. However, unlike the saga of Enron, this is not about a single company with mischievous executives, "this tale is about an entire industry that rose to a value of $2 trillion based on dubious promises by Wall Street and company executives for an explosive growth in demand." Cozy relations among formally competing firms led to what seems to be agreements to pad demand forecasts, overvalue assets and otherwise cook the books (Morgenson 2002: 1). Insiders were able to dump their stock at inflated prices before the collapse set in (Berman 2002). As, according to one article, "the fiber optic fantasy slips away," the promise of universal access to broadband communication remains just a promise (Romero and Schiesel 2002).

Meanwhile, in another spin of the wheel, even the well-known banker Felix Rohatyn, who once engineered a bailout when New York City declared bankruptcy, calls for a return to rigorous regulation to combat "the betrayal of capitalism" (Rohatyn 2002a:6): "I believe that market capitalism is the best economic system ever invented for the creation of wealth; but it must be fair, it must be regulated, and it must be ethical. The excesses of the last few years show how the system has failed in all three respects. . . . the system cannot stand much more abuse of the type we have witnessed." (Rohatyn 2002b: 6) The telecommunications industry has arguably suffered more than the computer industry from mismanagement and corporate crime. But Silicon Valley shows little evidence of learning from the sorry example of telecommunications. The

General Counsel for a large California investment company concludes that "Silicon Valley 'corporate governance' is an oxymoron." Success is measured by money raised, newspaper mentions, and general visibility, not by revenue. According to its critics, the Valley's swashbuckling approach to management "means more shareholder disasters waiting to happen" (Richtel 2002).[9] Nor does Washington hold out much hope for Rohatyn. In August 2002 President Bush reaffirmed his long-standing view that more deregulation is needed to expand access to broadband and other high-speed Internet services (Krebs 2002). The man he appointed to head the Federal Communications Commission agreed and proceeded to launch a series of steps to further reduce restrictions on corporate activity in the mass media and telecommunications. But there are some within the industry who worry about this strategy. According to the general counsel for AT&T, the industry's problems can be directly traced to the fact that "enforcement has not been vigorous enough. When so many problems have been a result of a lack of oversight, it's not generally wise to say let's deregulate further." (Labaton 2002) But with the Republicans winning control of the Senate in November 2002 and with the Federal Communications Commission insisting that its policies are sound, deregulation and the problems that Rohatyn has so clearly identified continued.[10]

A similar conundrum shapes the issue of privacy. The drive to use communication and especially the new media of cyberspace to expand the commodification process now includes personal identity (Lyon 2001). From a political economic perspective the threat to privacy is not just an offshoot of technology or a correctable oversight but is arguably intrinsic to the commodification process. From this point of view, the struggle for personal privacy is part of a wider one against the expanding commodity. The terrain for the struggle extends widely but "personal content" software provides one of the better examples. In January 2001 Nortel Networks announced a new line of this software that the company proposed to sell to Internet service providers. It would package online services to suit individual preferences by tracking every choice a user makes on the Internet and configure the network to deliver efficiently the kinds of material typically selected. In effect, Nortel's strategy, like that of numerous other firms, is to add value to the Internet by making it more responsive to customer profiles. But in doing so, the company makes it

possible to gather, package, and share information on customer choices, thereby expanding the commodification of content and audiences. The response of one privacy activist focuses on the company's responsibility charging that it is "unacceptable" to enable Internet service providers to watch where customers are going. However, Nortel's behavior is less a matter of corporate irresponsibility and more that of a firm which needs to expand the commodification of its major resource, the Internet. Given the company's precarious financial position, it is certainly understandable that Nortel would try to build a market in expanded Internet content and in the audiences that use it. But Nortel's product also reflects a fundamental contradiction besetting the business of cyberspace, i.e., the conflict between the goals of building consumer confidence to turn the Internet and its users into a universal market and commodifying without government intervention whatever moves over the Internet, including personal identity (Associated Press 2001b).

The End of the End of History?

As even this brief overview suggests, cyberspace begins to look somewhat different when the starting point is political economy rather than myth. But keeping in mind Thor's admonition at the start of this book, it is important to see vigilantly with both eyes. Building a bridge from myth to political economy does not discount the former. Far from it, the tensions that political economy creates, however unsettling, enrich what myth teaches. This is particularly evident when we move into areas where myth and political economy inevitably meet. One of these spaces is, as Klein has called it, at the end of the end of history. Specifically, in *No Logo* (2000) Naomi Klein maintains that the culture of globalization is built on the creation of a branded world. Starting from the view that the brand is "the core meaning of the modern corporation," she documents the global spread of brand identities made most successful in such visual brand icons as the Golden Arches of McDonald's and the Nike Swoosh. Brands have spread beyond the specific commercial product, like the hamburger or the running shoe, to encompass places, events, people, activities, and now governments. As Peter van Ham reminds us in a provocative piece on the postmodern or branded state, England has become Cool Britannia, and Belgium, reeling from scandals involving

child pornography rings and dioxin-polluted chicken, hired a branding team that recommends the country use ".be" as its logo and follow the lead of the Virgin corporation, which isn't big but you see it wherever you look. Similarly, Estonia is no longer a post-Soviet or even a Baltic state; it is pre-EU or downright Scandinavian. Unable to boast Finland's cell phone giant which leads some to call that country Nokialand, Estonia markets itself as a tiny green jewel, the un-Cola of industrial states and as E-Stonia, for its use of the Internet and strong presence in cyberspace (van Ham 2001).

If we can brand countries, why not the world? Indeed, from a cultural perspective, globalization might be better viewed as a brand for the world. It exists sui generis as the word for what is happening today, not unlike the mantra whose utterance places the chanter among a group of believers who need say no more. Concepts lead to questions. As a mythic brand, globalization leads only to one response: Amen. In essence, brands are the depoliticized speech, the period, exclamation point, and cultural or rhetorical stop sign of globalization.[11]

But proponents of a branded world are facing global social movements that in many old and new ways resist the power of the corporate and government brand. This demonstrates that mythic brands are more than depoliticized speech. Yes, for some, the Golden Arches and the Swoosh serve as powerful stop signs to political conversation and action. But, again following Doniger's position, they can also be prepolitical, the first step in a process that, when examined with both eyes, can restore, rather than deny, with every critical retelling, a political grounding that myths appear to leave out (Doniger 1998). In essence, myths can end politics, can serve to depoliticize speech, but they can also restore it by providing a rich cultural dimension that deepens political understanding. Indeed, cyberspace advances a form of political convergence that makes increasingly transparent the divisions between culture and political economy as well as between consumption and labor. In doing so, cyberspace fosters an anti-globalization movement that merges the politics of labor from an earlier era (Denning 1996) with the politics of representation that marked a more recent time (Klein 2000). Mass demonstrations in Seattle, in Prague, in Quebec, in Genoa, and in Washington, D.C., as well as the global movements organized around culture jamming, are grounded in a powerful and broad-based understanding of the convergence of labor

and consumption in the world today. These movements understand the links between Nike ads and sweatshops making running shoes, as well as between familiar brands like Wal-Mart, Esprit, Kmart, J. C. Penney, etc. and what can only be described as new forms of slave labor. The links between business and slave labor today are increasingly filling press accounts. In 2002, this was documented in a chilling account of slavery in the mahogany-rich forests and fast food producing cattle ranches of Brazil (Rohter 2002).[12] Global social movements are today based on the ability to strip the cover from the gloss of a brand to reveal not only the exploitation of labor, but also the commercialization of life and threats to the earth's environment. Today's movements range widely and include some whose work is primarily in cyberspace, such as the open source movement, what one analyst calls a loose network army of 750,000 software programmers worldwide made up of hackers, crackers, and people running file sharing heirs to Napster like KaZaA. The force is typically far looser than most armies, but it tends to unite against commercialism and the concentration of corporate control over cyberspace (Hunter 2002). It is also made up of the Centri Sociali movement in Italy that fights to reclaim public space. Their strategies and tactics are not always in line and there is always the threat of co-optation (Himanen 2001; Wright 2000; Harmon 2002). But they are united in providing a genuine alternative to the world that Fukuyama describes as inevitable. Naomi Klein (2001) suggests that by combining a cultural understanding and a political economic understanding they aim to bring about "the end of The End of History."

As Klein and Dyer-Witheford (1999) describe, many of the major opposition movements have been based on building global political networks through the use of communication systems. This strategy takes many forms including attacks on the communication systems of transnational companies and their political organizations, such as occurred in January 2001 when Microsoft's computer networks and the servers containing private data, such as credit card information, on the elite participants at the World Economic Forum meeting in Davos, Switzerland were hacked and opened (Weisman 2001; Reuters 2001b). It also includes, relatedly, the use of computer communications to organize an alternative to the annual Davos meeting that brought together some 20,000 people in Porto Allegre, Brazil for the World Social Forum, a

six day meeting whose theme "Another World is Possible" featured social movement groups representing labor, women, the environment, and minorities.

This potential for a political convergence between labor and consumption demonstrates that convergence does not just mean plugging a cable modem into a PC, or AOL into Time Warner. For some, these global social movements hold out hope for a renewed public sphere, cosmopolitan citizenship and a genuinely democratic cyberspace. The convergence of labor and consumption and the politics of citizenship, which seem to mark so much of what gets all too glibly called the anti-globalization movement, may be the most significant form of convergence to understand today. But there was more such hope before the events of September 11.

Back to Ground Zero: Post 9/11

The end of history, the end of geography, and the end of politics are compelling myths, and they are made all the more powerful with the expansion of cyberspace. However, with the spread of anti-globalization movements, and the substantial boost that cyberspace has provided them, even more so with the events of 9/11 and subsequent wars in Afghanistan and Iraq, it appears that time, space and power have returned with a vengeance. Indeed, we may be seeing the emergence of a new mythology, or the return of an old one. John Cassidy (2002: 313) put it this way: "After September 11, it seems ludicrous to speculate about an escape from history or geography." Putting it more powerfully, Robert Kaplan envisions a world ravaged by war, disease and environmental havoc, all of which lay the groundwork for what he calls *The Coming Anarchy* (1997). We have come a long way from Fukuyama's *End of History*, even from Bell's *Coming of a Post-Industrial Society*.

Let's begin to bring this story to its own end by returning to Ground Zero, move outward from there and conclude, with Salman Rushdie's guidance, in the mythical land of Oz. Start by considering what we know about the investigation of the WTC disaster and about planning for this once gleaming icon of a post-industrial information age, now primarily a symbol of the end of the end of history. There is much to be learned

about myths by excavating material details and Ground Zero is no exception. It was generally agreed from the start that one of the more important tasks was to thoroughly investigate the site and evidence from it in order to determine as much as possible about the destruction of the towers so that planners, engineers and builders can improve on the ability of large urban structures to withstand the range of disasters they might face. But it has also been the case that engineers, safety and evacuation experts, fire and construction specialists, have consistently criticized the WTC investigations for their lack of independence from political pressure, inadequate funding, and the inability to legally compel testimony (Glanz and Lipton 2002a,b). According to one account, it took a needlessly long time for investigators to obtain basic information like blueprints of the collapsed buildings (Glanz and Lipton 2001a). In addition to flaws in fireproofing, experts have tried with limited success to examine the lightweight steel trusses that supported individual floors on the towers. But this can no longer be done effectively because the city has already sold most of the remaining steel beams, columns and trusses that held up the buildings. As a result, causes and consequences may already be beyond the reach of investigators. The Federal Emergency Management Administration (FEMA), which initially led the investigation, pretty well gave up, admitting that its major mission is to help victims and emergency workers. Indeed, under questioning for shortcomings in the current inquiry, a FEMA spokesperson said "We are not an investigative agency." (ibid.) Agreeing with this conclusion, genuine investigators charge that FEMA and "politics" have nevertheless gotten in the way of finding answers.

Critics suggest that there is more than a little political embarrassment buried in the World Trade Center rubble. To cite one example: New York Fire Department officials warned the Port Authority and city government in 1998 and 1999 that a 6,000 gallon diesel fuel tank positioned above ground and near lobby elevators at 7 World Trade Center, which was used to power the mayor's emergency bunker on the 23rd floor of that building in the event of a power failure, was a hazard in violation of city codes and, according to one Fire Department memorandum, could produce a "disaster" (Glanz and Lipton 2001b).[13] The tank was not removed, and the 47-story tower, not struck by the aircraft, burned and collapsed several hours after the attack. Certainly it may still be possible

to examine what led the city to the seemingly odd decision to place the mayor's emergency bunker in a tower next to one that had already been the object of a 1993 terrorist bombing. And what led it to the equally strange decision to place a huge supply of diesel fuel above ground to serve that bunker. A report in March 2002 suggested that the fuel tank was likely responsible for melting transfer trusses or steel support beams, leading one expert who reviewed available evidence to conclude: "Without the fuel, I think the building would have done fine." (Glanz and Lipton 2002c) Consolidated Edison (the city's major utility) and its insurers have sued the Port Authority, charging that the diesel tanks were improperly designed and maintained and that they played a major role in the collapse (Glanz 2002a). But the absence of a serious examination of physical evidence makes it practically impossible to draw definitive conclusions. And this is far from an isolated case. A November 2002 check of a building near Ground Zero found 2,200 gallons of diesel fuel stored in its upper floors. It turned out that the structure housed a telecommunications center that used the extra fuel to provide backup support for its many computers in the event of a blackout. Critics are uncertain about whether to applaud uncovering the violation in time to alert the many other cities with such "telecommunications hotels" or to wonder why what is being called "a potential tinderbox" is doing in a residential neighborhood a few blocks from where improperly stored fuel was likely to have brought down a 47-story tower (Bagli 2002b).

Weaknesses in the investigation make it practically impossible to rigorously test the contention of former deputy fire chief of New York Vincent Dunn, who, in the words of one reporter, "raised a few eyebrows" with this statement about the WTC towers: "There is no other high-rise office building in New York City that would have pancaked down in 10 seconds. This was a fragile, unorthodox construction that should never have been allowed. It was a disaster waiting to happen." (Christian 2002) By the spring of 2003, there still did not appear to be much hope for a thorough investigation. Most analysts agree that for one to succeed it will take a commitment along the same lines that followed the attack on Pearl Harbor and the Kennedy assassination. In those cases, legislation approved the formation of independent investigative commissions that conducted wide-ranging studies which, if not satisfactory to their numerous critics, were certainly more open and thor-

ough than the best of what has appeared to date with respect to the World Trade Center attacks. Until 2003, the highest level investigation was a joint House-Senate Intelligence Committee review carried out in secret. Even at that, the findings released have proven embarrassing because they revealed numerous previously undisclosed warnings of an impending attack. Intense lobbying, particularly from the families of victims, led to an agreement for an independent investigation, but the Bush administration, most likely fearing that it would reveal more major intelligence failures, was reluctant to give its approval. And when it did, the choice of Henry Kissinger to chair the investigation met with widespread criticism, particularly about whether a committee under his direction would likely pursue politically charged issues like the failures of U.S. intelligence agencies and the role of the Saudi Arabian government in the 9/11 attacks. The controversy over Kissinger ended almost as quickly as it began when the former Secretary of State withdrew from consideration because of his reluctance to meet the government's ethical guidelines. The full committee membership was named in December of 2002 and it began to hear testimony in March 2003. But with a relatively small budget, $3 million, a fraction of the $40 million spent by special prosecutor Kenneth Starr to investigate former President Clinton and Monica Lewinsky, it is hard to be optimistic about the likelihood that it will shed much new light on the attacks.

There is more optimism about the actual site, owing largely to the generally favorable response to the selection of a design by Studio [Daniel] Libeskind, whose plan for the site focuses on the pit excavated at the base of what was the trade center and it is to be ringed by glass towers that swirl upward to a spire 1,776 feet tall. The pit is arguably the most powerful piece of the design in part because it challenges the end-of-history myth, if not all "end of" mythologizing. Specifically, the pit describes a 4½-acre memorial space, 30 feet below street level, into which people will descend and walk around the area that bore the weight of the collapsed buildings and observe the walls that held back the subterranean waters of the Hudson River and saved lower Manhattan from flooding. Although it will not be as deep as originally planned in order to accommodate new infrastructure, the pit and its walls will retain their power to remind visitors of what turned the purified space of the twin towers into Ground Zero. But it is more than just a reminder. The

western slurry wall that held back the Hudson will continue to restrain the river's force even as visitors walk by. One design critic put it as follows: "There will be . . . no firm demarcation of what was and what became. Where the wall was, it still is, and in such a place memory is a live event. History plays out in real time." (Johnson 2003) But it is not only the Hudson's waters that need to be kept back. There is also the danger of re-mythologizing or even fetishizing this space with visions of the sacred and a new purity that echoes the purification that the architect Minoru Yamasaki tried to impose on Radio Row. The process of creating a new myth has already begun as these almost prayerful words about the Libeskind pit attest: "New Yorkers need to stand watch to ensure that the final plans sanctify this space deep in the earth. Although unasked for, it is our Parthenon, our Stonehenge. Purified by loss, it is ours to shape and renew." (Meyerowitz 2003)

Perhaps. But with that said, the overall planning process for what to do with the site leaves little room to expect anything resembling a fundamentally new direction. There is certainly no reason to expect an open debate about diversifying the site and the local economy. The commitment to a post-industrial office monoculture, despite overproduction of office space, appears safe. Like all the other designs, Studio Libeskind was required to incorporate enormous amounts of office space, settling on 7.63 million square feet along with another 900,000 square feet of commercial retail space. The stipulation was put in place by the Lower Manhattan Development Corporation, the body that the state and city put together to make decisions about the future of the site. The LMDC, with the power to condemn land and override city land use regulations, is comprised of people appointed by the governor of New York State and mayor of New York City. Almost every one of the corporation's directors is from the banking and real estate sector, including the one labor representative from the Building and Construction Trades Council. And no one in authority even whispers what one scholar concluded in his analysis of the planning for the site. "Before rushing to create new office space," Angotti (2002) suggests, "it would be best to consider the millions of square feet of vacant office space that followed construction of the World Trade Center in the 1970s. Would it make sense to once again build for a market that never was there in the first place?" In the view of the architecture critic Herbert Muschamp (2002a), persistent answers to

the effect that it would indeed make sense represent the interests "of New York's largest corporate architecture firms and the politically connected real estate-development industry they serve." Although the resolution of the design competition did make some things clear, as another account put it, "battle lines are already being drawn over other issues." These include how the memorial will be paid for, when the commercial buildings will go up, or even "whether the towers will look much like the buildings in the design" (Wyatt 2003a). Indeed, just 3 months after Studio Libeskind won the design competition, the site's leaseholder, Larry Silverstein, called for limiting Libeskind's role to that of inspiring—not designing—the site (Dunlap and Wyatt 2003). And two members of the LMDC's board called for eliminating the pit from the site plan (Wyatt 2003b).

One factor that might shape final decisions is a declining economy that, even with government help in the form of subsidies, tax abatements, and the waiving of environmental rules, makes it difficult, if not impossible, to make money from a new set of towers. Between February 2001 and February 2003, New York City lost 176,000 jobs (Eaton 2003). In November 2002 there were 15.4 million square feet of vacant office space in lower Manhattan, more than the entire commercial market of Atlanta and businesses continued to relocate from the area and out of high rise office buildings generally (Bagli 2002a). Another is a public uproar. When the LMDC put its weight behind initial designs resulting from a competition that was even more strictly controlled to guarantee not only substantial office construction but dull buildings, concerned social groups and the general public reacted against what was clearly an effort to reproduce the office monoculture (Wyatt 2002a). The result was a new competition which chose new design teams with more flexible guidelines (along with warnings that public protests will slow down the entire process of rebuilding lower Manhattan). The result was a major improvement in design but no change in the office monoculture. So it is understandable that, in spite of some optimism, one noted design critic remains cautious because "we have learned in the past year that the development corporation needs to be watched closely, every step of the way. Blink, and the new design study could turn out to be no more than another set of sideshow distractions from an overly politicized process" (Muschamp 2002b).

New Yorkers are also very wary because much of the federal money promised in financial relief has simply failed to come forward. FEMA has also been criticized severely in an internal review for mishandling its front-line mission, providing emergency economic assistance (Chen 2003). In fact, as one report put it, "many victims, elected officials, business executives and others are both confused and angry about why, more than a year after the most serious terrorist attack on American soil, less than a quarter of the federal government's promise of financial assistance has been realized" (Wyatt et al. 2002).

In his farewell address to the city former mayor Giuliani promised to push for a "soaring, monumental" memorial on the WTC site (Cardwell 2001). Such a memorial to the victims is essential. But memorials are supposed to be about learning from the past and, as local authorities race to repeat past mistakes, or replicate cyberspace myths about an "informational city," not much learning is taking place. A complete memorial would including rethinking the site and adjoining neighborhoods. It would start with an investigation that would determine exactly how and why so many lost their lives and many others their livelihoods in the attack. Furthermore, it would include revisiting Jane Jacobs's call for diversifying the local economy and its social class composition. Or even, as one historian has suggested, a combination of Jacobs's philosophy with a dose of her nemesis Robert Moses. Despite his near obsession with megaprojects that undermined local neighborhoods, Moses had a keen sense of how public investment in the transportation infrastructure and in recreation facilities spread the benefits widely. That he and others were able to accomplish so much of this during the Great Depression is also a model for how government can rebuild on a significant scale even when the national economy is severely eroded (Wallace 2002). Finally, such a memorial would directly involve the families of those whom we would memorialize and people who live in the affected areas in all the planning decisions.[14] But, barring some significant change in the political climate, it is unlikely that we will see this kind memorial.

There are also other memorials emerging from beneath the surface of myth. Consider this one that would likely have disappeared were it not for the deft touch of a 2002 documentary film through which we learn that on January 12, 1995 detectives of the New York Police Department shot and killed two young Puerto Ricans from the Bronx. No charges

were brought against the officers who claimed to be acting in self-defense. The mother of one of the murder victims took her case to the city's Civilian Complaint Review Board which determined that the detectives had used unnecessary and excessive force. Autopsy evidence and the testimony of a witness suggested that the young men were shot in the back as they were lying on the floor. The director of the Review Board was fired as were investigators assigned to the case. One of the detectives was a voluntary bodyguard to Mayor Giuliani during the mayor's election campaign. At one point in the film we see a split screen: the mother is on one side pleading into the telephone to the mayor, who, on the other side, rebuffs her, falsely claiming that her son fired shots and that he had a criminal record. As a review of the film *Justifiable Homicide* concludes, it "is a sobering reminder that there was more to Mr. Giuliani's mayoralty than September 11" (Kehr 2002). Consider another. In the last days of his administration, Mayor Giuliani offered the New York Yankees and the New York Mets baseball teams $1.6 billion in increasingly scarce city revenue to help them build new stadiums and then secretly rewrote their leases to make it easier for them to leave if the new mayor did not agree with Giuliani's largesse (Steinhauer and Sandomir 2001; Steinhauer 2002). Finally, on the last day of Giuliani's mayoralty, his administration ordered the dismissal of 3,500 former welfare recipients, mostly single mothers, who were employed under a "workfare" program to clean the city's understaffed parks. It also withdrew the promise of such jobs from 1,200 others who were reaching their welfare time limits. They were all referred to a private temp staffing agency and some were hired back through the agency with city funds but at wages reduced from $9.38 an hour to $7.95 for the same work (Bernstein 2002). All of these too are memorials, but of another sort.

For some, what all this amounts to is the emergence of a myth far darker than the promises of cyberspace. Indeed, because it dealt so powerful a blow to the entire philosophy of neo-liberalism, laying bare the scars and contradictions that were building for years, the sociologist Ulrich Beck (2001) called the events of 9/11 "globalization's Chernobyl." One might also conclude that it dealt a serious blow to the myths of cyberspace. Beck suggests that we need to think much more seriously about the vulnerabilities that follow directly from a global political economy rooted in networks of communication and transportation.

Multiplying global communication and transportation links also multiplies the number of nodes from which to attack and the number of nodes that are open to attack. Consider the banal details of terror: Mohammed Atta, who helped fly an aircraft into one tower, made his booking on the American Airlines web site; his accomplices used Travelocity.com.

Hardt and Negri (2000: 58) described the contemporary predicament of "Empire": "Perhaps the more capital extends its global networks of production and control, the more powerful any singular point of revolt can be. Simply by focusing their own powers, concentrating their energies in a tense and compact coil, these serpentine struggles strike directly at the highest articulation of imperial order." All this would lead one to expect much more careful attention to security and we have seen some, including extreme, examples of this. But it is important to keep in mind that clashing with this process is the tendency of neo-liberalism to promote a retreat from the state, which means a retreat from the collective management of expanding networks at the national and international levels. "Today," Beck (2001) perceptively concludes, "the capitalist fundamentalists' unswerving faith in the redeeming power of the market has proved to be a dangerous illusion. In times of crises, neoliberalism has no solutions to offer. Fundamental truths that were pushed aside return to the fore. Without taxation, there can be no state. Without a public sphere, democracy and civil society, there can be no legitimacy. And without legitimacy, no security. From this, it follows that without legitimate forums for settling national and global conflicts, there will be no world economy in any form whatsoever." It is understandable that one hears, even at the highest levels of neo-liberal orthodoxy, what were once considered heretical calls for a return to a more active state, in regulation, policy, and security.

How long this interventionist position will last and with what outcome is very difficult to say. Again, it is important to keep in mind some of the less thoroughly considered lessons of the demise of the World Trade Center. The tale of the twin towers also reminds us that massive government economic and political support was essential to remake lower Manhattan and to sustain the entire district. The World Trade Center, this icon of post-industrialism, was built because the state condemned the existing properties, appropriated the land, paid for construction, provided tax subsidies higher than anywhere else in the city,

and filled the often vacant towers with state government workers (taking up fully 50 stories of one of the towers) (Darton 1999; Statement of the Mayor, April 25, 2001, City of New York Office of Management and Budget; Goldberger 2002: 91). It also built a tax subsidized luxury housing district adjacent to the towers (Battery Park City) and subsidized an area high-tech district now in decline (Silicon Alley). Government moved one of the city's elite public schools to the area, and added a state-of-the-art park at a time when city schools and parks were suffering from years of neglect. Strengthening the state apparatus can produce mixed results indeed. In conclusion, returning to Ground Zero suggests that we have come a long way from the breezy triumphalism of the dotcom boom and we do not know where it will lead. Sober second thoughts might increase support for a cosmopolitan politics, if not a new internationalism. But perhaps that will not be the case and we will find ourselves facing Kaplan's imagined anarchy, at first regionally and then perhaps even globally.

The Wizard and the Banal

This book began with a myth and now will end with one. In 1992 Salman Rushdie, in the heady days before a bounty was placed on his literal head, wrote an essay on one of the most popular movies, and myths, in American culture: *The Wizard of Oz*. Among its many resonant themes, the myth of technology must have stood out for readers of the original novel published in 1900, at a time of fierce debate about robber barons of industry corroding Lincoln's republic, as well as for Depression-weary viewers of the 1939 film.[15] For the movie hinges on unmasking a Wizard who promises, if not salvation, then a safe trip home, with a technology whose special effects are only matched by the secrecy surrounding their use. The Wizard operates behind a curtain; the source code, as it were, safely hidden, until Dorothy's dog Toto chews open the curtain, and we realize that the Great and Glorious Wizard of Oz is just an ordinary man, a Kansan like Dorothy, but with access to a special-effects machine. Dorothy learns that technology puts on a good show, with all the trappings of magic, but doesn't get you where you really need to go. After the dotcom bubble burst, who trusts Bill Gates to point out the road ahead? But, once again, it is easy to debunk the myth, finger the

conjurer, applaud the trickster, particularly one as cute as Toto. In a real sense, it's child's play. It is more difficult, but more important, to accept Rushdie's conclusion (2002: 30): "In the end, ceasing to be children, we all become magicians without magic, exposed conjurers, with only our simple humanity to get us through."

Notes

Chapter 1

1. Named in honor of former Vice-President Albert Gore, who claimed to have "[taken] the initiative in creating the Internet" and who originated the myth of the Global Information Infrastructure.

2. One *Wired* writer continues to believe, going as far as to attack "the myth of the myth of the new economy" (Surowiecki 2002).

3. RCA stock reached a price of $570 a share in April 1929, lost most of its value in the crash (75 percent in October 1929 alone), and did not recover its 1929 value until 1964, proving premature *Barron's* 1927 celebration of "a new era without depressions" (Cassidy 2002: 69–70). History may not repeat itself, but the media often do. In September 2000, *Barron's* asked rhetorically "Can anything stop this economy?" (ibid.: 69).

4. For another version, see Gardner 1977: 3–4.

5. For a description of mutual constitution, see Mosco 1996: 6–7.

6. Even the rational side has its mythic allure. The iconic classical helmsman was Odysseus, who spent 10 years at sea using a combination of trickster guile (hence Homer's epithet "wily Odysseus") and sober analysis to make his way home from the Trojan Wars.

7. Gibson attributes his vision of cyberspace to his first experience wearing a Sony Walkman, in the summer of 1981. He goes as far as to declare: "I haven't had that immediate a reaction to a piece of technology before or since. I didn't analyze it at the time, but in retrospect I recognized the revolutionary intimacy of the interface. For the first time I was able to move my nervous system through a landscape with my choice of soundtrack." (Headlam 1999) Gibson attributed his specific conception of cyberspace to an advertising poster for an Apple computer that showed only the processor and the keyboard, which led him to think: "If there is an imaginary point of convergence where the information this machine handles could be accessed with the under-the skin intimacy of the Walkman, what would that be like?" (ibid.)

8. One might agree for example that the so-called ancients and we moderns make equal use of myths but that the former developed them because positive

knowledge fell short of the imagination while our myths help us to cope with the tendency of positive knowledge to overwhelm the imagination.

9. Postman's book is one of the many "end of" chronicles that arrived not unexpectedly as we approached the end of the millennium. My point is that there is more to this fascination with end times than simply the arrival of the year 2000.

10. For a good example in an assessment of the work of the philosopher Jacques Ellul, see Karim 2001.

Chapter 2

1. From Silicon Alley in New York to Silicon Wadi in Israel, some seventy places have adopted 'Silicon' to designate a high-tech district. The long list of Silicon Valley "wannabes" confounds the evidence suggesting that most have little chance of emulating the Valley's success (Rosenberg 2002).

2. One might argue against this tendency by pointing out that information and software stored in a computer or in a company's protected network are far more sensitive than generic electricity stored either on-site or at a utility's power station. Will individuals and businesses trust a central utility to house this data? It is interesting to observe that at this very early stage in computer communication, we trust central servers to house enormous amounts of information, much of it publicly accessible. It is also interesting to observe that in 2002 IBM executives looked into the future of computing and concluded that we will most likely be purchasing computing power in the way we purchase electricity from utilities and, of even more pressing concern for businesses today, that Microsoft is moving to a subscription model for its software products (Lohr 2002a,b).

3. The historian Edward Thompson (1966: 12) spoke of the "massive condescension of posterity."

4. In 1953, the *Ladies Home Journal* declared that in the near future nuclear energy would create a world "in which there is no disease . . . where hunger is unknown . . . where food never rots and crops never spoil . . . where 'dirt' is an old fashioned word . . . where the air is everywhere as fresh as on a mountain top and the breeze from a factory as sweet as from a rose" (Del Sesto 1986: 58).

5. The novel itself soared up the list of best sellers once again in 2002 and 2003, propelled by *The Hours*, a novel (and later a film) that explores three lives: Virginia Woolf as she was writing *Mrs. Dalloway*, a woman in 1950s suburbia whose life changes forever as she reads the novel, and finally a Mrs. Dalloway of the 1990s.

6. For a fascinating discussion of how much of the discourse of cyberspace replicates that of the first age of print, including poetry that embodies Gibson's definition of cyberspace as a "consensual hallucination," see Rhodes and Sawday 2000.

7. For the version published in the *Journal of Finance,* see Cooper, Dimitrov, and Rau 2001.

8. In this regard I agree with Silverstone's point that these are the primary characteristics of the liminal that should be the focus of our attention. Silverstone

(1988: 26) is critical of anthropologists, such as Victor Turner, who concentrate on the marginal nature of the liminal and not "the original concept of the liminal in all of its extravagance: of separation, mediation, betwixt and betweenness, the jumbling of categories and the release of communitas."

9. It is also not a particularly new technique. Back in the 1960s "scenario creation," as the Institute for the Future described it, was a favored approach in business and government think tanks to develop prognoses for the future (Gordon 1971).

10. Compare today's communication model of post-industrial electronic utopia with an earlier era's zealous vision of paradise built on revolutions in transportation (Segal 1986).

11. Most, but not all, of the founding figures in personal computer history spun cyberspace myths. One exception was Adam Osborne, whose Osborne PC grew spectacularly in 1981 and 1982. Nevertheless, this founder of the company insisted on seeing his device as "adequate," proudly giving customers "90 percent of what most people need" (Markoff 2003).

12. It is interesting to see how Gates (1995: 18–19) effusively connects the space program with the Internet: "The idea of interconnecting all homes and offices to a high-speed network has ignited this nation's imagination as nothing has since the space program." Lauria and White (1995) provide a more detailed analysis of the commonalities between cyberspace and the space program.

13. For a detailed analysis of Gore's myth of the Global Information Infrastructure, see Nassr 1997.

14. Places with web cachet are replacing once politically sacred spaces such as Detroit auto plants and the NASA Space Center as locations for identifying with and leading the future. "Everybody comes here trying to get a little Silicon Valley dust on their shoes," Netscape CEO James Barksdale once said (Richtel 1999). This is not the first time that Barksdale used the language of magic to describe the world of Silicon Valley. Back in 1995, when Netscape was in the midst of its first major campaign to raise capital, Barksdale would regale venture capitalists with the language of a preacher: "'It's just like church,' he would tell his moneyed audience, 'Come on down and be saved.'" (Clark 2000: 218). In 1999, Silicon Valley emerged as a central location, a type of magic place, for the next presidential campaign. One commentator noted: "The dance is on between presidential candidates and high-technology executives, who were once regarded as bit players in campaign finance and whose industry in turn prided itself on its libertarian stream and almost dismissive attitude toward whatever was happening in Washington, D.C. Facing a host of tax and regulatory issues . . . many industry executives are clearly deciding that it pays to have friends in the White House and Capitol." (Verhovek 1999)

15. In a further demonstration of just what a complex and slippery terrain cyberspace can be, Gore also came under criticism for telling people that he and his wife loved the film *The Matrix*, which celebrates the rebel hacker. But the film is also filled with violence, much of it carried out by the movie's trench-coated heroes. *The Matrix* sparked debate when two members of what was dubbed the

"Trench-Coat Mafia" of their Colorado high school killed twelve students, a teacher, and themselves.

16. It is interesting to observe that when the new myth meets the banal world of practical politics, the myth must sometimes give way. One of the people who experienced a short stay among Apple's panoply of great people who "think different" was the Dalai Lama of Tibet. Apple backed down when his visage offended government officials in China, whose claim to Tibet the Dalai Lama resists (he *does* "think different"). But China is a major target market for Apple products.

17. Friedman's 1999 book *The Lexus and the Olive Tree* amplifies this myth of the Internet. After expounding on the connection between globalization and "the democratization of technology, finance and information" or what he calls the forces that "blew away the walls" to create "super-empowered individuals," we come breathlessly to the Internet. He tells us: "It is because of the Internet that I say you ain't seen nothin' yet. . . . As the Internet proliferates, it is going to become the turbocharged engine that drives globalization forward." (Friedman 1999b: 116–117) For another view of globalization, and one that stands up far better after the dotcom crash put the brakes on, see Harvey 2000: 53–72.

18. As chapter 3 describes, one of the ways that we mythologize is to first dehistoricize. Whether celebrated or demonized, the hacker is viewed as unique, singularly connected to the rise of the Internet. But this is not so, as Tom Standage demonstrates in *The Victorian Internet,* a book that documents the early years of telegraphy when coding and hacking were prominent ways to protect and crack open the first electronic messages.

19. For a good collection of classic stories on the wide-ranging metaphorical world of cyberspace, see Stefik 1996.

20. In his 1996 book *The End of Education,* Neil Postman offers what amounts to a set of ethical coordinates for understanding technology, particularly in education, in a more value-laden way than most metaphorical presentations permit. For example, the metaphor or vision of "spaceship earth" provides a sense of the global community's mission. These didactic images fall somewhere between the descriptive metaphor and the transcendent mythic narrative. Myths are sometimes didactic but ethical lessons are not central to their meaning and power.

Chapter 3

1. The list omitted several books that make explicit reference to the end of the millennium.

2. Some of our most powerful encounters with myth and time are connected to literacy. Eliade (1959: 205) put it as follows: "Whether modern man 'kills' time with a detective story or enters such a foreign temporal universe as is represented by any novel, reading projects him out of his personal duration and incorporates him into other rhythms, makes him live in another 'history.'"

3. Myth draws its power from the dreams it taps into, here of freedom and equality. It rarely deals with facts, particularly those critical ones that the

philosopher William James liked to call, "coercive facts," an example of which appeared about the time Fukuyama's book appeared. The crumbling of the corporate hierarchy, embodied, Fukuyama notes, in such icons of business as AT&T, would be news to employees of that company which completed the largest media buying spree in history, reconstituting itself as a global giant in every area of the media and new technology industry. When the telecommunications industry collapsed, amidst evidence of massive corruption and mismanagement, analysts pointed to rigid hierarchies and senior executives accountable to noone. AT&T's response was to buy Comcast and reestablish its claim to dominance in cable television.

4. Bell himself is well aware that his view was not a novel one in the 1950s. Citing the work of sociologists (Ralf Dahrendorf), political philosophers (Otto Kirchheimer), and once ideologically committed people like John Strachey and Bell's old friend Lewis Corey, he traces the roots of his own conception of the end of ideology. Interestingly, he notes that the only person genuinely and vocally appalled by the development of the ideologically barren "mixed economy," was the conservative economist Friedrich Hayek, whose tirade against this view marked the only dissonance at the well known Conference on Cultural Freedom in 1955, a foreshadowing of the "new right" of the 1980s.

5. A good example of how critics miss Bell's recognition that capitalism creates its own contradictions can be found in Marshall Berman's important assessment of modernism *All That Is Solid Melts into Air*. According to Berman (1988: 122–123), Bell believes that "modernism has been the seducer" and "capitalism . . . is wholly innocent in this affair: it is portrayed as a kind of Charles Bovary, unexciting but decent and dutiful, working hard to fulfill his wayward wife's insatiable desires and to pay her insupportable debts. This portrait of capitalist innocence has a fine pastoral charm but no capitalist could afford to take it seriously. . . ." But the point is, neither does Bell.

6. It is not a big step to suggest, as has one leading scholar/theologian, that business is now one of the world's dominant religions with its own theology "of sacraments to convey salvific power to the lost, a calendar of entrepreneurial saints, and what theologians call an 'eschatology'—a teaching about the 'end of history.'" With its own claims to the twin perfections of omniscience and omnipotence, the market itself can lay claim to serving this faith as its God (Cox 1999: 18–22).

7. My Jesuit education provided me with an early introduction to Teilhard.

8. Clarke combined the literary and scientific imaginations, with the latter demonstrated in his early work on the idea of a global communication satellite placed in geostationary orbit. He also acknowledged the connection between both worlds as he noted that "any sufficiently advanced technology is indistinguishable from magic." (Wegner 2002; see also Stivers 1999)

9. Negroponte's well-meaning call to digitize the Library of Congress receives a wild reposte in Neal Stephenson's novel *Cryptonomicon*. In a futuristic America in ruins, the Library of Congress is digitized, but it has also merged with the CIA, "kicked out a big fat stock offering," and been overrun by swarms of freelancers who upload the stories that fill the venerable institution's electronic "stacks" with a very different form of "information."

10. One not insignificant sign of the Internet's banality is the increasing tendency to decapitalize its proper name (Schwartz 2002b).

11. Among those who have more faith in nanotechnology, there is substantial concern about the social risks and ethical questions it raises (Feder 2002b).

12. Sure enough, soon after stories appeared about a possible ceiling on Moore's Law, research hit the press about revolutionary computer components no thicker than a single molecule and 100 billion times faster than a Pentium microprocessor. The use of words like 'Lilliputian' and the talk of "*Fantastic Voyage*-style machines" and "the power of 100 computer work stations in a space the size of a grain of salt" suggest how easy it is to restore the myth of miniature (Markoff 1999). By 2002, scientists at IBM were boasting about creating a logic circuit covering a trillionth of a square inch (Chang 2002).

13. We are now observing the explicit mixing of the traditionally religious world and cyberspace. In 1999, Roman Catholic Internet surfers promoted naming St. Isidore of Seville, a seventh-century bishop and the author of the twenty-volume proto-encyclopedia *Etymologiae*, the patron saint of the Internet. They see Isidore as combining a religious spirit with a drive to synthesize knowledge that would make him an appropriate object of worship and prayer. The Vatican has been less than supportive, perhaps because it is aware of a note in the 1967 edition of the *New Catholic Encyclopedia* that had Isidore taking liberties with texts: "Transcribing short passages from various authors, he often adapted his sources in various ways by lightly modifying texts and by coloring them with his own personal ideas. Hence, Isidore cannot be considered a first-class scholar nor an objective historian." But perhaps an all the more excellent choice for patron saint of the Internet! In any event, the Vatican announced in 2001 that it was seriously considering naming Isidore the patron saint of Internet users and computer programmers (Reuters 2001a).

14. Silverstone, like other media scholars (see Himmelstein 1984), focuses on the content of media for evidence of the mythic and the magical. It is admittedly important to examine how television drama and news stories conjure new realities. But it is also necessary to extend this analysis by examining how the stories of myth and magical conjurings define the new cultural terrain of cyberspace and to view the entire process of producing, promoting and simply telling the story of cyberspace as both mythical and magical. In this respect computer communication may be more powerfully mythical than television because the technology itself has taken on legendary importance. However, that also may just be a function of its newness relative to television.

15. John Perry Barlow, taking a page from *Childhood's End*, has pronounced that the gap between the older generation and their cyber-savvy children will grow so great that "I have a terrible feeling that your children, by the time they are my age, would be barely recognizable to me as human, so permanently jacked in to the Great Mind will they be." (cited in Cassidy 2002: 87)

16. Kurt Andersen provides an inspired, satirical view of the converging worlds of executives in the entertainment and new computer media industries in his novel *Turn of the Century*.

17. See also Lincoln 1999.

Chapter 4

1. Ohmae tries to distinguish himself from his end-of-history counterpart Francis Fukuyama but does not succeed. Attacking the end-of-history thesis ("nothing could be further from the truth"), he asserts that "larger numbers of people from more points on the globe than ever before have aggressively come forward to participate in history" (Ohmae 1995: 1). But this is precisely Fukuyama's point, as long as one agrees, as Ohmae does, that participation in history now means building a global monoculture—one type of economy, one type of politics, and ultimately one type of culture.

2. Ohmae's vision is shared by most of the leading cyber-gurus. Consider John Perry Barlow, described as a pioneering cowboy on the electronic frontier, who declares that the end of "body-based systems" means that anyone can enter the frontier "without privilege or prejudice accorded by race, economic power, military force, or station of birth" (Barlow 1996: 1).

3. The verb 'devoted' is appropriate: as is true of some other mythmakers, there is a devotional quality to Mitchell's writing. For example, he wonders whether "immersive, multisensory, telepresence at Mass" is the equivalent of being there (1995: 20). Will theologians carry on the same debates that occupied their time in the seventeenth century, when they wondered whether a Mass seen by a telescope was valid? There is also a playful quality that openly draws on myths to explain central points. Clicking a mouse to open and close windows on the desktop reminds Mitchell of "Dorothy click[ing] her heels to get back to Kansas" (ibid.: 23)

4. Marx (1973: 539) specifically referred to the revolution in transportation and communication which represented "the annihilation of space with time."

5. Fred Turner (1999) sees a deeper meaning in the electronic frontier myth. Examining the rhetoric of new spaces he concludes that it "works to transform a series of personal losses—of time with family and neighbors, of connection to one's body and one's community—into a collective myth. In other words its sub-scribers celebrate what they cannot avoid." More than just an escape from the drudgery of day to day work, "it transforms that predicament into a site of potential heroism in the tradition of American myth."

6. Wertheim is not alone. For a view of the medieval monastery as embodiment of virtual reality and a fascinating look at the history of virtual landscapes, see Mukerji 1999.

7. For a classic religious-philosophical discussion of space, see Eliade 1959 where it is viewed as discontinuous, ruptured, and divided, with its parts valued differently.

8. Reflecting on a career immersed in finding connections between the natural and the social, the biologist E. O. Wilson concludes that the human mind requires, and most often finds in nature, both sources of pleasure, love and the sublime, what he calls the need for the spirit to seek out a "beauty and mystery beyond itself." For him, nature offers an ineffable localness, a sense of place pro-viding solid roots for both the beautiful and the sublime. (Then and Now. Reflections on the Millennium: The Lure of Place in a Mobile World, *New York Times,* December 15, 1999)

9. This section draws from Vincent Mosco and Derek Foster, "Cyberspace and the end of politics," *Journal of Communication Inquiry* 25 (2001), no. 3: 218–236. Mr. Foster, then a doctoral student in communication at Carleton University, was primarily responsible for completing the section on the Progress and Freedom Foundation. My thanks to him for an excellent contribution to an earlier version of this section.

10. Although it has received little attention, Ronald Reagan's ability to articulate the American sense of the intimate connection between technology and religion has to be counted among the most significant sources of his widespread popularity. He appears to have understood very well what Noble (1997: 5) describes as the fact that "modern technology and religion have evolved together and that, as a result, the technological enterprise has been and remains suffused with religious belief." See also Stahl 1999.

11. For more on this document, see Moore 1996.

12. One signal in the New Age discourse about cyberspace is the sheer number of declarations, of which this is only one of the more prominent. Others include John Perry Barlow's "Declaration of Independence of Cyberspace" (Barlow 1996), Donna Haraway's "Manifesto for Cyborgs" (Haraway 1985), and Chris Gray's "Cyborg bill of rights" (Gray 2001: 26–29).

13. Examples of these can be found in calls for the technological makeover of citizen-state relations and the dawning of an electronic republic (Grossman 1996; Hollander 1985; Saldich 1979).

14. Toffler's claims for a third wave society also embody the politics of the academy. We can see the postmodernist's reification of difference in the assertion that the third wave constituency is highly diverse, de-massified and composed of individuals who prize their differences. The political landscape of the third wave society is claimed to be very much 'post-political' insofar as it is imagined to be populated by post-partisan, post-factional free agents whose very heterogeneity contributes to a lack of political awareness and a difficulty of unification (1995: 79). In this sense, the Tofflers' PFF-endorsed proposals to rethink political life reflect the pluralization and disaggregation of interests that one might also find in a postmodern perspective. While others decry the balkanization of society, they hail the emergence of a new abundance of spaces in which politics can flourish.

15. For simplicity's sake, dichotomizing this picture of social reality into the "old" and the "new" is a practical strategy. It also logically flows out of the PFF's own attempt to describe life in those very terms. In their New Magna Carta document, they use some of the following distinctions to describe the difference between the "Information Superhighway" and "Cyberspace": Limited Matter vs. Unlimited Knowledge; Centralized vs. Decentralized; Government Ownership vs. A Vast Array of Ownerships; Bureaucracy vs. Empowerment; Culmination of Second Wave vs. Riding the Third Wave.

16. One doubts that Gingrich is familiar with one of the pithier remarks made by Niels Bohr, a founding figure in quantum physics: "Prediction is very difficult, especially about the future."

Chapter 5

1. The actual Great White Way of Times Square was so covered in illuminated advertising that almost no publicly funded lighting was required.

2. The enthusiasm for "telephone concerts" at the turn of the twentieth century is strikingly like the hoopla that accompanied the "webcasting" of concerts at the next turn of a century. Billed as "a First for Web," the company Woodstock.com delivered over its web site a concert to honor the 30th anniversary of the original landmark event. What actually marked it as a first was the use of a single location user password that prevented multiple users from dodging the pay-per-view fee for the event (Flynn 1999).

3. Martin (1991: 138–139) concludes that "the diversity of the early uses of the residential telephone was astonishing" and cites this 1880 poem: "You can list to a concert and never go out, / But can hear every song that is sung; / You can easily know what a play is about / From the line when the curtain's uprung. / You can hear the debates in the House if you like, / But that twaddle might make many telephones strike."

4. The link between the promise of education on radio and all the current talk about virtual education in cyberspace is matched by the prominent fears of miseducation in both. The many references to evil "snake oil" salesman hawking miracle cures on radio are back, as investigators for agencies like the U.S. Federal Trade Commission, the same agency that tried to root out phony medical cures on radio, are now on the attack against evildoers in cyberspace. In a complaint that differs from the 1930s only in the addition of one new disease, one FTC spokesman said: "Sites touting unproven remedies for very serious diseases—cancer, heart disease, HIV/AIDS and, particularly, arthritis—are absolutely exploding on the Web." (Stolberg 1999). For the radio counterpart, see Barnouw 1966: 168–172.

5. Early radio demonstrates that cyberspace is far from the first to encourage young people to actively use, rather than just passively receive, a new technology. Indeed, the story of early radio documents that the often-repeated tale of today's computer prophets, to the effect that we have moved in a straight line from passive to active technologies and that young people are leading the way for the first time in the history of communication technology, is way off the mark. But it does makes a compelling myth. For a pure version of the myth, see Tapscott 1998.

6. A case can also be made that radio enjoyed two periods of history-making hopes. Its "second chance," as one hopeful commentator called it, arrived in the 1930s when FM radio brought the promise of realizing what early AM radio was perceived to have squandered. The story of this promise and how it was dashed can be found in Barnouw 1968.

7. It is hard to imagine Sarnoff disagreeing with the pronouncement appearing on the front gate of the 1933 Chicago World's Fair: Science Explores, Technology Executes, Man Conforms.

8. Dunlap undoubtedly felt the irony of his expectation that with television the United States and Japan were about to experience an era of harmony. Consider

this: "When the Japanese Premier . . . broadcast the first message of goodwill to listeners in the United States his voice was remarkably clear despite its long flight by short wave across the broad Pacific to the California shore. He opened a new era in international relations between the United States and the East. Then the airplane of Lindbergh flew over for a visit. The next link in the chain of friendship may be television—when Japan will see America and Americans will see the Japanese." (Dunlap 1942: 229)

9. I can recall the magic entering my sixth-grade classroom when my teacher wheeled in a television for the first time and tuned in to a class in mathematics. The fact that the math was way beyond what any of us could understand seemed to be irrelevant. The mere presence of the electronic talisman in the room would apparently be enough to spike a major leap in our mathematical comprehension. I cannot speak for my classmates, but that experience provided me with little more than good reason to be skeptical—actually not a bad lesson for an 11 year old to learn.

10. The book originally appeared in shorter form as a special issue of *The Nation* dated May 18, 1972.

11. "The mushrooming growth in available information and the demand for access to this information is bringing about a revolution in communications which will produce a profound change in the way society is structured and in the way we live." (Electronics Industry Association 1969)

12. Historians of the Internet understandably concentrate on the computer as the source of its development. But in doing so they miss the point that most of the ideas for specific services on the Net were developed in connection with earlier technologies, particularly cable television.

13. They embody the faith called for in an article written during the heyday of utopian visions about cable television. The futurist John Wren-Lewis saw the need to return to a faith in technology as "the prophetic faith which has always been found at the core of the world's great religions." Wren-Lewis (1970: 262) believed this was needed to combat the "tribalism" responsible for such woes as the "population explosion" in the Third World.

Chapter 6

1. http://www.infoplease.com

2. In a tape recording of his conversation, John Gotti was heard saying that DiBono had to die for the sin of disrespect. ("He refused to come in when I called.") DiBono's bullet-ridden body was found in a basement parking lot of the Trade Center (Glanz and Lipton 2002b: 43). The debate over fireproofing intensified in May 2003, when federal investigators reported that builders never carried out tests essential to determining how the towers would perform in a fire (Glanz 2003).

3. For example, by encasing stairwells in gypsum, rather than masonry and cement, engineers lightened the buildings and, as long as the gypsum held firm, increased fire prevention. But lightweight gypsum walls were easily breached and

shattered causing stairwells to collapse. In the south tower an estimated 300 people at or above the impact area survived the crash but only 18 could find an open stairway to escape (Glanz and Lipton 2002b).

4. Many of the high-tech districts or technopoles of the 1990s took on the myth and the mystique of magic places, spaces where remarkable transformations in economics, politics, and culture take place. Consider Kuala Lumpur, Malaysia. If New York is viewed as the information age phoenix rising from the ashes of manufacturing decline, then Malaysia is the magic land where palm-oil plantations were turned into a Multimedia Super Corridor almost overnight. Malaysia's Corridor enacted the alternative but related myth, *creatio ex nihilo,* when the Malaysian national government created a completely new built environment out of 400 square miles of rain forest and palm oil plantation south of Kuala Lumpur. It is interesting that, like New York, Malaysia anchored its showcase for the information age in the twin Petronas Towers, which are often compared to the WTC (Glanz 2002b; Arnold 2003).

5. This continued a policy, begun in the administration of Mayor Dinkins and accelerated with Mayor Giuliani, which provided massive tax and other benefits to businesses on the promise that they would not leave the city. Whether or not they actually intended to leave, companies sniffing around locations outside the city did very well. Forty-nine such "corporate retention" deals netted business $2 billion in the Giuliani years alone. Big media firms including ABC, CBS, and Bertelsmann received large subsidies without any threat to leave. Asked why he pocketed a second helping from a financially starved city, the head of CBS answered, "I just wanted to be treated like everyone else." (Wallace 2002: 18–19)

6. Lyman (1999) put it this way: "When digital filmmaking's full potential is reached, a growing number of people in the industry believe, it might even threaten a studio power structure that has held firm since the advent of sound and has absorbed such technological challenges as television and VCRs."

7. Ninety-five percent of fiber network capacity goes unused.

8. Enron was not the only friend of the Bush administration with ties to Global Crossing. In 2003 the company agreed to pay Richard Perle, a close Bush adviser and chairman of the influential Defense Policy Board, $725,000 to help win government approval to sell the company to a joint venture based on Hong Kong and Singapore. His support was considered particularly important since both the Pentagon and the FBI opposed the sale (Labaton 2003).

9. Here is how one long-time technology executive described her experience with the boards of dotcom firms: "I got off a couple of boards where I couldn't stomach what was going on. The capacity for illusion was limitless. You'd have a board meeting, and you'd say 'Where's the revenue page?' And the C.F.O. would say: 'Oh, don't worry about revenues. We're just looking at expenses, so we know when we need to raise more money.'" (Race 2002)

10. In June 2003 the FCC loosened many of the most important rules limiting the ability of media companies to extend their reach into new markets and to expand in markets where they already have a presence.

11. Coca Cola has actually branded highway signs across Tanzania so that its brand is literally that nation's stop sign.

12. But there is nothing very new in this account. Back in 1995, the front page of the *New York Times* featured a report on what amounted to slave labor in the Brazilian rain forest. The twin forces of debt and intimidation fill both articles (Schemo 1995).

13. The Mayor's Office of Emergency Management, established in response to the 1993 terrorist attack on the World Trade Centre was one of the planning disasters of the 2001 attack. As one analyst put it, "The belief in the coordinated public safety efforts of the Giuliani administration turned out to be much like the belief in the unsinkability of the Titanic." The OEM was evacuated early in the crisis because it was placed in the Trade Centre complex by the Mayor against the advice that it would be unwise to locate it in a terrorist target. Moreover, police radio warnings urging evacuation of a tower about to collapse were not heard by firefighters because police and fire operated separate communication systems (Dwyer 2002).

14. Instead, in what can only be considered business as usual, the Lower Manhattan Development Corporation appointed the former first vice president for global sponsorships and client events marketing for Merrill Lynch to oversee the creation of a memorial (Wyatt 2002b).

15. Rushdie notes that the novel's author Frank Baum put Dorothy in silver slippers (the movie made them ruby) because he supported the populist cause of basing the dollar on cheap silver and moving off a gold standard supported by the rich. Others have made more of this to the point of seeing in the Cowardly Lion the populist orator ("Thou shalt not crucify mankind upon a cross of gold!"), presidential candidate, and, for some, a cowardly turncoat, William Jennings Bryan. (See Littlefield 1964; Dreier 1978; Young 1976) For a discussion of Oz and the cyber-mythologies of films like *The Matrix,* see Klawans 1999.

References

Andersen, K. 1999. *Turn of the Century*. Random House.

Anderson, B. R. 1991. *Imagined Communities: Reflections on the Origin and Spread of Nationalism*. Revised and extended second edition. Verso.

Angotti, T. 2002. The makeup of the Lower Manhattan Redevelopment Corporation. Gotham Gazette (online).

Arnold, W. 2003. Vertically challenged in Malaysia. *New York Times*, March 8.

Associated Press. 2001a. Internet naming group criticized. February 14.

Associated Press. 2001b. Nortel unveils new technology tool. January 30.

Bagli, C. 2002a. Tall tower near Ground Zero is proposed. *New York Times*, November 12.

Bagli, C. 2002b. Fuel in storage inside buildings raises concern. *New York Times*, November 19.

Barboza, D. 2002. Signs of manipulation in broadband trading. *New York Times*, May 17.

Barboza, D., and Romero, S. 2002. Enron is seen having link with Global. *New York Times*, May 20.

Barlow, J. P. 1996. A Declaration of the Independence of Cyberspace. Davos, Switzerland. Reprinted in P. Ludlow, ed., *Crypto Anarchy, Cyberstates, and Pirate Utopias* (MIT Press, 2001).

Barnouw, E. 1966. *Tower of Babel: A History of Broadcasting in the United States*, volume 1. Oxford University Press.

Barnouw, E. 1968. *The Golden Web: A History of Broadcasting in the United States*, volume 2. Oxford University Press.

Barnouw, E. 1990. *Tube of Plenty*, second revised edition. Oxford University Press.

Barthes, R. 1972 (orig. 1957). *Mythologies*. Noonday.

Baudrillard, J. 1994. *The Illusion of the End*. Stanford University Press.

Beck, U. 2001. Globalisation's Chernobyl. *Financial Times*, November 6.

Becker, T. L., ed. 1991. *Quantum Politics: Applying Quantum Theory to Political Phenomena*. Praeger.

Bell, D. 1973. *The Coming of a Post-Industrial Society.* Basic Books.

Bell, D. 1996 (orig. 1976). *The Cultural Contradictions of Capitalism.* Basic Books.

Bell, D. 1988 (orig. 1960). *The End of Ideology.* Harvard University Press.

Bellamy, E. 1888. *Looking Backward: 2000–1887.* Houghton Mifflin.

Berman, D. 2002. Before telecom bubble burst, some insiders sold out stakes. *Wall Street Journal,* August 12.

Berman, M. 1988 (orig. 1982). *All That Is Solid Melts into Air.* Penguin.

Bernstein, N. 2002. City fires 3,500 former welfare recipients. *New York Times,* January 5.

Berry, W. 2002. The idea of a local economy. *Harpers,* April: 15–20.

Best, M. 1990. *The New Competition: Institutions of Industrial Restructuring.* Harvard University Press.

Bickerton, D. 1997. Digital dreams. *New York Times Book Review,* November 30: 6.

Borsook, P. 2000. *Cyberselfish.* PublicAffairs.

Bowman, L. M. 1999. ICANN opening meetings, deferring fees. Reuters News Service, July 19.

Brady, J. E. 1899. *Tales of the Telegraph.* Doubleday and McClure.

Brinkley, A. 2000. An idea whose time will not go. *New York Times Book Review,* April 16: 6–7.

Brinkley, J. 1999a. Gates' book offers a study in contrasts. *New York Times,* March 21.

Brinkley, J. 1999b. Listening to the sounds of a wave. *New York Times,* June 3.

Broad, W. J. 2000. Antimissile testing is rigged to hide a flaw, critics say. *New York Times,* June 9.

Broad, W. J. 2002. U.S. ignores failure data at outset of flights. *New York Times,* December 18.

Broad, W. J. 2003. MIT studies accusations of lies and cover-up of serious flaws in antimissile system. *New York Times,* January 2.

Browne, M. 1999. Is incredible shrinking chip nearing the end of the line? *New York Times,* June 29.

Buck-Morss, S. 2002. *Dreamworld and Catastrophe: The Passing of Mass Utopia in East and West.* MIT Press.

Burke, E. 1998 (orig. 1756). *Philosophical Enquiry into the Origin of Our Ideas of the Sublime and Beautiful.* Penguin.

Cairncross, F. 1997. *The Death of Distance.* Harvard Business School Press.

Campbell, J. 1988. *The Power of Myth.* Doubleday.

Cardwell, D. 2001. In final address, Giuliani envisions soaring memorial. *New York Times,* December 28.

Carey, J. W. 1992 (orig. 1989). *Communication as Culture.* Routledge.

Carey, J. W. 1993. Everything that rises must diverge: Notes on communications technology and the symbolic construction of the social. In P. Gaunt, ed., *Beyond Agendas*. Greenwood.

Caruso, D. 1999. Digital commerce. *New York Times*, August 16.

Cassidy, J. 2002. *Dot.con: The Greatest Story Ever Sold*. HarperCollins.

Castells, M. 1989. *The Informational City*. Blackwell.

Castells, M. 2001. *The Internet Galaxy*. Oxford University Press.

Chang, K. 2002. Scientists shrinking computing to molecular level. *New York Times*, October 25.

Chase, A. 2003. *Harvard and the Unabomber: The Education of an American Terrorist*. Norton.

Chen, D. W. 1997. New media industry becoming juggernaut. *New York Times*, October 23.

Chen, D. W. 2003. FEMA criticized for its handling of 9/11 claims. *New York Times*, January 8.

Chen, E. 1999. Gore has high-tech high—and low. *New York Times*, April 7.

Christian, N. M. 2002. A retiree's crusade: no more falling high-rises. *New York Times*, October 17.

Clark, J. 2000. *Netscape Time*. St. Martin's Press.

Clausing, J. 1999. Web domain to be assigned for Palestinian territory. *New York Times*, December 6.

Cobb, J. 1998. *Cybergrace: The Search for God in a Digital World*. Crown.

Cooper, M. J., Dimitrov, O., and Rau, P. R. 2001. A rose.com by any other name. *Journal of Finance* 56: 2371–2388.

Cousineau, P. 2001. *Once and Future Myths*. Conari.

Cox, H. 1999. The market as god. *Atlantic Monthly*, March: 18–23.

Coyne, R. 1999. *Technoromanticism*. MIT Press.

Darnton, R. 1999. The new age of the book. *New York Review of Books*, March 18: 5–7.

Darton, E. 1999. *Divided We Stand: A Biography of New York's World Trade Center*. Basic Books.

Davis, E. 1998. *Techgnosis: Myth, Magic and Mysticism in the Age of Information*. Harmony.

de Certeau, M. 1985. Practices of space. In M. Blonksy, ed., *On Signs*. Johns Hopkins University Press.

De Forest, L. 1942. *Television: Today and Tomorrow*. Dial.

Del Sesto, S. L. 1986. Wasn't the future of nuclear energy wonderful? In J. Corn, ed., *Imagining Tomorrow*. MIT Press.

Denning, M. 1996. *The Cultural Front*. Verso.

Dewey, F. 1997. Cyburbanism as a way of life. In N. Ellin, ed., *Architecture of Fear*. Princeton Architectural Press.

Dibbell, J. 1993. A rape in cyberspace. *Village Voice,* December: 36–42.

Doig, J. W. 2002. *Empire on the Hudson: Entrepreneurial Vision and Political Power at the Port of New York Authority.* Columbia University Press.

Doniger, W. 1998. *The Implied Spider: Politics and Theology in Myth.* Columbia University Press.

Douglas, S. J. 1986. Amateur operators and American broadcasting. In J. Corn, ed., *Imagining Tomorrow.* MIT Press.

Douglas, S. J. 1987. *Inventing American Broadcasting, 1899–1922.* Johns Hopkins University Press.

Dreier, P. 1978. Once upon a time, *The Wizard of Oz* was a populist fable. *In These Times,* December 20–26: 23.

Dunlap, D. W., and Wyatt, E. 2003. Leaseholder sees limited role for Libeskind at Trade Center. *New York Times,* May 30.

Dunlap, O. E. 1942. *The Future of Television.* Harper.

Dunlap, O. E. 1932. *The Outlook for Television.* Harper.

Dwyer, J. 2002. A calamity unimaginable in scope, and unexamined in all its dimensions. *New York Times,* September 11.

Dyer-Witheford, N. 1999. *Cyber-Marx: Cycles and Circuits of Struggle in High Technology Capitalism.* University of Illinois Press.

Dyson, E. 1997. *Release 2.0: A Design for Living in the Digital Age.* Broadway Books.

Dyson, E. 1998. *Release 2.1: A Design for Living in the Digital Age.* Broadway Books.

Eaton, L. 2003. With 176,000 jobs lost in 2 years, New York City is in grip of a recession. *New York Times,* February 19.

Eddy, W. C. 1945. *Television: The Eyes of Tomorrow.* Prentice.

Electronics Industry Association. 1969. *The Future of Broadband Communication.*

Eliade, M. 1959. *The Sacred and the Profane.* Harcourt, Brace, and World.

Emberley, P. 1989. Places and stories: The challenge of technology. *Social Research* 56: 741–785.

Feder, B. J. 1999. Plotting corporate futures: Biotechnology examines what could go wrong. *New York Times,* June 24.

Feder, B. J. 2002a. FCC says telecom isn't doomed by cutbacks. New York Times online, October 21.

Feder, B. J. 2002b. Nanotechnology has arrived. *New York Times,* August 19.

Feder, B. J. 2002c. Intriguing possibilities in sensors. *New York Times,* October 7.

Fiedler, L. 1996. *Tyranny of the Normal: Essays on Bioethics, Theology and Myth.* Godine.

Fischer, C. S. 1992. *America Calling.* University of California Press.

Fisher, D. E., and Fisher, M. J. 1996. *Tube: The Invention of Television.* Harcourt Brace.

Fisher, L. M. 2003. Job-rich Silicon Valley has turned sour, survey finds. *New York Times,* January 20.

Fitch, R. 1993. *The Assassination of New York.* Verso.

Fitzgerald, F. 2000. *Way Out There in the Blue: Reagan, Star Wars and the End of the Cold War.* Simon and Schuster.

Flynn, L. J. 1999. Concert broadcast is a first for Web. *New York Times,* June 21.

Foucault, M. 1973. *The Order of Things.* Random House.

Franzen, J. 2002. *How to Be Alone: Essays.* Farrar, Straus and Giroux.

Friedman, L. M. 1999. *The Horizontal Society.* Yale University Press.

Friedman, T. L. 1999a. Foreign affairs: Are you ready? *New York Times,* June 1.

Friedman, T. L. 1999b. *The Lexus and the Olive Tree: Understanding Globalization.* Farrar, Straus and Giroux.

Fukuyama, F. 1989. The end of history. *National Interest* 16, summer: 3–18.

Fukuyama, F. 1992. The *End of History and the Last Man.* Avon.

Fukuyama, F. 1995. *Trust: The Social Virtues and the Creation of Prosperity.* Penguin.

Fukuyama, F. 1999. *The Great Disruption: Human Nature and the Reconstitution of Social Order.* Touchstone.

Fukuyama, F. 2001. History is still going our way. *Wall Street Journal,* October 5.

Fukuyama, F. 2002. *Our Posthuman Future: Consequences of the Biotechnology Revolution.* Farrar, Straus and Giroux.

Fuller, R. B. 1962. *Educational Automation.* Southern Illinois University Press.

Gabriel, T. 1996. Decoding what "screen-agers" think about TV. *New York Times,* November 25.

Gardner, J. 1977. *On Moral Fiction.* Basic Books.

Gates, B. 1995. *The Road Ahead.* Viking.

Gates, B. 1999. *Business @ the Speed of Thought.* Warner Books.

Geist, M. 2002a. Internet overseer takes wrong path on accountability. *Globe and Mail,* August 8.

Geist, M. 2002b. Internet turf war playing out. *Globe and Mail,* November 7.

Gelernter, D. 2002. Forget the files and the folders: Let your screen reflect life. *New York Times,* November 7.

Gibson, W. 1984. *Neuromancer.* Ace.

Giddens, A. 1979. *Central Problems in Social Theory.* Macmillan.

Gilder, G. 2000. *Telecosm: How Infinite Bandwidth Will Revolutionize Our World.* Free Press.

Gilder, G. 1994. *Life after Television.* Norton.

Gilder, G. 1989. *Microcosm: The Quantum Revolution in Economics and Technology.* Simon and Schuster.

Gillespie, A. G. 2001. *Twin Towers.* Rutgers University Press.

Gitlin, T. 1999. We're all authorities. *New York Times Book Review,* May 23: 32.

Glanz, J. 2001. Cast of Star Wars makes comeback in Bush plan. *New York Times,* July 22.

Glanz, J. 2002a. Con Ed and insurers sue Port Authority over 7 World Trade. *New York Times,* September 11.

Glanz, J. 2002b. Comparing two sets of twin towers. *New York Times,* October 23.

Glanz, J. 2003. Towers untested for major fire, inquiry suggests. *New York Times,* May 8.

Glanz, J., and Lipton, E. 2001a. Experts urging broader inquiry into towers' fall. *New York Times,* December 25.

Glanz, J., and Lipton, E. 2001b. City had been warned of fuel tank at 7 World Trade Center. *New York Times,* December 20.

Glanz, J., and Lipton, E. . 2002a. Vast detail on towers' collapse may be sealed in court filings. *New York Times,* September 30.

Glanz, J., and Lipton, E. 2002b. The height of ambition. *New York Times Magazine,* September 8.

Glanz, J., and Lipton, E. 2002c. Burning diesel is cited in fall of 3rd tower. *New York Times,* March 2.

Glanz, J., and Moss, M. 2001. Since the beginning, questions dogged twin towers' fireproofing. *New York Times,* December 14.

Goldberger, P. 2002. Groundwork. *New Yorker,* May 20: 86–96.

Goldberger, P. 2003. Eyes on the prize. *New Yorker,* March 10, 67–82.

Goodman, P. S. 2002. Telecom sector may find past is its future. Washington Post Online.

Gordon, D. 1997. *Battery Park City: Politics and Planning on the New York Waterfront.* Gordon and Breach.

Gordon, J. S. 2002. *A Thread Across the Ocean: The Heroic Story of the Transatlantic Cable.* Walker.

Gordon, T. J. 1965. *The Future.* St. Martin's Press.

Gordon, T. J. 1971. *The Current Methods of Futures Research.* Institute for the Future.

Gore, A. 1994. Speech to International Telecommunications Development Conference. Buenos Aires, March 21.

Gramsci, A. 1971. *Selections from the Prison Notebooks.* Lawrence and Wishart.

Gray, C. H. 2001. *Cyborg Citizen.* Routledge.

Grossman, L. 1996. *The Electronic Republic: Reshaping American Democracy in the Information Age.* Viking.

Habermas, J. 1987. *The Philosophical Discourse of Modernity.* MIT Press.

Hague, B. N., and Loader, B. D., eds. 1999. *Digital Democracy: Discourse and Decision Making in the Information Age.* Routledge.

Haraway, D. 1985. The cyborg manifesto. *Socialist Review* 80: 65–107.

Hardt, H., and Brennen B., eds. 1995. *Newsworkers: Toward a History of the Rank and File.* University of Minnesota Press.

Hardt, M., and Negri, A. 2000. *Empire.* Harvard University Press.

Harmon, A. 2002. Marketers try to turn Web pirates into customers. *New York Times,* November 4.

Hartung, W. D., and Ciarrocca, M. 2000. Star Wars II: Here we go again. *Nation,* June 19: 11–20.

Harvey, D. 1996. *Justice, Nature and the Geography of Difference.* Blackwell.

Harvey, D. 2000. *Spaces of Hope.* University of California Press.

Headlam, B. 1999. Origins: Walkman sounded bell for cyberspace. *New York Times,* July 29.

Hees, P. 1994. Myth, history, and theory. *History and Theory* 33: 1–19.

Himanen, P. 2001. *The Hacker Ethic and the Spirit of the Information Age.* Random House.

Himmelstein, H. 1984. *Television Myth and the American Mind.* Praeger.

Hine, T. 1991. *Facing Tomorrow: What the Future Has Been, What the Future Can Be.* Knopf.

Hobart, M., and Schiffman, Z. 1998. *Information Ages: Literacy, Numeracy, and the Computer Revolution.* Johns Hopkins University Press.

Hollander, R. 1985. *Video Democracy: The Vote-from-Home Revolution.* Lomond.

Hoover, E., and Vernon, R. 1962. *Anatomy of a Metropolis.* Doubleday.

Houston, E. J. 1905. *Electricity in Every-day Life.* P. F. Collier.

Howe, P. J. 2002. Excess haunts Internet sector. *Boston Globe,* July 29.

Huber, P. J. 1995. New York, capital of the Information Age. *City Journal* 5, no. 1: 12–22.

Hughes, T. P. 1983. *Networks of Power.* Johns Hopkins University Press.

Hunter, R. 2002. *World without Secrets.* Wiley.

Hyde, L. 1998. *Trickster Makes This World.* Farrar, Straus and Giroux.

Jacobs, J. 1961. *The Death and Life of the Great American Cities.* Random House.

Jesdanum, A. 2002. ICANN's contrarian gets the boot. SiliconValley.com, October 29.

Jhally, S. 1989. Advertising as religion: The dialectic of technology and magic. In S. Jhally and I. Angus, eds., *Cultural Politics in Contemporary America.* Routledge.

Johnson, G. 1999a. Searching for the essence of the World Wide Web. *New York Times,* April 11.

Johnson, G. 1999b. A radical computer learns to think in reverse. *New York Times,* June 15.

Johnson, K. 2003. The very image of loss. *New York Times,* March 2.

Johnson, S. 1997. *Interface Culture*. HarperCollins.

Kait, C., and Weiss, S. 2001. *Digital Hustlers: Living Large and Falling Hard in Silicon Alley*. HarperCollins.

Kaplan, R. 1997. *The Coming Anarchy*. Knopf.

Karim, K. 2001. Cyber-utopia and the myth of paradise: Using Jacques Ellul's work on propaganda to analyze information society rhetoric. *Information, Communication & Society* 4, no. 1: 113–134.

Kehr, D. 2002. How did the bullets end up on the floor? *New York Times,* November 6.

Kelly, K. 2002. God is the machine. *Wired,* December: 180–185.

Kenny, C. 2003. Development's false divide. *Foreign Policy,* January-February: 76–78.

Kisseloff, J. 1995. *The Box: An Oral History of Television 1920–1961*. Penguin.

Kitchin, R. 1998. *Cyberspace: The World in the Wires*. Wiley.

Klawans, S. 1999. That void in cyberspace looks a lot like Kansas. *New York Times,* June 20.

Klein, N. 2000. *No Logo*. Knopf Canada.

Klein, N. 2001. A fete for the end of the end of history. *Nation,* March 19.

Kogut, B., ed. 2003. *The Global Internet Economy*. MIT Press.

Koppes, C. R. 1969. The social destiny of radio: Hope and disillusionment in the 1920s. *South Atlantic Quarterly* 68: 363–376.

Krebs, B. 2002. Bush stresses need for broadband deregulation. Washington Post Online, August 14.

Kriesberg, J. C. 1995. A globe, clothing itself with a brain. Wired online, June.

Kurzweil, R. 1999. *The Age of Spiritual Machines*. Viking.

Labaton, S. 2002. Telecom crisis? Take 2 aspirin and no one will call you in the morning. *New York Times,* July 25.

Labaton, S. 2003. Pentagon adviser is also advising Global Crossing. *New York Times,* March 21.

Lanham, R. A. 1993. *The Electronic Word: Democracy, Technology, and the Arts*. University of Chicago Press.

Lappin, T. 1995. Déjà vu all over again. *Wired,* May: 175–222.

Lash, S., and Urry, J. 1994. *Economies of Signs and Space*. Sage.

Latour, B. 1993. *We Have Never Been Modern*. Harvard University Press.

Lauria, R., and White, H. M., Jr. 1995. Mythic analogues of the space and the cyberspace: A critical analysis of the U.S. policy for the space and the information age. *Journal of Communication Inquiry* 19, no. 2: 64–87.

Lee, R. E. 1944. *Television: The Revolution*. Essential Books.

Lessig, L. 1999. *Code and Other Laws of Cyberspace*. Basic Books.

Lévi-Strauss, C. 1987. *Anthropology and Myth: Lectures 1951–1982*. Blackwell.

Lévi-Strauss, C. 1978. *Myth and Meaning: Cracking the Code of Culture.* University of Toronto Press.

Lévi-Strauss, C. 1963. The Structural Study of Myth. In Lévi-Strauss, *Structural Anthropology.* Basic Books.

Lewis, M. 2002. In defense of the boom. *New York Times Magazine,* October 27: 44ff.

Lincoln, B. 1999. *Theorizing Myth: Narrative, Ideology, and Scholarship.* University of Chicago Press.

Littlefield, H. M. 1964. The Wizard of Oz: Parable on populism. *American Quarterly* 16: 47–58.

Lohr, S. 1999. Is Mr. Gates pouring fuel on his rivals' fire? *New York Times,* April 18.

Lohr, S. 2002a. IBM looks into the future and sees companies buying their computing services as needed, something like electricity. *New York Times,* October 28.

Lohr, S. 2002b. Some yelp as Microsoft squeezes. *New York Times,* October 17.

Lohr, S. 2002c. New economy: The intellectual property debate takes a page from 19th century America. *New York Times,* October 14.

Longcore, T. R., and Rees, P. W. 1996. Information technology and downtown restructuring: The case of New York City's Financial District. *Urban Geography* 17, no. 4: 354–372.

Longstaff, P. F. 2002. *The Communications Toolkit.* MIT Press.

Lozano, E. 1992. The force of myth on popular narratives: The case of melodramatic serials. *Communications Theory* 2, no. 3: 207–220.

Lyman, R. 1999. New digital cameras poised to jolt world of filmmaking. *New York Times,* November 19.

Lyon, D. 2001. *Surveillance Society.* Open University Press.

Lyon, D. 1969. *The Destruction of Lower Manhattan.* Macmillan.

MacIntyre, A. 1970. *Sociological Theory and Philosophical Analysis.* Macmillan.

Maddox, B. 1972. *Beyond Babel: New Directions in Communications.* Simon and Schuster.

Markoff, J. 1999. Tiniest circuits hold prospect of explosive computer speeds. *New York Times,* July 15.

Markoff, J. 2003. Adam Osborne, 64, dies; was pioneer of portable PC. *New York Times,* March 26.

Marsh, C. S., ed. 1937. *Educational Broadcasting 1936: Proceedings of the First National Conference on Educational Broadcasting.* University of Chicago Press.

Martin, M. 1991. *"Hello, Central": Gender, Technology, and Culture in the Formation of Telephone Systems.* McGill–Queen's University Press.

Marvin, C. 1988. *When Old Technologies Were New.* Oxford University Press.

Marx, K. 1973. *Grundrisse.* Random House.

Marx, L. 1964. *The Machine in the Garden: Technology and the Pastoral Ideal in America.* Oxford University Presss.

Mattelart, A. 2000. *Networking the World, 1794–2000.* University of Minnesota Press.

Mauss, M. 1972. *A General Theory of Magic.* Routledge & Kegan Paul.

McChesney, R. 1999. *Rich Media, Poor Democracy.* University of Illinois Press.

McKercher, C. 2002. *Newsworkers Unite: Labor, Convergence and North American Newspapers.* Rowman and Littlefield.

McLuhan, M. 1969. Interview. *Playboy,* March.

Medina, J. 2002. Fees forcing college radio stations to scale back webcasts. *New York Times,* October 20.

Meyerowitz, J. 2003. Saving the wall that saved New York. *New York Times,* February 27.

Midgley, M. 1992. *Science as Salvation: A Modern Myth and Its Meaning.* Routledge.

Miège, B. 1989. *The Capitalization of Cultural Production.* International General.

Mihm, S. 2000. Utopian rulers, and spoofs, stake out territory online. *New York Times,* May 25.

Mills, C. W. 1963. *Power, Politics, and People.* Ballantine.

Mitcham, C. 1973. Philosophy and the history of technology. In G. Bugliarello and D. Doner, eds., *The History and Philosophy of Technology.* University of Illinois Press.

Mitchell, D. 1995. The end of public space? People's Park, definitions of the public and democracy. *Annals of the Association of American Geographers* 85, no. 1: 108–133.

Mitchell, W. J. 1995. *City of Bits.* MIT Press.

Mitchell, W. J. 1999. *E-topia.* MIT Press.

Moore, R. K. 1996. Cyberspace Inc. and the Robber Baron Age: An analysis of PFF's "Magna Carta." *Information Society* 12, no. 3: 315–323.

Morgenson, G. 2002. Telecom, tangled in its own web. *New York Times,* March 24.

Morgenson, G. 2003. From WorldCom, an amazing view of a bloated industry. *New York Times,* March 16.

Mosco, V. 1996. *The Political Economy of Communication.* Sage.

Mosco, V. 1999. New York.com: A political economy of the "informational" city. *Journal of Media Economics* 12, no. 2: 103–116.

Mosco, V. 2002. Report on Canada Industrial Relations Board File No. 22076-C re: Application Pursuant to Sections 18, 18. 1 35, 44, 45 & 46 of the Canada Labour Relations Code between the Telecommunications Workers Union and TELUS Communications Inc. Submitted to Canada Industrial Relations Board.

Mosco, V., and Foster, D. 2001. Cyberspace and the end of politics. *Journal of Communication Inquiry* 25, no. 3: 218–236.

Mosco, V., and Schiller, D., eds. 2001. *Continental Order? Integrating North America for Cybercapitalism.* Rowman and Littlefield.

Mukerji, C. 1999. Virtual landscapes. Paper presented at Annual Meeting of International Communication Association, San Francisco.

Mulgan, G. J. 1991. *Communication and Control: Networks and the New Economies of Communication.* Guilford.

Muschamp, H. 2002a. Rich firms, poor ideas for towers site. *New York Times,* April 18.

Muschamp, H. 2002b. Ground Zero: Six new drawing boards. *New York Times,* October 1.

Myhrvold, N. 1997. The dawn of technomania. *New Yorker,* October 20: 236–237.

Napoli, L. 2000. Reality dampening the dot-com hoopla. *New York Times,* December 25.

Nassr, J. L. 1997. The Myth of the GII: Who Does It Benefit? M.A. thesis, School of Journalism and Communication, Carleton University.

Negroponte, N. 1995. *Being Digital.* Knopf.

Negroponte, N. 1998. Beyond digital. *Wired,* December: 288.

Negroponte, N., and Hawley, M. 1995. A bill of writes. *Wired,* May: 224.

Nerone, J. 1987. The mythology of the penny press. *Critical Studies in Mass Communication* 4: 376–404.

New York City Planning Commission 1969. Plan for New York City.

Noble, D. F. 1997. *The Religion of Technology.* Knopf.

Noll, A. M. 1997. *Highway of Dreams.* Erlbaum.

Norris, F. 2003. 3 years later, investors crave safety. *New York Times,* March 10.

Nye, D. 1990. *Electrifying America: Social Meanings of a New Technology, 1880–1940.* MIT Press.

Nye, D. 1994. *American Technological Sublime.* MIT Press.

Oettinger, A. G., with S. Marks. 1969. *Run, Computer, Run.* Collier Books.

Office of Technology Policy, U.S. Department of Commerce. 2002. Understanding Broadband Demand: A Review of Critical Issues.

Ohmae, K. 1990. *The Borderless World: Power and Strategy in the Interlinked Economy.* HarperCollins.

Ohmae, K. 1995. *The End of the Nation State.* Free Press.

Ohmann, R. M., ed. 1962. *The Making of Myth.* Putnam.

Pacey, A. 1999. *Meaning in Technology.* MIT Press.

Paré, D. J. 2003. *Internet Governance in Transition: Who Is the Master of This Domain?* Rowman and Littlefield.

Pinch, T. 1986. *Confronting Nature: The Sociology of Neutrino Detection.* Reidel.

Piore, M. J., and Sabel, C. F. 1984. *The Second Industrial Divide.* Basic Books.

Pociask, S. 2002. *Putting Broadband on High Speed.* Economic Policy Institute.

Polkinghorne, J. C. 2002. *The God of Hope at the End of the World.* Yale University Press.

Pollack, A. 2002. Cities and states clamor to be Bio Town, U.S.A. *New York Times,* June 11.

Postman, N. 1996. *The End of Education.* Knopf.

Powell, C. S. 2002. *God in the Equation.* Free Press.

Price, M., and Wicklein, J. 1972. *Cable Television: A Guide for Citizen Action.* Pilgrim.

Raban, J. 1974. *Soft City.* Fontana.

Race, T. 2002. Scandals appall some longtime corporate chiefs. *New York Times,* July 1.

Reddick, A. 2002. *The Dual Digital Divide: The Information Highway in Canada.* Public Interest Advocacy Centre.

Regional Planning Association. 1968. The Second Regional Plan.

Reuters. 2001a. Vatican eyeing Isidore as patron saint of Internet users. February 6.

Reuters. 2001b. World Economic Forum says hackers got into system. New York Times online, February 5.

Rhodes, N., and Sawday, J., eds. 2000. *The Renaissance Computer.* Routledge.

Richtel, M. 1999. "Internet governor" woos Silicon Valley. *New York Times,* April 25.

Richtel, M. 2002. On its boards, Silicon Valley tends to stand by its culture. *New York Times,* July 8.

Robertson, D. S. 1998. *The New Renaissance: Computers and the Next Level of Civilization.* Oxford University Press.

Rohatyn, F. 2002a. The betrayal of capitalism. *New York Review of Books,* February 28: 6.

Rohatyn, F. 2002b. From New York to Baghdad. *New York Review of Books,* November 21: 4, 6.

Rohter, L. 2002. Brazil's prized exports rely on slaves and scorched land. *New York Times,* March 25.

Roland, A., and Shiman, P. 2002. *Strategic Computing: DARPA and the Quest for Machine Intelligence, 1983–1993.* MIT Press.

Romero, S. 2002a. In another big bankruptcy, a fiber optic venture fails. *New York Times,* January 29.

Romero, S. 2002b. Price is limiting demand for broadband. *New York Times,* December 5.

Romero, S., and Schiesel, S. 2002. The fiber optic fantasy slips away. *New York Times,* Febuary 17.

Rosenberg, D. 2002. *Cloning Silicon Valley: Inside the World's High Tech Hotspots.* Financial Times/Prentice-Hall.

Rothstein, E. 1997. Digerati are unlikely celebrants of a primitivist conflagration in the Nevada desert. *New York Times,* July 21.

Rushdie, S. 2002. *Step Across This Line: Collected Nonfiction 1992–2002.* Knopf Canada.

Saldich, A. R. 1979. *Electronic Democracy: Television's Impact on the American Political Process.* Praeger.

Samuelson, R. J. 2000. Gutenberg vs. the Net. *Washingon Post,* January 19.

Sassen, S. 1992. *The Global City: New York, London, Tokyo.* Princeton University Press.

Schemo, D. J. 1995. Brazilians chained to job and desparate. *New York Times,* August 10.

Schiesel, S. 2002. Trying to catch Worldcom's mirage. *New York Times,* June 30.

Schiller, D. 1999. *Digital Capitalism.* MIT Press.

Schwartz, J. 2002a. From unseemly to lowbrow, the Web's real money is in the gutter. *New York Times,* August 26.

Schwartz, J. 2002b. Who owns the Internet? You and i do. *New York Times,* December 29.

Searle, J. 1999. I married a computer. *New York Review of Books,* April 8: 34–38.

Segal, H. P. 1986. The technological utopians. In J. Corn, ed., *Imagining Tomorrow.* MIT Press.

Sidak, J. G. 2002. The FCC's duty. *New York Times,* October 8.

Silverstone, R. 1988. Television, myth and culture. In J. W. Carey, ed., *Media, Myths, and Narratives.* Sage.

Simon, B. 2001. A telecom umbrella extends its shadow. *New York Times,* December 24.

Siska, T. J. 2002. No community voices wanted. *Extra!* October 22.

Slaton, C. D. 1992. *Televote: Expanding Citizen Participation in the Quantum Age.* Praeger.

Sloan Commission on Cable Communication 1971. *On the Cable: The Television of Abundance.* McGraw-Hill.

Smith, A., and Paterson, R. 1998. *Television: An International History.* Oxford University Press.

Smith, J. 1987. Reagan, Star Wars, and American culture. *Bulletin of the Atomic Scientists,* January-February: 19–25.

Smith, R. L. 1972. *The Wired Nation: Cable TV.* Harper & Row.

Stahl, W. A. 1999. *God and the Chip: Religion and the Culture of Technology.* Wilfred Laurier University Press.

Standage, T. 1998. *The Victorian Internet.* Walker.

Steinberg, T. 1993. "That World's Fair feeling": Control of water in 20th-century America. *History and Technology* 34, no. 2: 401–409.

Steinfels, P. 1999. Beliefs: In a wide-ranging talk, Al Gore reveals the evangelical and intellectual roots of his faith. *New York Times,* May 29.

Steinhauer, J. 2002. Giuliani loosened ball clubs' leases days before exiting. *New York Times*, January 15.

Steinhauer, J., and Sandomir, R. 2001. Let's play two: Giuliani presents deal on stadiums. *New York Times*, December 29.

Stefik, M. 1996. *Internet Dreams: Archetypes, Myths, and Metaphors*. MIT Press.

Stivers, R. 1999. *Technology as Magic: The Triumph of the Irrational*. Continuum.

Stolberg, S. G. 1999. Trade agency finds Web slippery with snake oil. *New York Times*, June 25.

Stoll, C. 1995. *Silicon Snake Oil: Second Thoughts on the Information Highway*. Doubleday.

Sunstein, C. 2001. *Republic.com*. Princeton University Press.

Surowiecki, J. 2002. The New Economy Was a Myth, Right? Wrong. Wired online, October 7.

Sussman, G. 1998. *Communication, Technology, and Politics in the Information Age*. Sage.

Sussman, G., and Lent, J., eds. 1998. *Global Productions*. Sage.

Tapscott, D. 1996. *The Digital Economy*. McGraw-Hill.

Tapscott, D. 1998. *Growing Up Digital: The Rise of the Net Generation*. McGraw-Hill.

Tedeschi, B. 2002. EBay is the Internet's retailing success story. So why are some people making cautionary noises? *New York Times*, November 25.

Teilhard de Chardin, Pierre. 1959. *The Phenomenon of Man*. Harper.

Thompson, B. 2002. Why the poor need technology. BBC News World Edition, October 6.

Thompson, E. P. 1966. *The Making of the English Working Class*. Vintage.

Toffler, A. 1990. *Powershift: Knowledge, Wealth and Violence at the Edge of the 21st Century*. Bantam.

Toffler, A. 1980. *The Third Wave*. Morrow.

Toffler, A. 1970. *Future Shock*. Random House.

Toffler, A., and Toffler, H. 1995. *Creating a New Civilization: The Politics of the Third Wave*. Turner.

Turkle, S. 1995. *Life on the Screen: Identity in the Age of the Internet*. Simon and Schuster.

Turner, F. 1999. Cyberspace as the new frontier? Mapping the shifting boundaries of the network society. Paper presented to Annual Meeting of International Communication Association, San Francisco.

van Ham, P. 2001. The rise of the brand state: The postmodern politics of image and reputation. *Foreign Affairs* 80, no. 5: 2–6.

Varmus, H. 2002. The DNA of a new industry. *New York Times*, September 24.

Verhovek, S. H. 1999. Candidates falling into the open arms of high technology. *New York Times*, May 11.

Wallace, M. 2002. *A New Deal for New York*. Bell and Weiland.

Wayner, P. 1999. A stay of execution for the silicon chip. *New York Times,* July 1.

Webster, F., and Robins, K. 1986. *Information Technology: A Luddite Analysis.* Ablex.

Weed, W. S. 2002. Phony science: Questions for Paul Ginsparg. *New York Times Magazine,* October 13: 27.

Wegner, D. M. 2002. *The Illusion of Conscious Will.* MIT Press.

Weinberg, S. 2002. Can missile defense work? *New York Review of Books,* February 14: 41–47.

Weinstein, L. 2002. ICANN needs another long trip. Wired online, November 18.

Weisman, R. 2001. DoS attacks: Internet plague without a cure? NewsFactor Network, January 31.

Weiss, T. R. 2001. ICANN, under fire, targets alternate top-level domain name system. *Computerworld,* May 31.

Wertheim, M. 1999. *The Pearly Gates of Cyberspace.* Norton.

Williams, R. 1989. *Resources of Hope.* Verso.

Wolf, C. 1988. *Cassandra: A Novel and Four Essays.* Noonday.

Wolfe, T. 1996. Sorry, but your soul just died. *Forbes* ASAP, December 2.

Wolfram, S. 2002. *A New Kind of Science.* Wolfram Media.

Woodward, K., ed. 1980. *The Myths of Information.* University of Wisconsin Press.

Woolf, V. 1925. *Mrs. Dalloway.* Harcourt.

Woolgar, S. 2002. *Virtual Society.* Oxford University Press.

Wren-Lewis, J. 1970. Faith in the technological future. *Futures* 2, no. 3: 258–262.

Wright, S. 2000. "A love born of hate": Autonomist rap in Italy. *Theory, Culture, and Society* 17, no. 3: 117–135.

Wyatt, E. 2002a. Slowing down at a cost. *New York Times,* July 22.

Wyatt, E. 2002b. Arts organizer said to be choice to oversee 9/11 memorial effort. *New York Times,* June 28.

Wyatt, E. 2003a. Design chosen for rebuilding Ground Zero. *New York Times,* February 27.

Wyatt, E. 2003b. Panel is facing strong lobbying over design of 9/11 tribute. *New York Times,* May 30.

Wyatt, E., et al. 2002. After 9/11, parcels of money, and dismay. *New York Times,* December 30.

Yeats, W. B. 1971. The circus animals' desertion. In P. Alt and R. Alspach, eds., *The Variorum Edition of the Poems of W. B. Yeats.* Macmillan.

Young, T. R. 1976. Research in the Land of Oz: The yellow brick road to success in American sociology. Occasional paper, Red Feather Institute, Fort Collins, Colorado.

Index